Autodesk 3ds Max 8

Essentials

ELSEVIER

Amsterdam • Boston • Heidelberg • London
New York • Oxford • Paris • San Diego
San Francisco • Singapore • Sydney • Tokyo

Focal Press is an imprint of Elsevier

Focal Press

Acquisitions Editor:	Elinor Actipis
Publishing Services Manager:	Simon Crump
Assistant Editor:	Robin Weston
Marketing Manager:	Christine Degon
Cover Design:	Eric DeCicco
Interior Design:	Autodesk Media and Entertainment

Focal Press is an imprint of Elsevier
30 Corporate Drive, Suite 400, Burlington, MA 01803, USA
Linacre House, Jordan Hill, Oxford OX2 8DP, UK

Library of Congress Cataloging-in-Publication Data
Application submitted

British Library Cataloguing-in-Publication Data
A catalogue record for this book is available from the British Library.

ISBN 13: 978-0-240-80790-4
ISBN 10: 0-240-80790-1

For information on all Focal Press publications
visit our website at www.books.elsevier.com

05 06 07 08 09 10 10 9 8 7 6 5 4 3 2 1

Printed in the United States of America

Autodesk 3ds Max 8

Essentials

Contributors

Project Lead
Amer Yassine

Project Coordination
Caitlin Troughton

Authors
Roger Cusson
Sebastien Primo
Steven Schain
Luc St-Onge
Amer Yassine

Editing, Quality Control
Randy Clark
David Duberman
Caitlin Troughton

Indexing
Sarah Blay

Graphics and Production Specialists
Sarah Blay
Greg Pastuszko
Caitlin Troughton
Roberto Ziche

DVD Production
Jean-Marc Belloncik

Table of Contents

Introduction

Welcome to the Autodesk® 3ds Max® 8 Essentials Courseware. If you are new to 3ds Max, you will find that this book has been written with you in mind. The material contained within this volume takes you from a raw beginner to a seasoned professional using 3ds Max confidently in a production environment.

This courseware manual was designed primarily for use in an instructor-led classroom, while providing complete instructions so that individuals can also use the material to learn on their own. Since a variety of instructors in a multitude of learning environments use this material, flexibility was built into its design. The manual comprises five chapters: Getting Started, Modeling, Animation, Materials & Mapping and Rendering.

Each chapter has a series of theory lessons and one lab. The theory lessons introduce you to new functional areas of 3ds Max and explain these features with short simple examples. The lab shows you a practical application of the theory learned in a particular chapter. Combined, a chapter gives you a sound understanding of the functions, features and principles behind 3ds Max, and show you how to apply this knowledge to real-world situations.

Getting Started

The Getting Started chapter contains a functional overview of the essential tools and principles of 3ds Max. The first lesson discusses the user interface in detail. A practical example of how to use the various tools in 3ds Max follows. You will then learn how to create and manipulate objects and properly use transformation and modification tools.

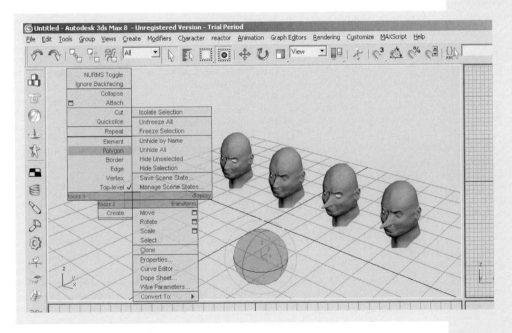

- Lesson 1: User Interface
- Lesson 2: Overview Lab
- Lesson 3: Files and Objects
- Lesson 4: Transform Tools
- Lesson 5: Modifiers

User Interface

This lesson covers the essentials of the 3ds Max user interface. The user interface, or UI for short, is the method by which the user communicates with the software. The UI is split into two main components: the Graphical User Interface or GUI (what you see on the screen), and input devices such as keyboard and mouse. You can customize most of the 3ds Max UI.

Objectives

After completing this lesson, you will be able to:

- Use the UI components in the 3ds Max interface.
- Manipulate and configure the viewport area.
- Use the command panel to create a simple object.
- Control animation in a 3ds Max scene with the animation playback controls.
- Manipulate a model in the viewport with viewport controls.

User Interface Components

Once you start 3ds Max you will encounter the following GUI on your screen.

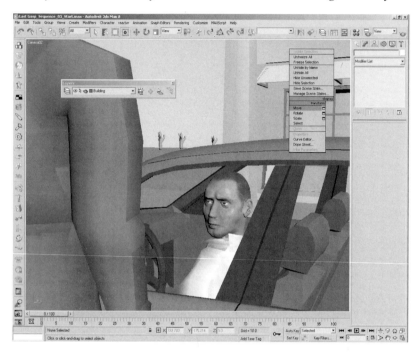

The UI is logically laid out and easy to use. We'll go though the various elements, so you understand how to work with them and the terminology used.

Viewports

The viewport area of the UI displays the scene you are working on. 3ds Max is quite flexible with how you can arrange the viewports and how your model appears in each viewport.

Adjusting Viewport Size

The size of the viewports can be easily adjusted by clicking the line between the viewports, and then dragging it to another point in the viewport area. In the illustrations below, the default four equal viewports have been changed to a large Perspective viewport by clicking and dragging the center to the upper left.

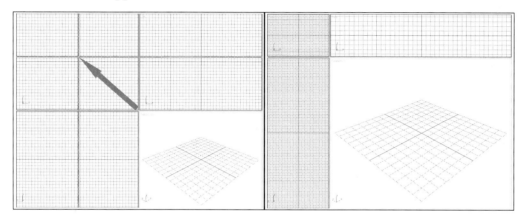

Viewport Configuration

By default, 3ds Max opens with four equal-sized viewports displayed in the UI. You can change this layout with the Viewport Configuration dialog.

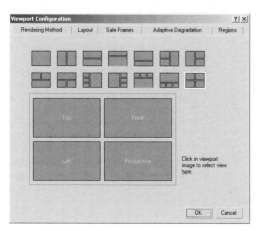

The Viewport Configuration dialog shows the variety of viewport layouts available. You simply choose one to make that layout current. You can also click the active layout in the dialog to change what the viewports show before exiting the dialog. Which layout you choose depends largely on your personal preference and the type of scene you are working on.

Home Grid and Default Views

By default, the four viewports that are displayed when 3ds Max is started are Perspective view, Front view, Top view, and Left view. Each one of these viewports has its own home grid. The home grid is the working or construction plane of the view. By default, objects are created on that plane or grid.

When you make a viewport active by clicking it, a yellow border appears. The corresponding home grid also becomes current. The following illustration shows four 3D letters, each created in a different viewport while that viewport was active. P is for Perspective, L for Left, T for Top and F for Front.

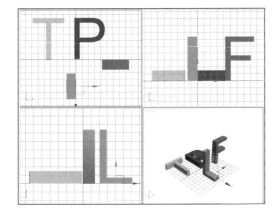

Hint: If you don't like the default layout of the 3ds Max viewports, you can create your own layout and save it as *maxstart.max* in the *scenes* folder. 3ds Max will look for this file and use it as a base template when you start and reset the software.

Getting
Started

Menu Bar

The menu bar, found at the top of the 3ds Max user interface, contains a series of pull-down menus. These include some common menus, such as File and Edit, found in most Windows applications.

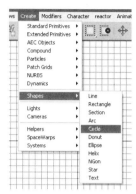

Create menu with submenu. Most Create functions are available here.

In addition, the menu bar contains many functions found in 3ds Max that also appear in other menus. For example, the Create menu, shown above, duplicates the Create commands on the command panel.

Toolbars

Toolbars play an important role in the 3ds Max UI. You can dock toolbars at the edge of the viewports, or float them on top of the 3ds Max window or off to the side, for example, on a second monitor.

Toolbars docked on top and side of the UI, and floating

Toolbars are not always displayed by default. For instance, the Layers toolbar does not display when 3ds Max is launched for the first time. To display a toolbar, right-click a blank part of the toolbar, such the area just below a drop-down list.

Right-click menu showing the displayed

A list of toolbars currently defined in the UI appears. The check marks indicate which toolbars are currently on screen.

You can dock a toolbar by dragging the toolbar's title bar to the edge of the viewport area.

Dragging a floating toolbar to a docked position

The dragged rectangle changes shape when you can release the mouse and dock the toolbar.

Toolbar now docked in position

You can undock a docked toolbar by dragging the double lines at the left end of the toolbar into an open area of the UI.

Handles of toolbars used to undock the toolbar

If the 3ds Max window uses a resolution lower than 1280 x 1024, the main toolbar is not fully visible. If you don't see the teapot icons at the right end of the toolbar, this is the case.

Buttons at the end of the main toolbar

You can scroll the toolbar by positioning the mouse cursor over an empty area of the toolbar. The icon then changes to a Pan hand, and you can drag horizontally or vertically, depending on the orientation of the toolbar.

Exercise 1: Working in the User Interface

Now that you have seen a few elements of the UI, you can start using them.

1. Launch 3ds Max.

2. From the File menu, choose Open.

3. Navigate to the directory that contains your lesson files and open the file *letters.max*.

 If the Units Mismatch dialog appears, click OK to accept the default option.

Getting Started

4. In the viewport area of the UI, position your cursor at the center of the viewports.

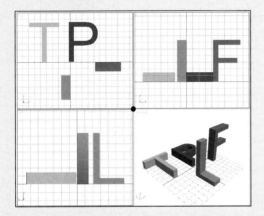

5. Click and drag the center point to the upper left of the viewport area.

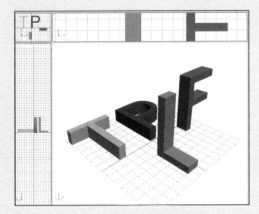

6. In the largest viewport, right-click the Perspective label.

The viewport right-click menu appears.

7. Choose Configure from the menu.

8. Click the Layout tab on the Viewport Configuration dialog.

9. Change the viewport layout by choosing the third image in the second row of layouts.

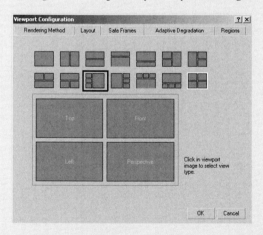

10. In the Viewport Configuration dialog, click in the Left viewport. In the menu that appears, choose the Right option to change the viewport to a right-hand view.

The Layout changes to three small viewports on the left and one large viewport on the right.

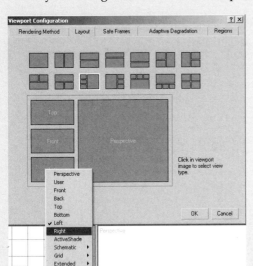

11. Click OK to exit the Dialog.

12. Click the Front viewport. Its border turns yellow.

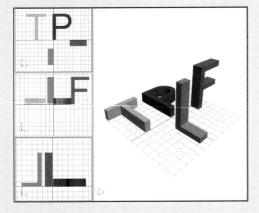

13. Press the B key on your keyboard.

The view in the viewport changes to the Bottom view. Preset hotkeys make it easier and faster to switch views.

14. In the Bottom viewport, right-click the viewport label. Choose Views > Back to switch to a rear view of the scene.

If there is no hotkey, or you cannot remember the hotkey, you can right-click the viewport label and choose Views to choose from the list of available views.

15. Go back to the standard four viewport configuration either through the Viewport Configuration dialog or by choosing Reset from the File pull-down menu.

Note: When you reset 3ds Max, the viewports are cleared of objects and returned to their default setup.

Exercise 2: Creating Objects

In the next exercise, you'll create some objects using the user interface.

1. Start or reset 3ds Max.

2. From the Create pull-down menu, choose Standard Primitives > Cylinder.

3. In the Perspective viewport, click and drag the base radius of the Cylinder.

4. Move the cursor upwards and then click to give the cylinder a positive height.

You will want to come back to this point in the scene, so you will use the Hold and Fetch commands, found on the Edit pull-down menu.

5. From the Edit pull-down menu choose Hold. This bookmarks the progress up to this point.

6. Next you'll create another object, this time using the command panel. Click the Create tab.

7. Click the Geometry button.

8. Choose Extended Primitives from the list.

9. Click the ChamferBox button.

10. In the Perspective viewport, click and drag to set the base. Release the mouse button.

11. Move the cursor vertically and click to set a positive height.

12. Move the cursor to the left and click to set a positive chamfer radius.

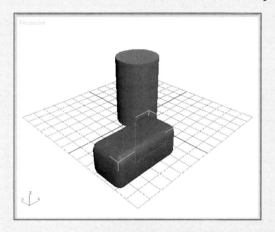

13. Right-click the Front viewport to make it active.

14. Make sure the Create panel and the Geometry button are still active.

15. From the drop-down list, choose Standard Primitives.

16. Click the Cylinder button.

17. Create the radius of the base of the cylinder in the Front viewport.

18. Drag the cursor upwards and then click to create a positive height for the cylinder.

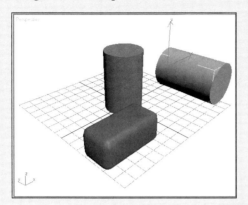

This cylinder is oriented differently from the first one because of the different construction planes being employed by the Front and Perspective viewports. The Front viewport's construction plane is more like drawing on a wall, whereas the Perspective viewport works more like the Top view, like drawing on the floor.

19. Create another Cylinder in the Left viewport.

Note the orientation and construction plane of this new object.

20. From the Create pull-down menu, choose Shapes > Line.

This activates the Create panel, the Shapes button, and the Line button. The command panel responds to commands entered elsewhere in the interface.

21. Press ESC to terminate the command.

22. From the Edit pull-down menu choose Fetch. When prompted "About to Fetch?", click Yes.

23. Your scene reverts to the bookmark you set earlier using Hold, when there was only one cylinder in the scene.

Exercise 3: Customizing Toolbars

In the following exercise, you will look at how to manipulate toolbars in the interface.

1. Restart or reset 3ds Max.

2. Right-click the grey area just under the first drop-down list on the main toolbar.

 The main toolbar, command panel, and Reactor toolbar are currently visible.

3. Click Layers to enable this toolbar.

 The Layers toolbar appears, floating in the upper-left area of the viewports.

4. Right-click the main toolbar again.

5. Choose Reactor. The Reactor toolbar disappears.

6. Drag the title bar of the Layers toolbar and place it just below the main toolbar.

7. When you are in the correct position to dock the toolbar, the appearance of the cursor and dragged window change subtly. When you release the mouse button, the toolbar appears in its docked position.

8. Enable the Axis constraints toolbar and dock it right behind the Layer toolbar.

9. Remove the Layers toolbar, and then enable it again. The toolbar remembers its last position and docked status.

10. Click and drag the two vertical lines at the left end of the Layers toolbar. Drag inside the viewports area and release the mouse button.

11. Click the X button on the Layers toolbar title bar to close the toolbar.

12. On the Customize menu, choose "Revert to Startup Layout". Click Yes when prompted. The UI returns to its initial state.

Command Panel

The command panel is the most-used area of the user interface. The command panel is organized in a hierarchical fashion, with six panels, activated by clicking tabs at the top of the panel.

Some of the command panels contain buttons and drop-down lists that further organize the panel. For example, the Create panel includes a row of buttons. Depending on which button is active, there may be a drop-down list.

As with toolbars, you can float or dock the command panel.

Create Panel

The first command panel is the Create panel. It contains different levels of creation parameters that allow you to build different types of geometry. By default the Create > Geometry > Standard Primitives area of the panel is displayed. Briefly, some areas of the Create panel are described below.

Geometry

In the Geometry area, you find commands to create 3D geometric objects.

Standard primitives are rudimentary 3D geometric objects.

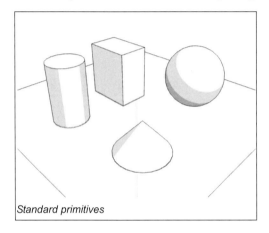
Standard primitives

Extended primitives are more complex than standard primitives.

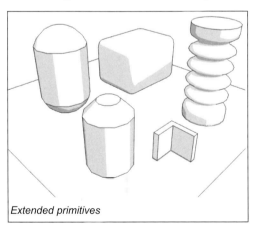
Extended primitives

Compound objects usually combine two or more objects together.

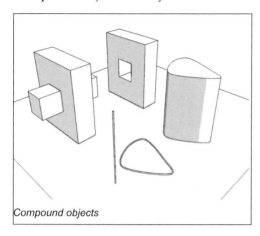

Compound objects

AEC extended, doors, and window objects are generally meant for AEC (Architecture, Engineering, and Construction), but can be useful in other applications.

AEC extended, doors &

Shapes

Shapes are divided into two basic types: splines and NURBS curves. Shapes are typically 2D but can be created in 3D as well.

Splines are based on Bi-Cubic Rational B-Splines. This allows you to draw straight lines and curved lines based on the properties of the vertices of the spline.

Splines

NURBS, or Non-Uniform Rational B-Splines, function differently from other splines in 3ds Max. You can control the NURBS curve from a point or from a control vertex which is off the actual curve.

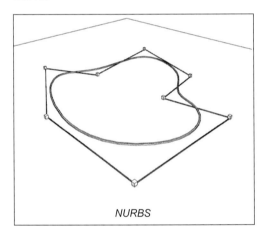
NURBS

Lights

Lights are used to illuminate the 3D scene in 3ds Max. Two types of lights are available: standard and photometric.

Standard lights comes in a variety of types. They are not based on real-world scale or illumination.

Standard

Photometric lights are similar in type to standard lights. However, they are based on real-world scale, illumination, and lighting distribution.

Photometric

Cameras

Cameras allow you to frame your compositions in a way that captures the attention when an action is taking place. There are two types of cameras in 3ds Max, both of which can be animated.

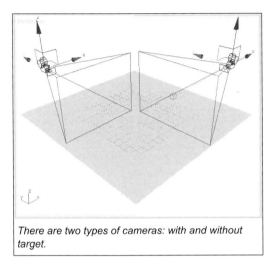

There are two types of cameras: with and without target.

Helpers

There are a number of helper types. A helpers is a non-renderable object whose purpose is to help you model and/or animate objects in the scene.

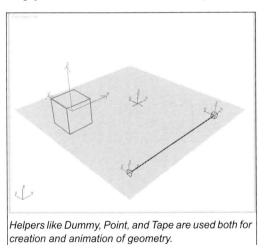

Helpers like Dummy, Point, and Tape are used both for creation and animation of geometry.

Space Warps and Systems

The last two buttons on the Create panel represent the Space Warps and Systems areas. These areas contain advanced features beyond the scope of this book, although some elements will be covered in later lessons.

Modify Panel

The Modify panel controls let you modify the base parameters of objects or change them using modifiers.

Hierarchy Panel

The Hierarchy panel is used when manipulating objects which are linked to one another. In such a situation the objects are in a parent/child relationship. This panel controls some of the relationships between these objects. The panel is also used to control the location and orientation of an object's pivot point.

Motion Panel

The Motion panel is used to control the animation of objects. Animation controllers can be assigned to objects in this panel.

Display Panel

The Display panel is used to control an object's color, visibility, freeze/thaw status, and other display properties.

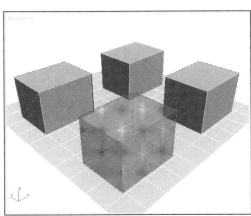

Utility Panel

The Utility panel contains a variety of commands generally not found elsewhere in the user interface.

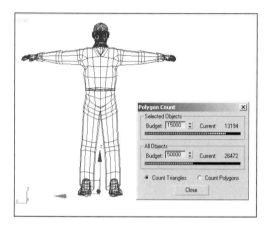

Exercise 4: Using the Command Panel

In this exercise, you will create and modify a simple object using the command panel.

1. Start or reset 3ds Max.

2. On the command panel, choose Create > Geometry and then click the Cylinder button.

3. In the Perspective viewport, drag out the base radius of the cylinder. Release the mouse button, move vertically, and then click to set the height of the cylinder.

4. On the command panel, click the Modify tab.

5. On the Parameters Rollout, change the Radius to 10, and the Height to 60.

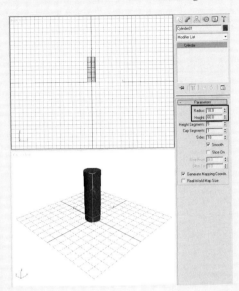

The base parameters of an object can be changed at the time of creation, but it is recommended that you switch to the Modify panel before changing these values.

6. Click the Modifier List, and choose Bend from the list.

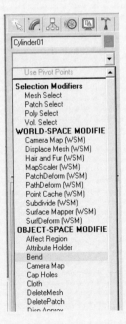

7. On the Parameters Rollout change the Angle value to –100 and the Direction value to –90.

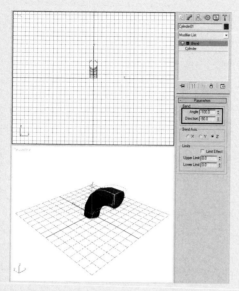

8. Right-click the Direction spinner. This sets the value to 0.

Note: In general, whenever you want to set a value to 0, you can right-click its spinner. There are a few exceptions to this rule where the value will go to 1.

9. Click the Zoom Extents All button in the lower-right area of the UI.

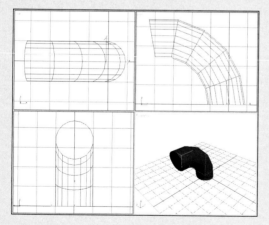

10. Go to the Display tab, and click the Hide Selected button. The object disappears.

11. In the same area of the UI, click the Unhide All button. The cylinder reappears.

12. Click the Freeze label to expand the Freeze rollout.

13. Place the cursor in an empty area of the rollout. The cursor turns into a Pan hand.

14. Click and drag upward until the lower area of the panel appears.

Other User Interface Elements

Other important UI Elements include the quad menu, dialogs, and several areas at the bottom of the 3ds Max window.

Quad Menu

The quad menu is a floating menu that adapts to the context, whenever the menu is activated. In order to access the menu, right-click in the active viewport.

Quad menu when no object is selected

Quad menu when a 3D Editable Mesh object is selected

Quad menu when a 2D Editable Spline object is selected

Dialog Boxes

Dialogs are used to present the user with information that doesn't fit easily into other areas of the UI. These may contain a large amount of information, graphs, thumbnails, schematic representations, and so on. Some typical dialogs include the following.

File Dialogs

File dialogs such as Open and Save look similar, and have the ability to display thumbnails.

Render Dialog Box

The Render dialog is typical of many dialogs in 3ds Max. It contains options organized in many rollouts on multiple tabs.

Track View Curve Editor

Track View is a tool that helps you edit and control the animation in the scene.

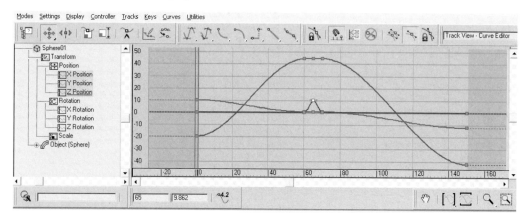

The Track View Curve Editor shows animation data in a curve format that allows you to adjust your animations easily.

Time Slider, Track Bar, and Timeline

The area just below the viewports is where the time slider, track bar and timeline are found.

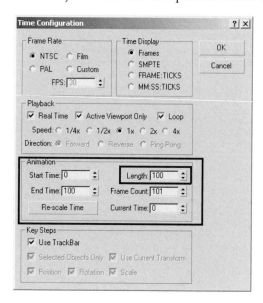

You can scrub the animation backward and forward by dragging the time slider. Alternatively, the arrows on the time slider allow you to move one frame at a time.

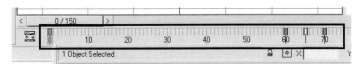

The track bar shows you the keys of a selected, animated object along a timeline. In this example, the timeline is displaying in frames and showing that the selected object has keyframes at frames 0, 60, 65, and 70.

Status and Prompt Lines

The status line shows information pertaining to the object selected and the scene.

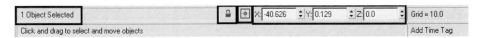

In the above example, the status line shows that one object is selected, as well as the coordinates of the pivot point of that object.

In the above example, the status line shows two objects selected. The prompt line prompts you to perform an action. In this case, the XYZ coordinates are blank because multiple objects are selected.

Animation Controls

There are two approaches to enable animate mode in the main UI. They are both identified in the animation controls area. These two modes are called Auto Key and Set Key. When Auto Key is active, the frame around the active viewport turns red, as does as the time slider background. When this mode is on, most changes that you apply in 3ds Max are recorded and can be played back later.

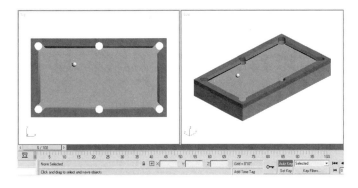

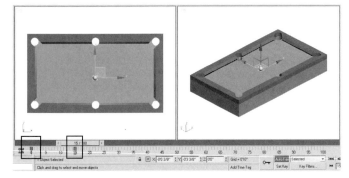

When Auto Key is on, you move the time slider to the desired frame, and then make a change to the scene, in this case, moving the ball between two points in space. At frames 0 and 15, keys that retain the state of an object are automatically created for the ball's motion.

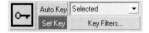

Set Key is the other animation approach that favors pose-to-pose animation. Set Key mode is usually used for animating characters. In Set Key mode, changes are not recorded unless you click the Set Keys button.

Playback Area

The playback area controls let you play your animations live in the viewports. Also here are tools you can use to adjust the animation.

The upper part of the playback controls area work much like the buttons on a VCR or DVD player. The current frame is listed in the numeric field. When you change the number, you go to that frame.

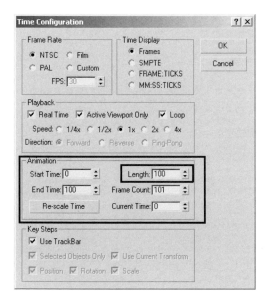

The Time Configuration button at the extreme lower right of the group brings you to the Time Configuration dialog. One of the things you will frequently do in this dialog is change the length of the animation.

Exercise 5: Using the Animation Playback Controls

In the following sequence you will use the animation controls to play back and adjust a simple animation.

1. Open the file *Pool Table Cue.max*.

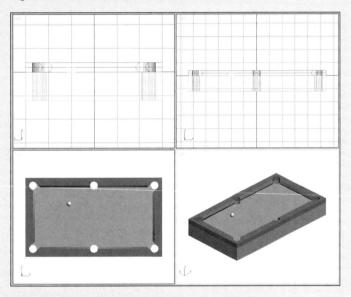

2. Right-click the User viewport to make it active.

3. ▶ Click the Play Animation button. The animation plays in the User viewport.

4. While the animation is still playing, right-click in the Top viewport. The animation playback switches to that view.

5. Click the Play Animation button again (it now looks like a "pause" symbol) to stop the playback.

Getting Started

6. Click the white Cue Ball object to select it.

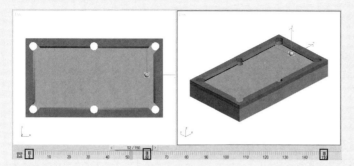

An animated object will typically have keys along the timeline. These represent pivotal moments in the object's animation.

7. Drag the time slider back and forth between frames 50 and 70. The ball moves towards and away from the bumper of the table.

8. Leave the time slider on frame 60. Frame 60 is the frame where the ball changes direction, as you would expect from hitting a bumper on a pool table.

9. Click the key at frame 60. It turns white, and the mouse cursor becomes a left/right arrow while over the key.

10. Drag the marker to frame 40.

11. Play the animation again. The ball gets to the bumper more quickly now.

Viewport UI Elements

You can break down the controls of the viewports into two general areas. The viewport navigation buttons allow you to control the orientation and positioning of the views in the viewports. The viewport right-click menu allows you to control the configuration, rendering mode, and type of view in the viewport.

Viewport Navigation Icons

The viewport navigation tools are found at the lower-right of the 3ds Max UI. These buttons let you control the positioning of the vantage point of the viewer of the 3D scene. The icons are context sensitive and can change depending on the type of view currently active.

Above is the most common layout of the viewport control tools. This layout appears when a orthogonal viewport is active, such a Top, Front, or User viewport.

Some of the buttons in this area contain flyouts with additional options. After you choose a different flyout button, it becomes current, making it easier to choose a second time.

Viewport Right-Click Menu

When you right-click a viewport label, a menu appears. This menu contains a number of commands for controlling the viewports.

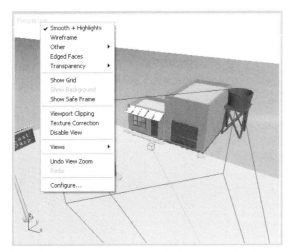

The viewport right-click menu controls rendering levels and the configuration of the viewport layout.

Rendering Levels

The viewport right-click menu offers a number of different rendering modes. You'll probably use these most often:

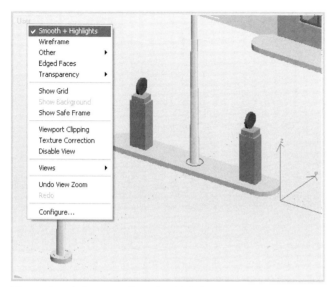

Viewport rendering set to Smooth + Highlights.

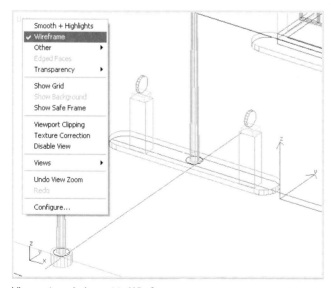

Viewport rendering set to Wireframe.

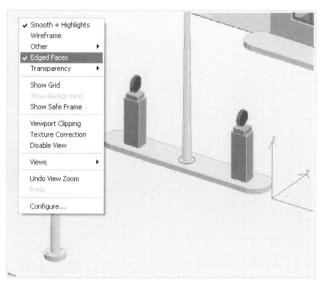

Viewport rendering set to Smooth + Highlights with Edged Faces on. This combination of shaded and wireframe views can be useful when modeling.

Since most animators switch among these rendering modes frequently, 3ds Max includes predefined hotkeys to speed access to these modes.

- The F3 function key toggles between Wireframe display and Smooth + Highlights.
- The F4 function key toggles Edged Faces display.

Grid Toggle

You can toggle the grid that appears by default in the viewports through the viewport right-click menu. Choosing Show Grid from the menu toggles the grid status on or off. The **G** hotkey does the same thing.

Undo View Operation

The Undo View operation function in the viewport right-click menu (third option from the bottom) undoes the last view operation, be it a Zoom, Pan, Arc Rotate, etc. The wording of the entry changes based on the last operation. The **SHIFT+Z** hotkey has the same result.

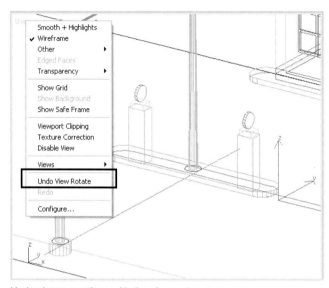

Undo view operations with the viewport menu.

Exercise 6: Orthographic View Manipulation

In the following exercise, you will look at how to manipulate a model in one or more orthographic viewports.

1. Open the file *Gas Station Blockout.max*. This is a rough block-out of a scene that you will be working on in more detail later.

2. Right-click the Top viewport to make it active.

3. 🔍 Click the Zoom button in the viewport controls area.

4. Zoom in with the cursor approximately centered on the building.

The building scrolls out of the viewport. You can adjust the zoom control so that it zooms about the mouse button.

5. Use the **SHIFT+Z** hotkey to undo the zoom operation in the Top viewport.

6. From the Customize pull-down menu, choose Preferences.

7. On the dialog that appears, click the Viewports tab.

8. Turn on Zoom About Mouse Point for both Orthographic and Perspective views.

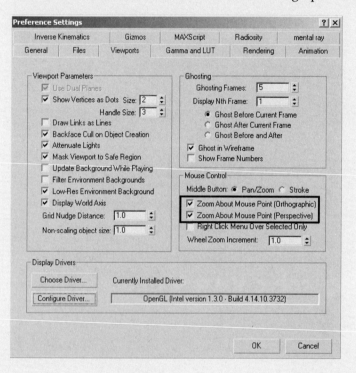

9. Click OK to exit the dialog.

10. Repeat the operation of zooming into the model with the cursor centered on the building.

Depending how close you placed the cursor to the center of the building, the building will stay visible in the viewport much longer.

11. Undo the View operation (SHIFT+Z).

12. With the Top viewport still active, click the Zoom Extents button.

All visible objects in the scene are now displayed in the Top viewport. The building is only a small area in the center.

13. Click the Zoom Extents all button.

All the Viewports zoom out in a similar fashion. If you want to get back to your previous views in each viewport, you have to do an Undo Viewport operation in each viewport individually. If you would like to isolate a few objects, you can use Zoom Extents Selected.

14. Press the **H** key on your keyboard to bring up the Select Objects dialog.

15. Highlight the object Bldg_High, and then click the Select button on the dialog.

16. Click the Zoom Extents All button and hold until the flyout appears.

17. On the flyout, choose the button with the filled white square.

All four viewports zoom about the selected objects.

18. Click the Front viewport and then use the Zoom tool to zoom out of the view about 50%.

19. Click the Region Zoom button and then drag a rectangular area around the right lamp to zoom into that lamp.

20. Click the Pan tool and then pan the view to the right so you display the left-hand lamp.

21. Roll the middle mouse wheel in either direction to zoom your view in and out. To pan the view, hold down the middle mouse button and move the mouse.

22. Right-click the User viewport to make it active.

23. Click the Arc Rotate button.

 A circle with four small squares at the quadrants of the circle appears.

24. Click the right-hand square and drag left to right.

25. Click the upper square and drag up and down.

Using these squares limits the arc rotate motion. Clicking inside the circle provides you freer movement in both horizontal and vertical directions. Clicking outside the circle provides you with a roll that can sometimes be difficult to control.

26. Undo your viewport operations (**SHIFT+Z**) to get back to the original view.

27. Select the object Bldg_High, if necessary. (**H**)

28. On the Arc Rotate flyout, click the icon with a filled-in white circle.

29. Perform some of the same operations you did previously and note that the rotations now occur around the building (the selected object).

30. The last button in the viewport controls group is Maximize Viewport Toggle. When you choose this icon, the active viewport toggles to full screen.

Exercise 7: Perspective View Manipulation

In the following exercise you will learn how to manipulate a model in one or more Perspective viewports.

1. Open the file *Gas Station Blockout_01.max*.

2. Make the User viewport active and press the **P** key on the keyboard.

The User viewport changes to a Perspective viewport. One of the buttons in the viewport control group changes.

3. Click the Field Of View button.

4. Click and drag in the Perspective viewport and the view will move in and out along the perspective view line.

 Note: Use care with the Field of View tool. Extreme distortion of the perspective can occur if the field of view is made too large. Use Undo View operation (**SHIFT+Z**) to return to the previous view.

5. Type the Letter **C** and the Perspective View will change to the view of a camera present in the scene.

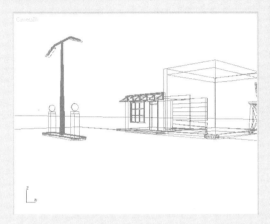

 If there was more than one camera, 3ds Max would prompt you for which camera you wanted to use.

6. In the view navigation area, choose the Walk Through tool on the Pan flyout. This tool allows you to move through your scene interactively using a combination of mouse motion and keyboard keys, as in many video games.

7. Press the **UP ARROW** key on the keyboard to move the camera into the scene.

 You can use the left and right square bracket keys on the keyboard to reduce or increase the speed of motion. Release the arrow key, press a bracket key one or more times to change the speed, and then resume navigating with the arrow key.

8. Press the **LEFT ARROW** key to move to the left. Press the **RIGHT ARROW** key to move to the right. The **DOWN ARROW** Key moves you away from the scene.

9. Hold the **SHIFT** key down and press the **DOWN ARROW** key.

10. Try this again with the **UP ARROW** Key.

 SHIFT+UP ARROW and **SHIFT+DOWN ARROW** move the camera vertically rather than in or out of the scene.

11. Right-click to end the command.

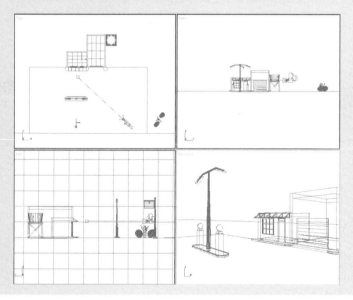

Keyboard

3ds Max uses keyboard shortcuts to invoke commands. In many cases, experienced users can do much of their work faster using the keyboard. A few shortcuts have been indicated throughout this lesson. A list of the Standard Keyboard Shortcuts is available in a keyboard shortcut card.

Help

3ds Max contains a complete Help system. The Help menu gives you access to the New Features Guide, User Reference, Tutorials, and Additional Help.

The Help pull-down menu

The 3ds Max User Reference

Summary

Now that you have completed this lesson, you should have a thorough understanding of how the UI components in 3ds Max work. You should be able to manipulate and configure the viewport area and use the command panel to create and manipulate simple objects. You should be able to view a simple animation and control its playback. Finally, you should understand how to manipulate the view of a model in the viewports.

Overview Lab

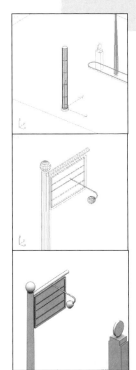

In this overview lesson, you will explore the basic creation, modification, and animation tools available in 3ds Max. You'll open an existing scene, The "Last Gasp" Gas Station, and add a signpost to it. You will then animate the sign as if one of the chains holding the sign has broken and the sign is swaying in the air. To see where you should be at the end of this lesson, play the file

Sign Breaking.avi.

Objectives

After completing this lesson, you will be able to:

- Create objects.
- Create and add materials to objects.
- Create lights.
- Create a simple animation.
- Render your animation to a movie file.
- Understand the overall workflow of an animation.

Exercise 1: Creating the Signpost

In this section, you start the geometric creation process. If you have not already done so, play the file *Sign Breaking.avi* to see the goal of this exercise.

1. Open the file *Sign Breaking.max*. You'll add a cylinder to use as a signpost to this scene.

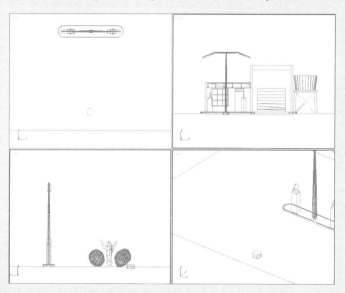

2. Right-click in the Top viewport to make the viewport active.

3. Click the command panel > Create panel > Geometry button, and then click the Cylinder button.

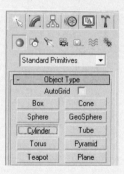

4. In the Top viewport, click and drag the center and radius of the cylinder on top of the circular object. Make it slightly smaller than the existing object.

5. Release the mouse button to set the radius of the base of the cylinder. Move your mouse to adjust the height, and then click anywhere to set it.

The User viewport shows the height more clearly.

Don't be concerned about the size of the object. You'll adjust it with the Modify panel controls. You can make changes on the Create Panel; however, it is recommended that you use the Modify panel to do so.

6. 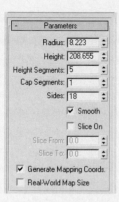 On the command panel, click the Modify tab.

The Modify panel appears, showing the parameters of the selected object.

7. Drag the spinner next to the Height value up or down until the height of the selected signpost matches the existing light post in the scene. Keep an eye on the Front viewport for reference.

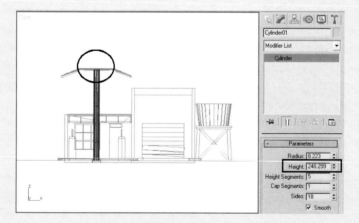

8. Use the spinner next to the Radius value to change the radius to 8 or 9 units.

9. Right-click the spinner next to Height Segments.

Note: Right-clicking a spinner normally sets it to 0. In this case, it is set to the minimum value of 1.

10. Click the Sides field, and then enter a value of 12.

11. Give the object a proper name by clicking the name field on the Modify panel (it should read Cylinder01). Change the name to

12. Post.

13. On the Modify panel, click the Modifier List to open the list of available modifiers, and then scroll down the list to the Taper modifier entry.

The Taper modifier is near the bottom of the long list of modifiers. By default, the modifiers are listed in alphabetical order.

14. Click the Taper modifier.

15. On the Parameters rollout adjust the Amount value so the signpost is smaller at the top. A value of –0.4 to –0.5 works well.

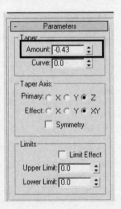

16. Return to the Cylinder level of the modifier stack by highlighting its entry in the list.

17. Change the Radius of the cylinder to 6.

18. Go back to the Taper entry in the modifier stack.

19. Change the Amount value to –0.35

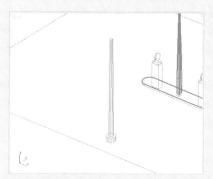

The completed signpost

You can see that 3ds Max provides considerable flexibility when you model. You can often go back and change sizes and values of modifiers to achieve the result you want.

Exercise 2: Adding Modeling Elements to the Signpost

In this next section, you'll continue modeling some geometric elements for the signpost structure. You'll need to create objects, move them into place, and make some modifications to them.

1. Continue with your previous file or open the file *Sign Breaking_01.max.*

2. In the Front viewport, zoom into the top of the signpost.

The top of the signpost appears with more geometry in the background.

3. Select the horizontal element.

4. Right-click, and from the menu, choose Hide Selection.

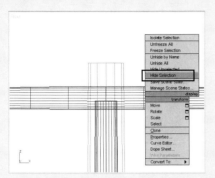

Hiding objects removes them from the display temporarily, making it easier to work in that area.

5. On the Create panel, in the Geometry category, click the Cylinder button.

6. In the Front viewport create a cylinder with a base radius of about 2 to 3 units near the top of the signpost.

7. Move the mouse and then click to set the height to any value.

8. Go to the Modify panel.

9. Change the name of the object to Sign Post Hanger.

10. Change the Radius to 2 units and the height to 60.

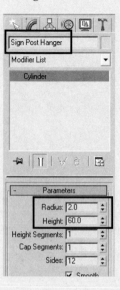

11. You cannot see the object in any of the viewports because the construction plane of the Front viewport is outside the viewing area of the other viewports.

12. With the new object still selected, right-click in the Top viewport to make it active.

13. In the view controls, click and hold on the Zoom Extents button, and then from the flyout choose Zoom Extents Selected.

Zoom Extents Selected frames the selected object in the active viewport.

14. 🔍 Use the zoom command or your mouse wheel to slowly zoom out of the Top view.

As you zoom out you should start recognizing some familiar objects.

15. ✛ On the Main Toolbar, click the Select And Move Tool.

16. Drag the green vertical arrow upward till the cylinder moves close to the signpost.

Clicking on the green arrow restricts movement to the Y-axis direction only.

The desired end result is shown in the above illustration.

17. In the view controls, click Zoom Extents All Selected.

18. Use Zoom All to zoom out slightly on all four views at once.

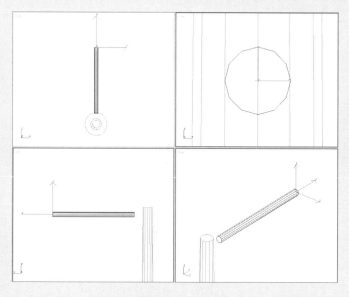

All four views show a clear view of the signpost structure.

19. If it is not already active, click Select And Move.

20. In the Top viewport, move the cylinder until it clearly intersects the top of the signpost.

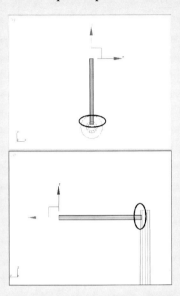

Check the intersections, particularly in the Left viewport. It's better to intersect slightly than not at all. In the Top viewport, it might look as though you are intersecting the post at the top, while in fact you are intersecting it at the bottom. Remember the post has been tapered.

21. In the Top viewport, create a sphere of approximately 6 units in radius, centered on the pole of the signpost you created earlier.

22. Go to the Modify panel.

23. Set the Radius to 6 units, and the Segments value to 16.

24. Change the object name to Sign Post Sphere.

25. Zoom out to get a better look at the scene. In either the left or the front view, move the sphere up until it is resting on top of the pole.

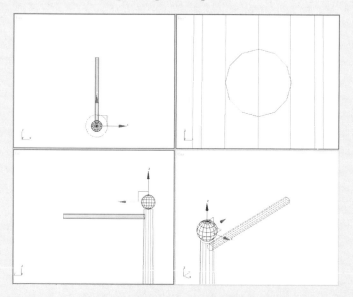

Exercise 3: Adding More Components: Creating the Sign

In this next section you will create the sign itself. You will model in some cases from 2D splines and in other cases directly in 3D.

1. Continue with your previous file or open the file *Sign Breaking_02.max*.

2. Right-click the Left viewport to make it active.

3. Right-click the viewport label in the top-left corner and choose Views > Right.

4. Enlarge the Right viewport by moving the center of the viewports to the upper right.

5. Use the Pan tool to pan the view so there is plenty of room below the signpost structure.

6. On the Create panel, click the Shapes button, and then click Rectangle.

7. Drag out a rectangle approximately 60 units wide and 40 units in height. Position it as shown.

8. On the Object Type rollout, click the Start New Shape check box to turn it off.

When Start New Shape is off, new splines you create become part of the selected shape, and are treated as a single object.

9. Drag another rectangle inside the first one to create a frame.

10. Go to the Modify panel, and from the Modifiers List choose the Extrude modifier.

11. Use the spinners to set the Amount value to 2.0.

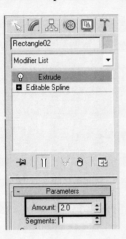

12. Press the F3 function key. The Right viewport is now shaded.

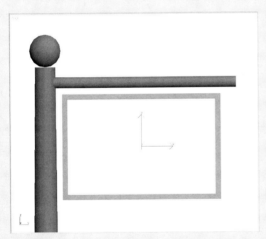

Because the two splines were created as one shape, extruding the object creates a frame rather then one box inside another.

13. Press the F3 function key again; the Right viewport returns to Wireframe display.

14. On the Create panel, click the Geometry button and then click Box.

15. Create a box along the bottom of the frame approximately 8 units in Length and 1 unit in Height. Use the Modify panel to adjust the box size if necessary.

16. On the main toolbar click the Select And Move Tool ✛.

17. Hold the Shift key down and click and drag the green vertical arrow up to a position with a small gap between one plank and the other.

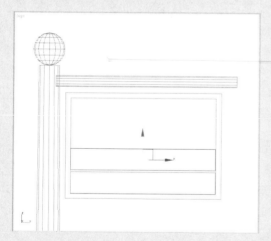

The Shift+Move operation creates a clone of the original object.

18. On the Clone Options dialog set Number Of Copies to 3, and make sure the Object option is set to Copy.

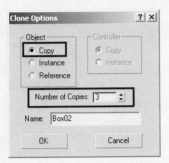

19. Click OK. Your scene should now look similar to the illustration.

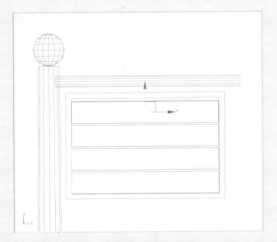

You'll introduce some randomness to the sign planks by moving them and adjusting their sizes.

20. Make sure the upper plank (Box04) is selected.

21. Go to the Modify panel and change the Length to 8.5.

22. Move the upper plank so it reaches the underside of the upper part of the frame.

23. Continue to introduce randomness to the sign by changing values and position of the planks. Your scene should look something like the illustration.

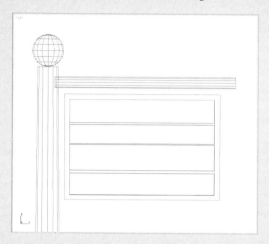

24. Region-select all the objects in the sign.

To region-select with a crossing region (the default method), click in an empty part of the viewport and then drag across the objects to select.

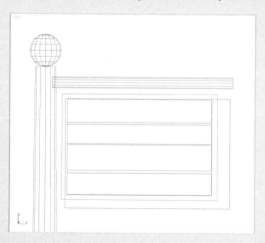

25. Check the status line. It should tell you that there are five objects selected.

26. On the menu bar, from the Group menu, choose the Group command.

27. On the dialog that appears, name the group Sign and then click OK.

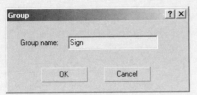

A group is a collection of objects and needs to be named; giving a group a descriptive name helps you to remember its purpose.

The sign is complete but has been created on the construction plan of the Right viewport. You need to find it and position it correctly.

28. Right-click a splitter bar between viewports.

29. Choose Reset Layout from the menu that appears.

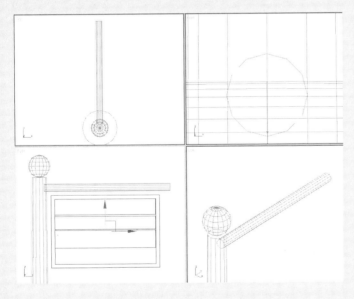

30. Using the Zoom tool 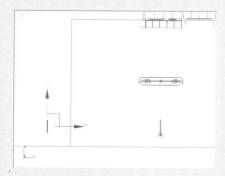, slowly zoom out of the Top viewport until you see the sign on the left side.

Unless you accidentally deselected the group, the Sign group will have the transformation axis on it, making it easier to locate visually.

31. Right-click to exit the Zoom tool and return to Select And Move, and then drag the red arrow to move the Sign group as close to the signpost as possible.

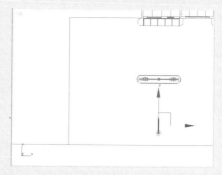

32. Right-click the Front viewport, and then zoom out enough to see the Sign group.

33. Make some final adjustments to center the Sign group on the Sign Post Hanger object.

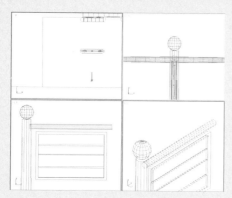

Exercise 4: Merging a Sign Lamp: Merging an Object from Another File

In this next section you will bring in an object from another file into the current scene. Frequently, modelers save objects that they use repeatedly into a library and then merge them into a scene that they are working on.

1. Continue with your previous file or open the file *Sign Breaking_03.max*.

2. On the menu bar choose File > Merge.

3. Use the Merge File dialog to locate your lesson directory and select the file *Sign Lamp.max*, and then click Open.

4. Highlight the Sign Lamp object on the Merge dialog and click OK.

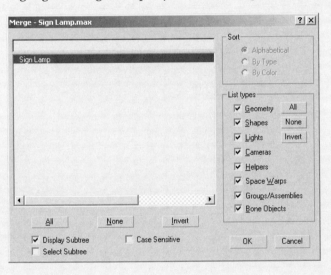

Getting Started

5. Click Zoom Extents All Selected ⊞ .

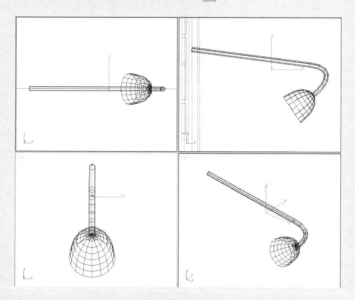

6. Zoom out of the Top viewport until you find the signpost.

7. Use the Move tool to position the lamp roughly in the center of the Lamp Pole.

8. Click Zoom Extents All Selected ⊞ .

9. Use Zoom All ⊞ to zoom out about 60–70% on all viewports.

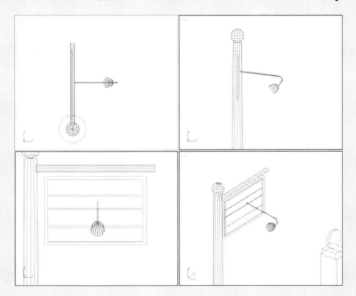

10. Use the Move tool to position the Sign Lamp object as shown.

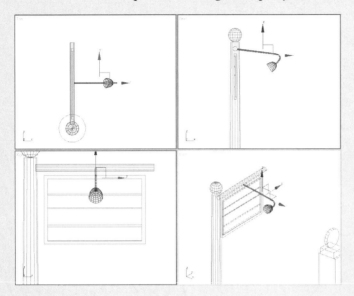

Exercise 5: Adding Basic Materials to the Signpost

In this section, you will create materials and apply them to the objects you have created in this scene. Materials allow you to change the default appearance of an object, and can make 3D computer objects photorealistic.

1. Continue with your previous file or open the file *Sign Breaking_04.max*.

2. Activate the Right viewport and press F3 to set its rendering mode to Smooth + Highlights.

3. On the main toolbar click the Material Editor ⊞ button.

4. Click the second sample sphere to make it active.

5. Change the name to White Paint.

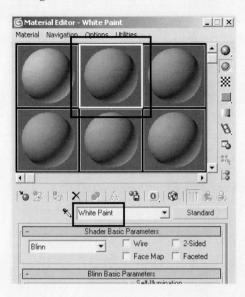

6. On the Blinn Basic Parameters rollout, click the gray Diffuse color swatch and change the Value setting to approximately 230. This makes the material off-white.

7. Close the Color Selector dialog.

8. On the Blinn Basic Parameters rollout of the Material Editor change Specular Level to 60 and Glossiness to 5. This makes the material shinier.

9. Position the Material Editor dialog so that you can see the Right viewport.

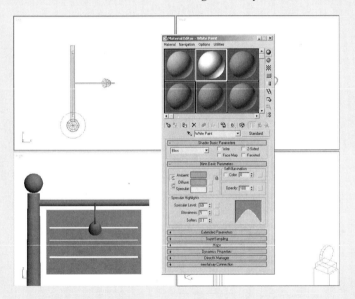

10. Use the Select tool ![cursor] to select the Sign Post object. With the CTRL key depressed, also select Sign Post Hanger and Sign Lamp.

11. Click the Assign Material To Selection button. This assigns the White Paint material to the selected objects.

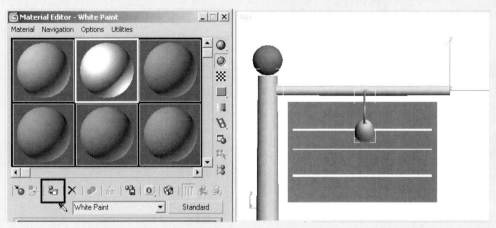

The material is applied to the three selected objects.

12. Click the third sample sphere in the top row.

13. Click the Get Material button.

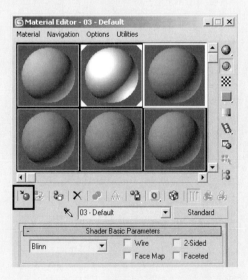

14. On the Material/Map Browser dialog that opens, choose Browse From > Mtl Library.

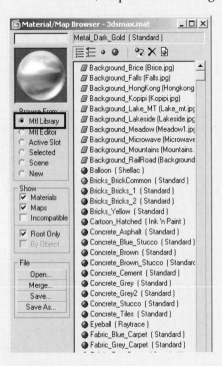

15. Scroll down the list of materials until you reach a group of materials that start with the word Metal.

16. Click the Metal_Dark_Gold material. The Material/Map Browser thumbnail window displays a sample of this material.

The Material/Map Browser provides a wealth of predefined materials. You can find even more by opening other material libraries.

17. Double-click the Metal_Dark_Gold material. This brings the material into the Material Editor and makes the Material Editor dialog active.

18. Drag the Metal_Dark_Gold sample sphere to the Sign Post Sphere object. This applies the material to the object.

19. Close the Material/Map Browser.

Exercise 6: Adjusting Ambient Lighting and Adding Lighting for the Sign

In this section, you will reduce the amount of ambient lighting in the scene and add some lighting to enhance the illumination of the sign. This makes the lighting more consistent with a twilight scene.

1. Open the file *Sign Breaking_05.max*. Do not continue with the previous file.

2. Make sure the Right viewport is active.

3. On the main toolbar, click the Quick Render Button .

This rendering gives you an idea how the lighting looks in the scene currently.

4. Dismiss the Rendered Frame Window.

5. From the Tools menu choose the Light Lister command.

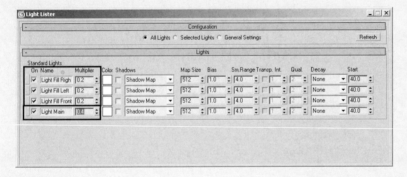

6. Change the Multiplier values for the Light Fill lights to 0.2, and for the Light Main value to 0.4.

7. Dismiss the dialog. The lighting in the scene is now considerably darker.

8. On the main toolbar, click the Quick Render Button.

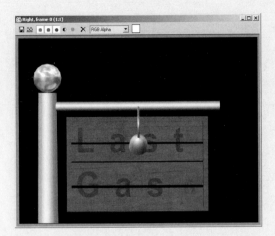

The rendering is considerably darker.

9. Dismiss the Rendered Frame Window.

10. Go to the Create panel and click the Lights button and then the Omni button.

11. In the Front viewport, click a point inside the lamp to place an Omni light just inside the Sign Lamp object.

12. In the Top viewport, adjust the zoom level so that you can see the signpost structure and the new Omni light.

As with geometric objects, lights are added on the construction plane. In this case the light is not where it should be in the Top viewport and will need to be moved.

13. Click the Select And Move tool ✛.

14. Move the Omni light close to the Sign Lamp object in the Top viewport. If necessary, zoom in to make it easier to center the light.

15. Make the Right viewport active and then click the Quick Render Button ⦿.

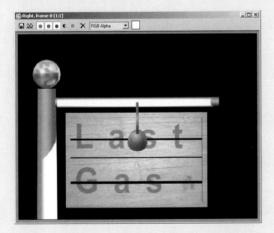

The sign appears to be mostly illuminated from the new Omni light.

16. Dismiss the dialog.

17. Go to the Modify panel and change the name of the Omni01 light to Sign Lamp Light.

It is always important to remember to name your objects; otherwise a scene can be difficult to decipher.

Exercise 7: Adding the Broken Sign Animation: Animating the sign breaking

In this section you will animate the action of the sign breaking and swinging on a single chain.

1. Open the file *Sign Breaking_06.max*. Do not continue with your previous scene.

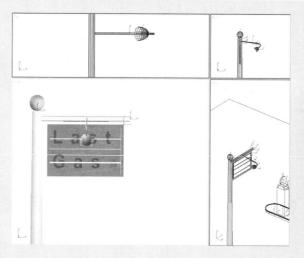

The images that follow depict the desired motion of the sign. A sequence of images like this to show how an animation should proceed is called a storyboard.

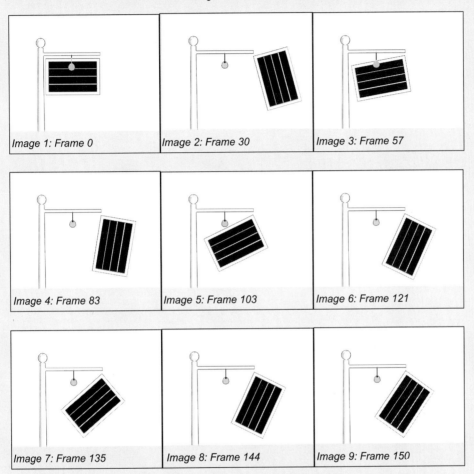

Image 1: Frame 0

Image 2: Frame 30

Image 3: Frame 57

Image 4: Frame 83

Image 5: Frame 103

Image 6: Frame 121

Image 7: Frame 135

Image 8: Frame 144

Image 9: Frame 150

You will need to create a keyframe at each of the indicated positions.

2. Click the Auto Key button near the bottom of the 3ds Max window.

When Auto Key is active, the border of the active viewport turns red, reminding you that changes that you make while in this mode cause the software to record changes and create keyframes.

3. Move the time slider to frame 30.

4. On the main toolbar click the Select And Rotate tool ↻.

5. Click the sign to select it.

6. In the Right viewport a circular element appears. Drag the outer circle and rotate the sign to the angle shown in Image 2, below.

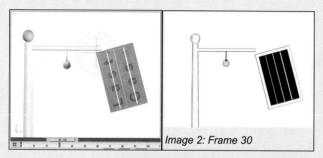

Image 2: Frame 30

Note the keys created on the timeline at 0 and 30.

7. Move the time slider to frame 57.

8. Rotate the sign back to a position as indicated in the following image.

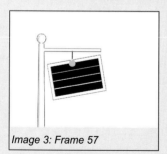

Image 3: Frame 57

9. Note the creation of a new key at frame 57.

10. Repeat this process for the remainder of the images illustrated.

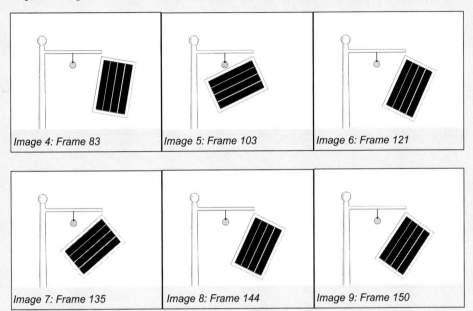

Image 4: Frame 83 Image 5: Frame 103 Image 6: Frame 121

Image 7: Frame 135 Image 8: Frame 144 Image 9: Frame 150

11. Click the Auto Key button to turn off Auto Key mode.

Always remember to turn off Auto Key mode when you are done creating animation of a part or scene. If you leave Auto Key mode on, you could accidentally create animation when you do not want to.

12. Go to frame 0 and click the Play button ▶ to see your animation.

Exercise 8: Rendering your animation

In this final section you will render your animation to a movie file.

1. Continue with your previous scene or open the file *Sign Breaking_07.max*.

2. Click in the Right viewport to make it active.

3. Click the Render Scene Dialog button 🖥 on the main toolbar.

4. Set Time Output to Active Time Segment.

Getting Started

5. Make sure Output Size is set to 640 x 480.

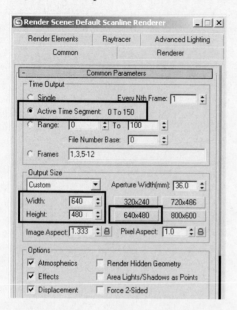

Scroll down the Render Scene dialog until you see the Render Output group.

6. Click the Files button.

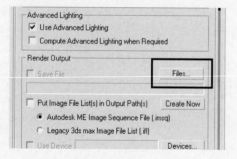

7. Set Save As Type to AVI File (*.avi). Enter the file name Sign Breaking.

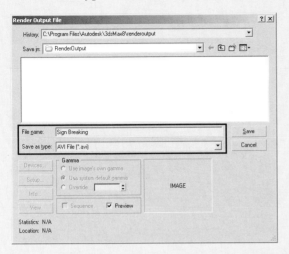

You can render the movie file in its default location or choose a different directory.

8. Click the Save Button.

9. The AVI File Compression Setup dialog opens. Click OK to accept the default settings.

10. At the bottom right of the Render Scene dialog, click the Render button.

11. The rendered images display in the Rendered Frame Window.

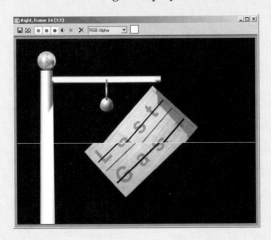

12. When the rendering is completed, dismiss the Rendered Frame Window.

13. From the File menu choose View Image File.

14. Click *Sign Breaking.avi* and then click the Open button.

15. A Media Player window opens and plays the animation.

16. After the animation finishes playing, close the Media Player window.

17. Save the scene file as *My Breaking Sign.max*.

Summary

In this lesson you built some simple elements, embellished them with materials and proper lighting, and completed a simple animation. You should now understand the overall workflow of a simple project. You can create objects, materials, lights, and animation as well as make some adjustments to elements in the scene. Finally, you can now render your animation to a file for playback or distribution.

Files and Objects

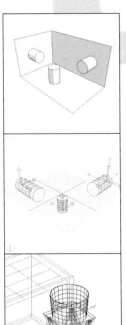

In this lesson, you will see how to work with scene files and objects in 3ds Max. This lesson will show you different ways to save scene files. You will also see different ways that files can be combined, and how to handle the internal organization of objects within a file.

Objectives

After completing this lesson, you will be able to:

- Save scene files
- Save a scene file to a temporary file buffer and retrieve it
- Combine scene files
- Set up the units and grid of a scene file
- Understand the basic elements of an object
- Select objects using a variety of methods
- Organize objects through selection sets and groups
- Attach objects together

Scene File Manipulation

There are several things you can do with a scene file in 3ds Max. You can: save a file, save a file temporarily and retrieve it, and combine scene files. As you have seen in previous lessons, 3ds Max saves its scene files with the file name extension *.max*. Most of the Files section of this lesson is about manipulating *.max* files.

Saving Files

Save

When 3ds Max is running and you choose Save from the File menu, the program prompts you to name your file. If, for example, you call it *Dog*, 3ds Max creates a file named *Dog.max*. Once you've named your file, the Save command doesn't prompt you for a file name. It automatically saves your file under its current name.

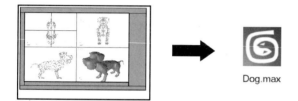

The 3ds Max scene is saved to a MAX file.

Save As

The Save As command allows you to rename and save an existing file. Using the previous example, if you first save the file as *Dog*, and then use the Save As command, you are prompted to enter a name. If you enter *My Dog*, the new file would be called *My Dog.max*. In addition, the file that is now current in 3ds Max for editing is *My Dog.max*. The file *Dog.max* remains in the state it was in when you last saved it.

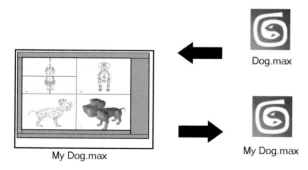

Two versions of the 3ds Max scene now exist.

As a convenience, the Save As dialog includes a Plus button [+] . Clicking this button saves the file with an automatic sequence number appended to its name. For example:

```
My Dog.max
```

```
My Dog01.max
```

```
My Dog02.max
```

```
My Dog03.max
```

In some work situations, it is convenient to save several versions of a given scene file. For example, one might contain geometry only; another would contain the material treatment; and another would save the lighting of the scene. Sequential saved files can also be used to store several different options for a character, or different poses of a character in an animation.

Hold and Fetch

The Hold and Fetch commands, found on the Edit menu, are used together. When you use the Hold command, it saves a temporary file with the contents of your scene, bookmarking the present state of your scene. Then, when you use Fetch, 3ds Max loads the contents of the Hold file, restoring the scene to the state is was in when you used Hold.

Note: Neither Hold nor Fetch affects the state of your saved *.max* scene file.

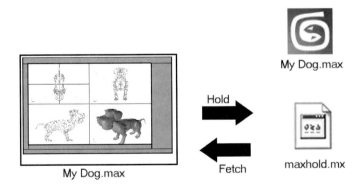

Hold and Fetch can be seen as a temporary save, leaving your actual MAX file intact.

Getting Started

Merging Files

Merging files is a method of combining all or part of one 3ds Max scene into another. While you have a 3ds Max file, using the Merge function prompts you to pick another scene file. After you specify a *.max* file, you can choose to merge some or all of the elements in the scene.

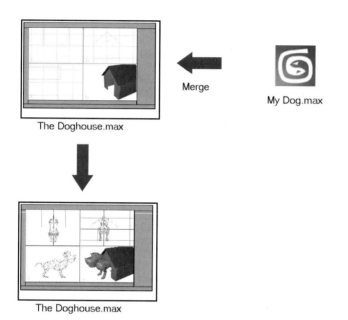

When you merge a file you take objects from one file (e.g., My Dog.max) and place it in another (e.g., DogHouse.max). The My Dog file is been unaffected by this operation, but the Doghouse file has new objects in it.

Save Selected

The Save Selected command on the File menu allows you to take selected objects and save them to a *.max* scene file. You could look at it as the reverse of merging objects from a file.

The Doghouse with Dog.max
(Doghouse Object Selected)

Save
Selected

The Doghouse.max

When you use Save Selected, whatever is selected is saved to a file.

Import and Export

These commands are used to bring files of various formats into and out of 3ds Max. The Import command brings in files from many other programs, such as 3D Studio DOS, AutoCAD, Adobe Illustrator, MotionBuilder, and Lightscape, among others. Export saves 3ds Max scene files into most of the same file formats that Import supports. It also exports to the new 3D DWF file format supported on the Web.

File Link and XRef

The File Link and XRef toolsets also allow you to combine files together. They are meant to be used within a collaborative environment. In this case, these commands are designed to maintain a live link between the files so that changes in one linked file are reflected in another.

Starting your Scene

When you start 3ds Max or choose the Reset command from the File menu, the workspace contains a new scene that has yet to be named. You can begin to work immediately, working in the default scene setup, units, and grid setup. If you wish to work in a different environment, you can change the scene setup using commands from the Customize menu.

Units Setup

The Units Setup command from the Customize menu lets you change the units in the scene.

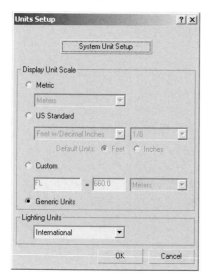

The Units Setup dialog. You can choose linear units to be Metric, US Standard, Custom, or Generic.

Grid Settings

The Grid And Snap Settings command on the Customize menu brings you to a dialog with four tabbed panels. The Home Grid tab gives you options for changing the grid settings in your scene.

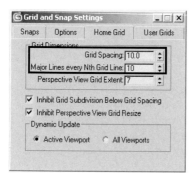

Grid Spacing is the number of units between grid lines. Major Lines Every Nth Grid Line determines where a heavy grid line will appear.

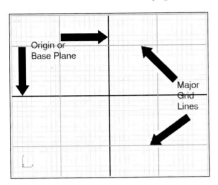

Exercise 1: Units and Grid Setup

In this exercise, you'll set up the units and grid of a scene file.

1. Start or reset 3ds Max.

2. From the Customize menu, choose Units Setup.

3. On the Units Setup dialog, choose Metric, and then open the drop-down list.

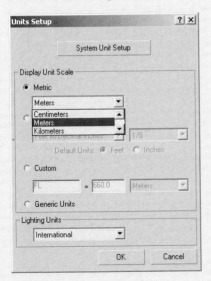

The Metric unit type gives you
four choices of metric units.

4. Choose US Standard units, and look at the choices from its associated drop-down lists. The second list is available only when you choose an item with "Fractional" in its name from the first list.

5. Next, choose Custom units, and open the drop-down list at the right, with choices for Custom.

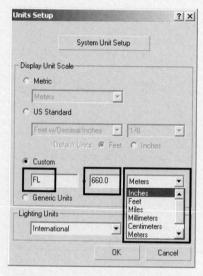

The Custom unit type allows you the ultimate flexibility: Simply identify the unit and specify a multiplier of a known US Standard or Metric unit.

6. Finally, choose Generic Units and then click OK to dismiss the dialog.

 Generic Units is the default choice for 3ds Max scenes.

Exercise 2: Options for Grid Display

Next, you'll look at some of the options for grid display.

1. From the Customize menu, choose Grid And Snap Settings

2. In the dialog that appears, click the Home Grid tab.

 In the next two steps, you will set up the grid of 3ds Max viewports to match a games engine that works with a foot measure that is subdivided into 12 units. You will then give yourself a heavy grid line so you can easily see each five-foot interval easily.

3. For Grid Spacing, enter 12. This represents the number of units in a foot.

4. For Major Lines Every Nth Grid Line, enter 5.

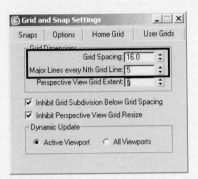

5. Close the dialog by clicking the X button in the upper-right corner.

Simple Geometry Creation and Pivot Points

When you create an object in 3ds Max, it is important to note that it contains an element called a pivot point. The pivot point is the point about which an object's transformation occurs.

Pivot Point Location

The location of a pivot point is chosen usually by default, but you can move the pivot point if you need to.

Exercise 3: Simple Geometry Creation and Pivot Point Location

In this exercise, create a simple geometry and set its pivot point.

1. Start or reset 3ds Max.

2. On the Create panel > Object Type rollout, click the Box button.

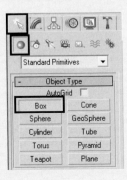

3. Right-click the Perspective view to make it active, if necessary.

4. Drag in the Perspective viewport to define the base of the Box.

5. Release the mouse button, move the cursor vertically, and then click to set the height of the box.

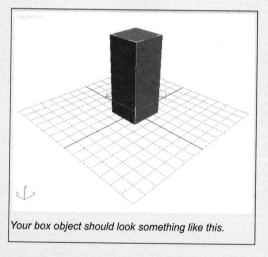

Your box object should look something like this.

You can create most 3ds Max built-in objects with click-and-drag operations.

6. Press the F3 function key to switch to wireframe display.

The XYZ axes at the base of the object show the location of its pivot point.

7. On the main toolbar, click the Select And Rotate tool ⟳ to turn it on. A spherical Rotation gizmo replaces the previous pivot point icon.

Each color-coded circle represents rotation about a given axis. Remember RGB = XYZ, so the red circle rotates about the X axis, green about Y, and blue about Z. The outer gray circle rotates perpendicular to the direction of the view, and the inner gray circle allows free rotation.

8. Click and drag the red circle. The red circle becomes yellow when the cursor is over it.

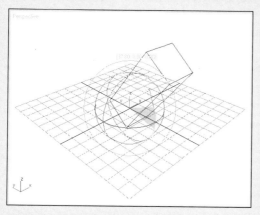

Dragging the red circle rotates about the X axis.

9. Press **CTRL+Z** to undo the rotation.

10. Click the Select And Move tool ✥ to turn it on.

11. Go to the Hierarchy panel.

12. Click the Affect Pivot Only button to turn it on.

When Affect Pivot Only is on, the pivot gizmo is displayed more prominently. While Affect Pivot Only is active, transformations such as Move affect the pivot, not the entire object.

13. Drag the blue arrow on the pivot to move it to the top of the box.

Hint: You might want to pan the view down if you cannot see the pivot point icon at the top of the box.

14. Click Affect Pivot Only again to turn it off.

15. Click the Select And Rotate tool.

16. Drag the rotation gizmo's red circle. Now the box rotates about its top instead of its base.

Rotation takes place about the pivot, which is now on the top of the box.

Object Orientation

When you create an object in 3ds Max, the initial orientation of the object is determined by the viewport where the object is created. Each viewport has a base plane where Z=0; this is where the objects are created.

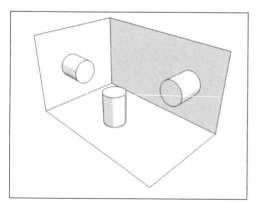

Creating cylinders in the Top, Front, and Left viewports is like creating these objects on the floor, front, and side walls of a room.

Pivot Point Orientation

The pivot point of an object is affected by the view in which the object is created. In the case of a cylinder, the Z-axis of the default pivot point is parallel to the height of the cylinder.

Exercise 4: Viewport Base Plane Geometry and Pivot Point Orientation

In this exercise, learn about how pivot points are oriented in the base plane. The viewport in which a geometry is created determines its pivot point orientation.

1. Start or reset 3ds Max.

2. Right-click the Top viewport to make it active.

3. On the Create panel click the Cylinder button.

4. In the Top viewport, create a cylinder below and to the left of the center of the view. After dragging out the base, move the mouse and then click to set the cylinder's height while observing the height in the other viewports.

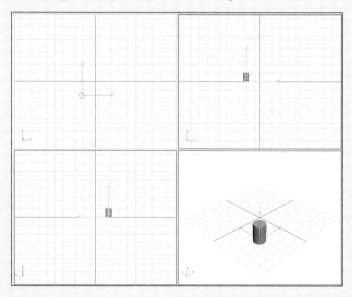

5. Right-click the Left viewport to make it active.

6. Create another cylinder, this time to the right and above center.

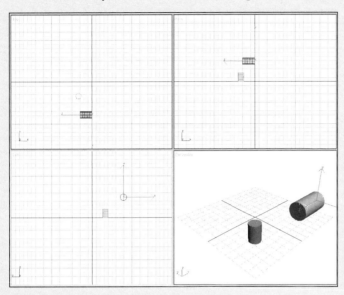

7. Right-click the Front viewport to make it active.

8. Create a third cylinder to the left and above the center.

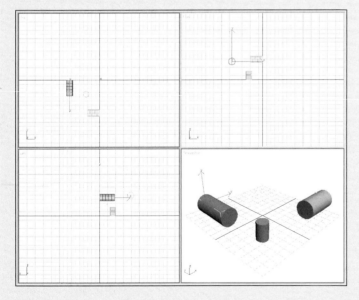

9. Right-click the Perspective viewport, then press the F3 function key to set the display to wireframe mode.

10. On the main toolbar, click the Select Object tool ⌖ to turn it on.

The button appears yellow when the tool is turned on.

11. Go to the Hierarchy panel. Turn on Affect Pivot Only.

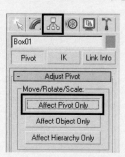

12. The last cylinder should still be selected. Hold down the **CTRL** key, then click the other two cylinders to select them as well.

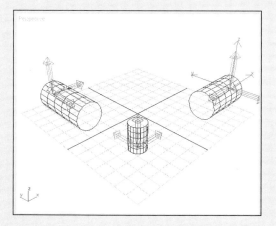

The blue arrow in the pivot, representing the Z-axis, points away from the base plane of the viewport that was active when the cylinder was created.

Modifying Standard Objects

When you create an object in 3ds Max, a standard practice is to switch from the Create panel to the Modify panel before making changes to the object's parameters. Often you will create an object "by eye" in the viewports, then change its dimensions to round numbers.

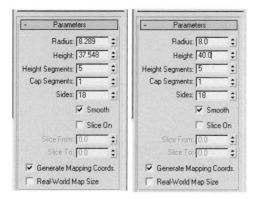

On the left, the cylinder has fractional Radius and Height values after creating it by clicking and dragging in a viewport. On the right, the Radius and Height values have been changed to round numbers.

On the Modify panel, and throughout 3ds Max, you can animate numeric values such as the Radius and Height of a cylinder. Parameters represented by check boxes or radio buttons usually cannot be animated.

The check boxes shown above represent values that cannot be animated.

Face Count

Whenever you create geometry in 3ds Max, you should always be aware of, and careful of, the number of faces that an individual object or the overall scene employs. This is important for several reasons:

- High face counts take more memory. The larger the scene, the more evident this becomes, especially when you open a scene, or render it.
- Applications such as games have tight controls on how many faces a character or a prop can use. If the face count is too high, it affects the smoothness of the game play.
- Face counts affect render times and advanced lighting calculations such as radiosity. When there are more faces, the calculations take longer.

Exercise 5: Modifying Objects and Face Counts

In this exercise, you'll modify objects and face counts.

1. Start or reset 3ds Max.

2. Create two cylinders of similar dimensions next to each other.

3. Press the F4 function key to display the cylinders in Edged Faces mode.

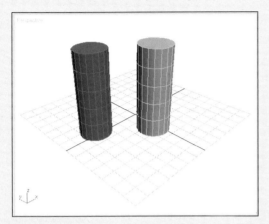

 Both cylinders have identical face counts and look the same.

4. Select the cylinder on the right, and then press the 7 key to display the polygon counter in the viewport.

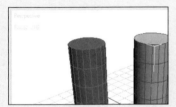

 The Polygon counter appears just below the Viewport Label and indicates the number of faces in the selected object.

5. Go to the Modify panel and change Height Segments to 1. You can accomplish this by right-clicking the spinner next to the numeric value.

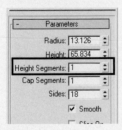

 The number of faces changes from 216 to 72.

6. Change the Sides value to 12. The number of faces is now 48.

7. On the main toolbar, click Quick Render 🝆.

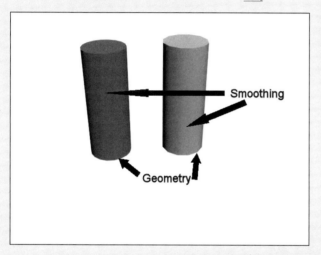

Both Cylinders look almost identical despite the difference in their face counts. The body of the cylinder has been smoothed by 3ds Max. The reduced face count is apparent at the top and bottom edges of the cylinder on the right.

Selecting Objects

3ds Max gives you numerous ways to select objects. This section covers the most important selection methods.

Selection Tool

The most fundamental method of selecting objects is through the use of the Select tool ⬚ on the main toolbar.

- When the Select tool is active and you click an object, you select that object. Any prior selection is cancelled.

- If you click in an empty area and then drag across a viewport, by default you will select whichever objects are crossed by the selection region you create.
- If you hold the **CTRL** key down while you click objects individually, the objects will be added or removed from the selection set. The **CTRL** key acts as a toggle.
- Holding down the **CTRL** key while you drag a selection region adds all objects in the selection region to the selection.
- Holding down the **ALT** key while you click objects or drag a selection region removes those objects from the selection.

Selection Lock Toggle

Near the bottom of the 3ds Max window is the Selection Lock Toggle button 🔒. When you turn it on, the button turns yellow to indicate that the selection is locked. No changes can be made to the current selection until you turn off the button to unlock the selection. The Selection Lock Toggle is useful when you have numerous operations to do with a selection, especially when the scene is crowded and it would be easy to select other objects by accident.

Select Objects By Name

Often in a scene you already know your object's name, or you might need to select numerous objects that have similar names. If these objects are difficult to select by clicking in a viewport, using the Select Objects dialog can help. To access the Select Objects dialog, click Select By Name on the main toolbar.

The Select Objects dialog makes it easy to select objects by name.

Naming Objects

One of the first ways to bring order to your scene is to use an appropriate naming convention for your objects. 3ds Max has a default naming convention for objects that looks like this:

The default naming convention may be less useful in a complex scene.

When 3ds Max creates a box object, it first looks in the list of objects for a box named Box01. If that does not exist, it uses that name. This process continues, producing a sequence of objects named Box01, Box02, Box03, and so on. Choosing a more descriptive naming convention for objects is the first step in good scene management.

Selection Filter

As your 3ds Max scene becomes more and more filled with objects of different types, the Selection Filter list can become useful.

When you choose one of the items in the list (for example, Lights), all other object types are unavailable for selection in the viewports (for example, you can select only lights).

Don't forget to set the list back to All when you are done!

Selection Window/Crossing

When you use region selection in 3ds Max, you can toggle the selection mode to be either a crossing region or a window region. The crossing region selects everything that touches the region as well as what is completely contained. The window region selects only objects completely inside the selection window.

To switch the region mode, click the Window/Crossing Toggle button on the main toolbar.

When Crossing mode is active (as it is by default), making a selection region as shown selects both the dog and the doghouse.

When Window mode is active (the Window/Crossing button turns yellow), making a selection rectangle as illustrated selects the dog only. Window mode selects only objects completely contained within the selection rectangle.

Selection Region Type

Five different selection region methods are available in 3ds Max: the default Rectangular selection region and four other types. You choose the mode by using the Selection Region flyout on the main toolbar.

The following illustration shows the five kinds of selection region.

Clockwise from the upper-left corner: Rectangular, Circular, Fence, Paint, and Lasso selection regions.

Hiding and Freezing Objects

You can make complex scenes more manageable by hiding and freezing objects. Hiding an object removes it temporarily from the viewport display. Freezing an object makes the object nonselectable, and by default turns the object's color to gray in viewports.

By Selection

When an object is selected, you can hide or freeze it in a number of ways. One way is to use the quad menu, which appears when you right-click a selected object.

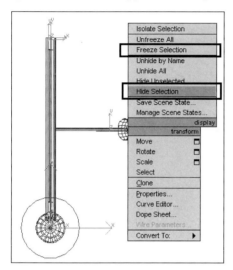

You can also access Hide and Freeze through the Display floater (choose Tools menu > Display Floater).

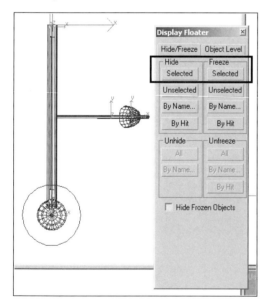

Hide and Freeze are also available on the Display panel, which is one of the command panels.

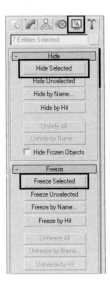

Once an object is Hidden or Frozen, options to unhide or unfreeze it appear in the same UI locations.

Hide By Category

When you find that a type of object needs to be hidden in your scene, you can hide that object by its category. For example, if you have too many lights and cameras cluttering the scene, you can hide those object categories, thus preventing them from being displayed. Hide By Category is available on the Display panel and on the Object Level tab of the Display Floater.

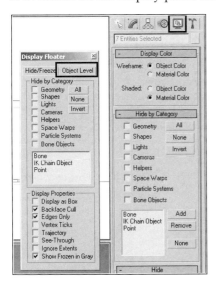

Isolation Mode

If you need to work on an object or group of objects for a period of time without any other objects in your scene cluttering up your viewport display, you can use Isolation Mode. When you select an object and then choose Isolate Selection from the Tools menu (or press **ALT+Q**), only the selected objects remain in the viewport. When you exit Isolation Mode, all objects that were in the viewport previously are displayed again.

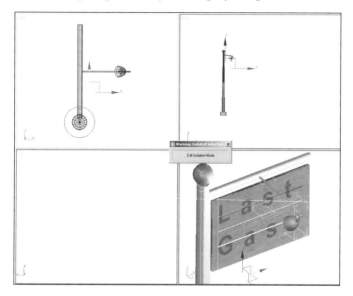

Isolation Mode quickly removes everything other than your selection from the viewports. Click the Exit Isolation Mode button to bring back everything that was in the viewport previously.

Exercise 6: Selecting Objects by Name and Naming Objects

1. Open the file *Blockout of Gas Station 02.max*.

2. Press the **H** key to access the Select Objects dialog.

The Select Objects dialog shows a list of all the objects in the scene. Even in this relatively simple scene, the list is long.

3. Click the object name Box 07 and then drag to Box 08 immediately below it. Dragging is the easiest way to select a range of items in the list.

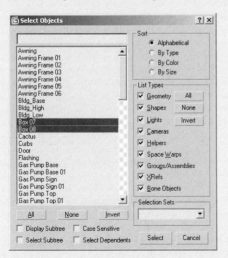

4. Click the Select button. Both objects are selected in the scene.

5. Right-click the User viewport and then click Zoom Extents Selected 🔲.

This button is available from the Zoom Extents flyout among the navigation buttons in the lower-right corner of the 3ds Max window.

6. Press **F3** to switch to wireframe display mode.

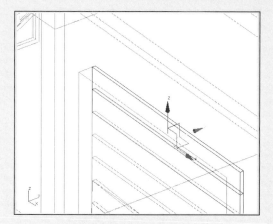

Box 07 and Box 08 are selected.

7. Click one of the objects just below Box 07 (the lower object).

8. Go to the Modify panel and check the name of the object.

The Object is named gdxx, where "gd" stands for Garage Door, and "xx" is one of a sequence of numbers.

9. Select Box 07.

10. Highlight the word Box in the name field and type gd. Be sure to remove the space between Box and 07.

11. Repeat this procedure to rename Box 08 to gd08.

12. Press **H** on the keyboard.

13. Scroll down the list until you see the series of objects whose names begin with "gd."

14. Drag from gd01 to gd08 to highlight all "gd" objects.

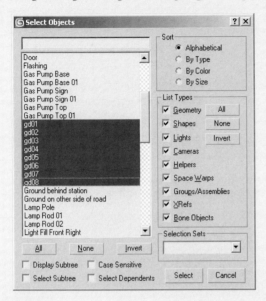

15. Click Select.

In the User viewport, you can see that all the garage door elements are now selected.

Organization of Objects in a Scene

You can use several different methods to organize objects in a scene. One simple method, already mentioned, is to give objects names that are easy to recognize. Other ways to further organize objects in a scene include:

- Selection Sets: Naming a selection set allows you to quickly restore the selection later. You pick the selection set from a list of named selection sets. Selection sets are particularly useful for objects to be animated.

- Groups: A group is a collection of objects that behave as a single object. Groups are also named, and are selectable both in viewports and from the Select Objects dialog. Groups work best with static objects.

- Attaching Objects: Object attachment is a way of reducing the number of objects in a scene whenever you don't need to work on these objects individually anymore.

- Layers: Layers are used to organize objects and modify object properties. Layers let you control the visibility of objects (Hide and Freeze states) as well as other properties such as color and radiosity.

Selection Sets

Using selection sets is the easiest way to organize a scene. This method does not affect your ability to transform and animate member objects. You create selection sets by entering a name on the main toolbar or with the Named Selection Sets dialog.

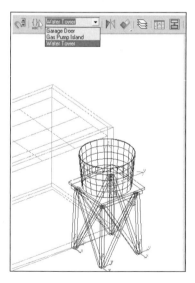

Selection sets can be created by entering a name in the Named Selection Sets drop-down list on the main toolbar. You can then use the list to choose each selection set.

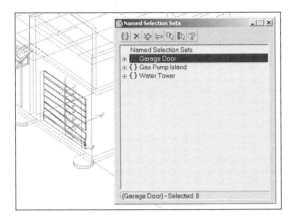

The Named Selection Sets dialog, accessible from the Edit menu and the main toolbar, allows you to create and edit selection sets as does the Named Selection Set drop-down list. In addition, this dialog lets you edit a selection set by adding and removing objects.

Exercise 7: Selection Sets

In this exercise, you'll create a selection set and add objects to it.

1. Open the file *Blockout of Gas Station 03.max*.

2. On the main toolbar, set the selection mode to Window , and then use a rectangular region to select all the objects that comprise the water tower to the right.

3. Go to the Named Selection Sets drop-down list and enter Water Tower.

Make sure to press **ENTER** after you type the text. If you forget to press **ENTER**, the selection set and its name won't be saved.

4. Deselect the water tower by selecting a different object in the scene.

5. Click the triangle button at the right of the Named Selection Sets drop-down list, then choose Water Tower from the list.

The Water Tower is selected once again.

The selection set simplifies the selection of the objects making up the water tower.

6. From the Edit menu, choose Edit Named Selection Sets. The following dialog appears.

The selection set you created appears in the Named Selection Sets dialog as well as in the drop-down list.

7. Move the dialog close to the gas pump island

8. Select some of the objects in the gas pump island, using a Window region selection as shown in the illustration.

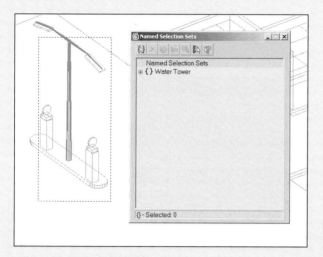

Most of the objects in the selection region will be selected except for the island base and the left side of the light pole.

9. Click the Create New Set button in the Named Selection Sets dialog.

10. Enter Gas Pump Island in the New Set entry in the list.

11. Click the plus sign next to the Gas Pump Island entry to expand that selection set.

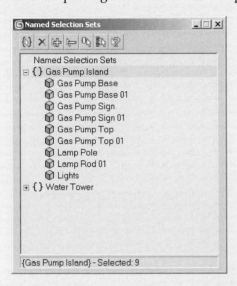

Clicking the plus sign adjacent to the selection set name reveals all the objects in the selection set. This allows you to edit the contents of the set.

12. In a viewport, click the Island Curb object to select it.

13. In the dialog, click to highlight the Gas Pump Island selection set.

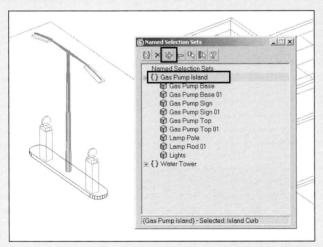

14. In the dialog, click the Add Selected Objects button .

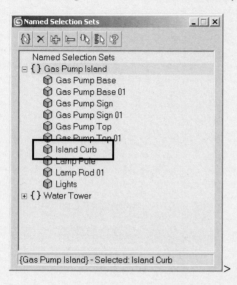

15. In a viewport, select the Lamp Rod 02 and Lights 01 objects by using a Window region selection as illustrated.

16. In the dialog, click Add Selected Objects once more.

17. In the dialog click the Select Objects by Name icon .

The Select Objects Dialog appears.

18. Select all objects that begin with the word "Lamp" or "Lights."

19. On the dialog, click the Remove Selected Objects button ⊨ to remove the lamps and lights from the selection set.

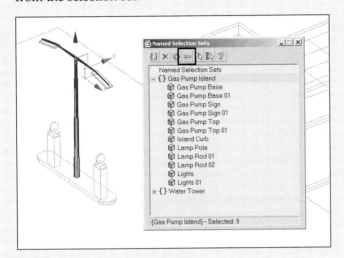

20. Click the Gas Pump Island selection set once more.

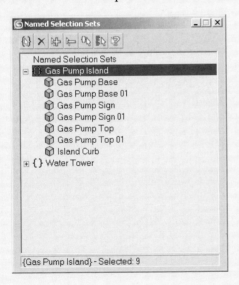

21. Click Select Objects In Set .

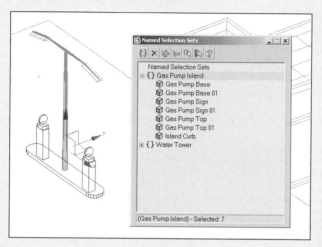

Only the Gas Pump and Curb objects are now selected.

22. You can double-check which objects are selected by using the Move tool and moving the remaining selected objects around.

Groups

Naming objects and selection sets appropriately is a good starting point in a well-organized scene. Another method at your disposal is groups. You might be able to see when these two are appropriate for given situations by looking at their relative advantages and disadvantages.

- Selection sets always allow you to pick objects in the set independently. There is nothing tying the objects together.

- A group is a single object that you select with a single click. Objects within a closed group behave as if they were one object.

- Objects in a selection set still appear separately in the Select Objects dialog, giving you the choice of selecting them individually or as a set.

- Groups bring all the objects in the group into one named object. Twenty objects grouped together will be represented as one entry in the Select Objects dialog.

- You must be careful when animating groups, as the group itself can be animated as well as the objects within it. Ungrouping will lose the animation of the group itself, leaving only the animation of the individual objects.

Exercise 8: Groups

In this exercise, you'll organize objects in the scene into a group.

1. Continue working on your current file or open the file *Blockout of Gas Station 04.max*.

2. Use the Zoom Region tool and zoom into the garage door area of the structure.

3. Press the **H** key. On the Select Objects dialog, highlight all objects whose name starts with "gd."

4. Click the Select button. All the garage door panels are now selected.

5. From the Group menu, choose Group.

6. On the dialog that opens, enter the name Garage Door.

7. Click OK.

8. Press **H** on the keyboard.

The Garage Door group appears as an entry in the Select Objects dialog. The eight objects beginning with "gd" are no longer listed. You can distinguish groups in the Select Objects dialog by the [] brackets that surround their names.

9. Click Select to exit the dialog.

10. Click an empty area of the viewport to deselect the garage door panels.

11. Now click any one of the garage door panels. The entire garage door is selected.

12. From the Group menu, choose Open. Open allows you to edit the group's individual objects.

13. On the main toolbar, click Select And Move ⊕ to turn it on.

14. Select the fourth panel from the bottom of the door.

An open group displays a pink bounding box around the group. You can now modify individual objects inside the group.

15. Drag the blue vertical arrow downward. This moves the panel down in the Z direction only.

16. Click to select the fifth panel of the group.

17. From the Group menu, choose Detach.

18. Press the **H** key.

19. Turn on the Display Subtree check box at the bottom of the dialog.

20. Scroll down to the area of the list where you see the Garage Door group and the gd05 object.

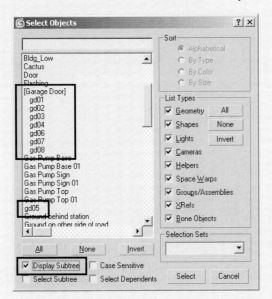

When you turn on Display Subtree, the order of the list changes slightly. Objects that are part of a group appear indented beneath the group name, while objects such as gd05, which is detached from the group, display independently.

21. Click the name of the object gd05.

22. Click Select.

23. On the Group menu, choose Attach, and then in a viewport click the Garage Door group.

24. On the Group menu, choose Close.

25. Now that the group is closed, if you select any object in the group, the entire group will be selected as before.

Attaching Objects

Another strategy for organizing objects is to attach objects together into one object. When you attach objects they lose their independence and become part of a single object. Unlike groups, which can be opened for temporary editing, attached objects must be detached to become independent again.

Exercise 9: Attaching Objects

In this exercise, attach objects together.

1. Continue with your current file or open the file *Blockout of Gas Station 05.max*.

2. Adjust your view so you can see the gas pump island area and the lamp pole.

3. Select the Lamp Pole object.

4. Go to the Modify panel.

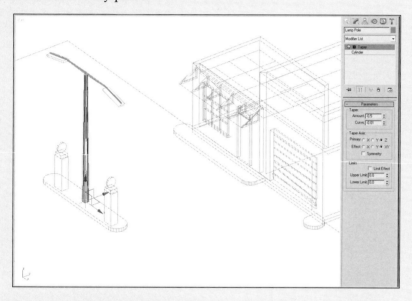

The modifier stack display on the Modify panel shows that the object is a base cylinder with a Taper modifier applied to it. Before you can attach other objects, you must convert this object to an editable form.

5. Right-click the viewport.

6. From the quad menu that appears, choose Convert To > Convert To Editable Mesh.

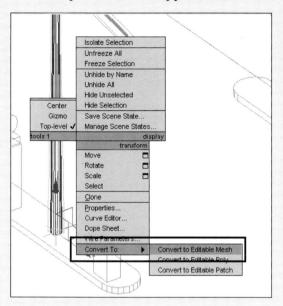

7. On the Modify panel, verify that the object is now an Editable Mesh object.

8. Scroll down the Modify panel until you see the Attach and Attach List buttons on the Edit Geometry rollout.

9. Click the Attach button.

10. In the viewport, click the Lamp Rod 02 object.

When the Lamp Rod is attached to the Lamp Pole object, it becomes an element of the Lamp Pole object. The attached object's color changes to match the Lamp Pole object's color.

11. Click the Attach List button.

12. Find Lamp Rod 01 in the list and click it.

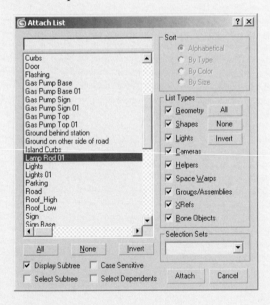

Attach List gives you a list of objects. It is similar to selecting objects by name.

13. Click the Attach button at the bottom of the dialog.

14. Click the Attach button on the Modify Panel to turn it off. The button changes color from yellow to gray.

15. On the main toolbar, click Select And Move ✛ to turn it on.

16. Drag the Lamp Pole object in any direction to verify that the other objects have been attached.

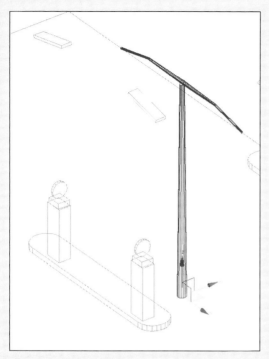

17. Right-click to cancel the movement, or Undo (**CTRL+Z**) the move if you need to.

18. Pan your view to see the front of the garage building.

19. Select either one of the curbs in front of the building. Both curbs should be selected, since they are part of the same object.

20. On the Modify panel, click the + sign next to the Editable Mesh entry in the modifier stack.

21. In the expanded list that appears, click Element.

When an object has distinct parts, these are considered elements and can be selected at the Element sub-object level.

22. In the viewport, click the left-hand curb object.

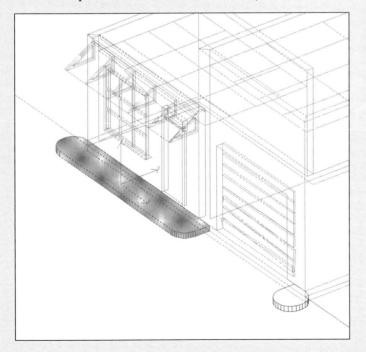

When you select an element at the sub-object level, it displays in a translucent red color.

23. On the Edit Geometry rollout, click Detach.

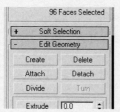

24. On the dialog that appears, enter the name Curb Left in the Detach As field, and then click OK.

25. Press the **H** key to display the Select Objects dialog.

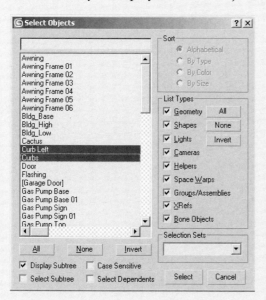

Curb Left appears as a new object.

Summary

In this lesson you learned about working with 3ds Max files, setting up a scene, and working with objects within a scene. You learned how to save 3ds Max files in different ways, and different methods for combining scenes together. You also learned how to set up a 3ds Max scene's units and grid. You learned how to create simple objects, control their orientation in viewports, and use and adjust an object's pivot location. You learned that naming objects and creating selection sets eases the selection process. Finally, you learned how to combine objects into groups and how to attach objects together.

Transforms

In this lesson you will learn how to transform objects in a 3ds Max scene. You'll use the transform commands to move, rotate, and scale objects, and you'll learn about tools that assist you in using transform commands, namely coordinate systems and snaps. Finally, you will see how to use transform commands to model a scene.

Objectives

After completing this lesson, you will be able to:

- Transform objects using the basic transform commands
- Use the Transform gizmos when you use basic transform commands
- Choose the different transform base points, and use them when transforming objects
- Use different coordinate systems.
- Apply snapping tools
- Use the Align tool
- Clone objects
- Mirror objects
- Understand some more advanced transform commands like Array, Spacing and Clone & Align.

Transform Tools

You use basic transform tools in 3ds Max to move, rotate, and scale objects. Other tools you'll see a little further on in this lesson essentially do the same thing, but with a different user interface that can automate several operations into one command. You'll start with a look at the basic transform tools.

Move

Move lets you position an object anywhere in a scene. You can move objects along a specific axis or plane, or freely. Move is useful when modeling and animating. You can move objects in the viewport using the Transform gizmo or the Transform Type-In.

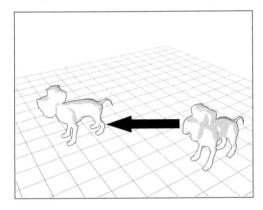

Moving an object freely allows you to displace the object anywhere in 3D space.

Move Transform Gizmo

The Move Transform gizmo appears at the pivot point location of an object. The gizmo allows you to restrict movement of the object by dragging an axis or a plane in the gizmo.

When using the Move tool, if you drag one of the three axes in the gizmo, movement is constrained to that direction. In this example movement is restricted to the X axis.

If you drag one of the rectangles in the gizmo, you restrict motion to a plane. In this example the XY plane was chosen, so the object cannot move in the Z direction.

Move Transform Type-In

In addition to the gizmo, the Move tool has a Transform Type-In dialog box that lets you enter the displacement numerically. When you right-click the Select And Move tool ⊕, the Transform Type-In dialog appears.

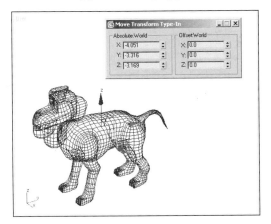

The Transform Type-In shows you the XYZ coordinates of the pivot point in the Absolute World group of the dialog, and allows you to adjust the position in this absolute format. The Offset group is for displacement relative to the object's current position.

Rotation

Rotating objects is another type of transform you use frequently when working with 3ds Max. The results you obtain depend greatly on the location of the point you rotate about and the axis of rotation. By default, the pivot point is used as the rotation center.

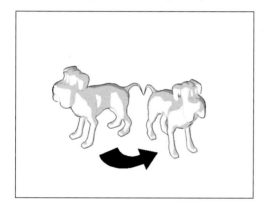

The dog has been rotated with its pivot point at its tail.

Rotate Transform Gizmo

The Rotate Transform gizmo appears at the pivot point location of an object. The gizmo comprises five circles. The Illustrations below describe the functions of these five circles.

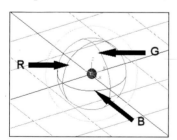

The XYZ axis rotation restrictions represented by the red, green, and blue circles. For example, if you click the red circle and drag, the object rotates about the X axis.

You can rotate the object freely by dragging the outer circle defined by the profile of the sphere. You can also do so by placing the cursor anywhere inside the gizmo but not on one of the concentric circles.

To restrict the rotation about a line perpendicular to the view plane, that is, the line of sight, drag the outer circle that is offset from the sphere.

Rotation Transform Type-In

In addition to the gizmo, the Rotate tool has a Transform Type-In dialog that lets you enter rotation values numerically.

As with the Move Transform Type-In, the Rotate Transform Type-In has absolute and offset (relative) methods of numerical entry.

Scale

3ds provides three commands for scaling objects: Select And Uniform scale, Select And Non-uniform scale, and Scale And Squash. You'll find all three operations on the Scale tool flyout on the main toolbar.

Scale tool flyout

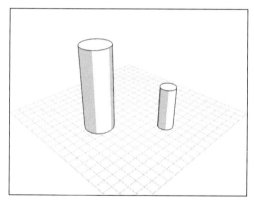

With Uniform scale, the first tool on the Scale flyout, all three dimensions of the object are scaled equally.

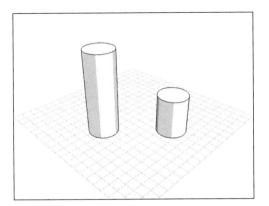

With Non-uniform Scale, the second tool in the scale flyout, you can scale one or two dimensions while the other remains constant. In the above illustration, the Z dimension of the cylinder has been scaled while X and Y have not changed.

Scale And Squash, the third tool on the Scale tool flyout, lets you change one or two dimensions while the other axis or axes automatically adjust in the opposite direction. In the above illustration the Z axis has been scaled down while Scale And Squash increases the X and Y directions to compensate, with the result that the object's original volume is maintained.

Scale Transform Gizmo

The Scale Transform gizmo appears at the pivot location of an object. You can use the gizmo to scale along one axis, on two axes, and uniformly.

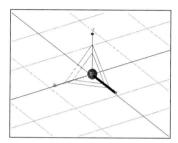

When you drag one axis of the gizmo the object is scaled along that axis.

When you drag the plane between two axes as shown above, the object is scaled in that plane. In the above illustration the XZ plane was clicked with the result that scaling occurs on the X and Z axes.

When you drag the inner triangle, you scale on all three axes simultaneously.

Scale Transform Type-In

In addition to the gizmo, the Scale tool has a Transform Type-In dialog that lets you enter Scale values numerically.

The Scale Transform Type-In provides absolute scale values that can be entered individually, thereby scaling the object disproportionately. The Offset value lets you to scale the object proportionally relative to its current size.

Getting Started

Transform Base Point

When you transform objects you have a choice of the base point. By default, scaling uses the pivot point of the object. Alternatively, you can use the selection center and the transform coordinate center. You set the mode with the Transform Center flyout.

Transform Center flyout

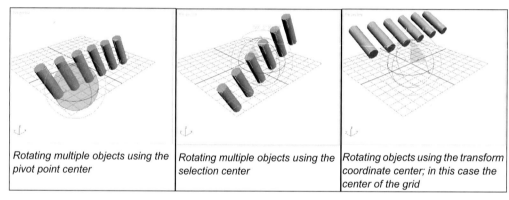

Rotating multiple objects using the pivot point center	*Rotating multiple objects using the selection center*	*Rotating objects using the transform coordinate center; in this case the center of the grid*

Exercise 1: Simple Transform Exercise

1. Open the file *Empty Tire Rack.max*.

The scene contains an empty tire rack and a single tire on the ground. You will place this tire on the rack and create a few more tires using transform tools.

2. Click Select And Rotate ↻ and then select the tire in the Right viewport.

3. Press A on the keyboard to constrain rotations to five-degree increments. You will learn more about this feature later in the lesson.

4. Drag the inner circle of the Rotate transform gizmo to rotate the tire 90 degrees counterclockwise.

5. Click the Select And Move Icon ✛ and make the Front viewport active by right-clicking it.

6. Place your mouse cursor on the square in the Move transform gizmo and then drag to move the tire so that it sits on the rack.

7. Make the Right view active and move the tire to the left side of the rack by dragging the X-axis (red axis) of the Move transform gizmo.

8. With the Move tool still selected, press and hold the SHIFT key on your keyboard, click and hold on the X-axis of the Move transform gizmo, and drag approximately one-and-a-half tire widths to the right.

9. On the dialog that opens, choose the Copy option and enter 2 as the Number of Copies. Click OK to continue.

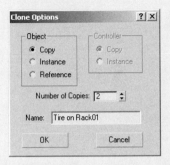

10. Click the Select And Scale icon in the main toolbar.

11. In the Right viewport select the center tire and then drag the X-axis of the Scale gizmo and scale the tire to approximately 75% of its original size. Keep an eye on the status bar for reference.

12. In the User viewport select the rightmost tire. Drag near the center of the scale icon and scale the tire down to 80% of its original size.

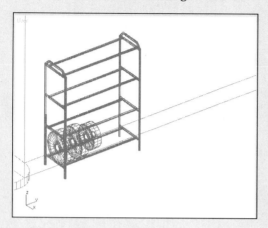

13. Use the Rotate tool to make the second and third tires lean toward the left.

14. Finalize the placement of the tires with the Move tool.

Coordinate Systems

Eight coordinate systems are available in 3ds Max. In this section you will see some of the more common and useful systems. You change the current coordinate system using the Reference Coordinate System list on the Main Toolbar.

World

The World coordinate system is based on the XYZ axes in the 3ds Max workspace. The XY plane is the ground plane and the Z axis is perpendicular to this plane. The World coordinate system does not change, and is practical in that respect since you always know the orientation of the space around you.

The World coordinate system used as a reference. The Perspective viewport is active; note the orientation of the Move transform gizmo.

The World Coordinate system is still in use but now the Left viewport is active. Note that the orientation of the Move transform gizmo remains the same as when the Perspective viewport was active.

View

The View coordinate system is the default coordinate system used by 3ds Max. It is a coordinate system that adapts to the active viewport to keep the XY plane perpendicular to that viewport. This applies to isometric (2D) views only. If a 3D view such as the Perspective viewport is active, the View coordinate system behaves like the World coordinate system, where the XY plane lies flat on the ground and the Z-axis is vertical.

View coordinate system with the Perspective viewport active. Note the orientation of the Move transform gizmo.

View coordinate system with the Left viewport active. The orientation of the Move transform gizmo has changed.

Local

The Local coordinate system is based on the coordinate system of the object being transformed. An object's local coordinate system follows rotation of the object.

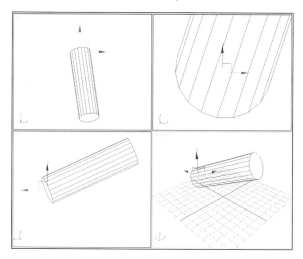

A freely rotated cylinder with the World coordinate system active.

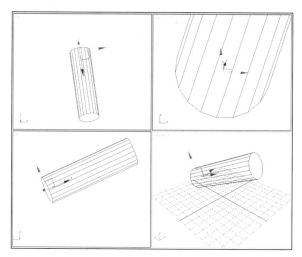

The Local coordinate system orients itself to the object. In this case the Z-axis of the coordinate system points along the height of the cylinder while the XY plane lies on the base.

Pick

The Pick Coordinate System is so called because it allows you to pick another object to use as a transform center. Once you choose Pick and then pick the object, the selection center must be set to Use Transform Coordinate Center.

Pivot point of the (picked) Table object is used as the center of rotation when clones of the chair are created.

Snaps

Four different snapping types are available in 3ds Max.

- Object Snaps: allow you to snap to grids and parts of objects such as vertices and midpoint of edges
- Angle Snap: limits rotation increments to a fixed number of degrees
- Percent Snap: used with the Scale tool to control the percentage of scaling of objects
- Spinner Snap: sets the single-click increment/decrement value for all spinners.

Object Snaps

Object snaps can be useful when you are laying objects out along a grid or tracing an existing object and wish to snap to the object's vertices. When you right-click the Snaps Toggle button on the main toolbar, the Grid And Snap Settings dialog opens. Note that this doesn't turn on snapping; it simply lets you adjust the settings.

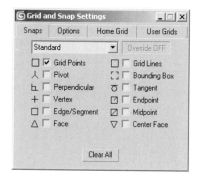

Grid Points is on by default.

When you click the Snaps Toggle button 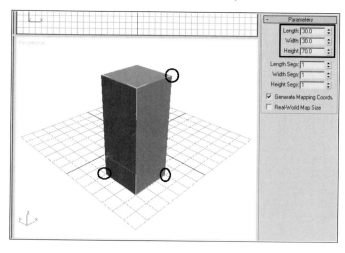, the active options in the snap dialog are used. You can also enable snap mode using the keyboard shortcut **S**.

If Grid Points snapping is on when you create a box, each point of the base lands on a grid intersection, and the height is restricted to the grid spacing.

If you turn on Vertex snapping, you can position new geometry accurately using the vertices of existing geometry in the scene; in this case, the vertices at the corners of the dog house.

Angle Snap

When you wish to rotate an object precisely without the use of the Rotate type-in, Angle Snap is quite useful. Angle Snap restricts the rotation of an object to a predetermined angle increment. Right-clicking the Angle Snap Toggle ⛰ opens the Grid And Snaps Settings dialog with the Options panel active.

The Angle Snap value is controlled by the Angle value in the General group. The default setting of 5.0 is useful for most situations.

To turn on Angle Snap, click the Angle Snap Toggle and the button turns yellow, indicating the mode is active. You can also use the keyboard shortcut A.

The Angle Snap restriction of rotation is made clear with XYZ rotation values appearing outside the Rotation Gizmo.

Scale Percent Snap

Percent Snap controls how the Scale value. Percent Snap is less commonly used and works in much the same fashion as Angle Snap. The Percent Snap Toggle activates the mode and right-clicking the button brings you to the same dialog panel as Angle Snap.

The Percent value controls the Percent Snap mode.

Exercise 2: Transforms using Snaps and Coordinate Systems

1. Open the file *Oil Can Rack.max*.

2. Click the Select And Move tool and in the Left viewport select the Oil Can object.

3. Click the rectangle in the Move transform gizmo.

4. Drag the Oil Can to the lower edge of the oil can rack.

5. Turn on the Angle Snap Toggle.

6. Click the Select And Rotate tool.

7. Click the inner circle of the Rotate transform gizmo.

8. Rotate the Oil Can 10 degrees counterclockwise. Because Angle Snap is on and defaults to 5 degrees, this should be easy.

9. Zoom in to the Oil Can in the Left viewport.

10. Click the Select And Move button.

Note the Oil Can is not exactly positioned properly and the Transform gizmo is not well oriented to help.

11. From the Reference Coordinate System drop-down list, choose Local.

12. Now that the Transform gizmo is oriented to the local coordinate system of the Oil Can, drag the Y axis to move the can up and down, and the X axis to move left and right. This should make it easy to get the Oil Can in the proper location.

Exercise 3: Transforms with the Pick Coordinate System

1. Open the file *Tire Rack.max*.

In the Tire Rack scene a ramp has been constructed to facilitate the placement of tires on the rack. You want to be able to make the tire follow the angle of the ramp.

2. Select the Tire To Move object.

3. Click the Select And Move tool ⊕.

4. Right-click in the Front viewport to make it active.

5. Try to move the tire up the ramp. It's a bit difficult because the tire does not follow the angle of the ramp.

6. Right-click to cancel the operation, or undo any movement if necessary.

7. Make sure the Move tool is still active and the tire object is still selected.

8. From the Reference Coordinate System drop-down list, choose the Pick option.

9. Click the Ramp object.

The tire's Move transform gizmo now aligns with the Ramp object.

10. Move the tire along the ramp.

This is greatly facilitated by using the coordinate system of the ramp.

Getting Started

Align

The Align Tool lets you line up a selected object, called the source object, with the position of a target object. You can also use Align to match a source object's orientation to that of a target object. The Align tool is accessed from the Align button 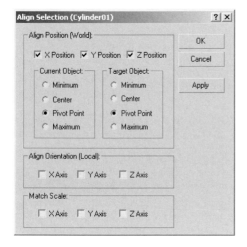 on the main toolbar.

Align XYZ Position

When you use Align to reposition an object in XYZ, you can use one of four different alignment options: Minimum, Center, Pivot Point, and Maximum. You can apply this setting separately to the current and target objects on any combination of axes. For example, take the two objects shown below:

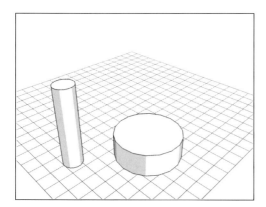

Using Align on these objects can yield a variety of results.

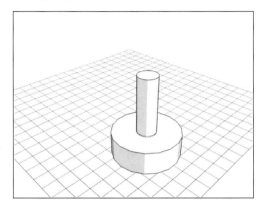

This is a simple application of Align where the pivot points are aligned.

This is a more complex application of Align. On the X axis, the pivot points were aligned; on the Y axis the maximum positions of the objects were aligned, and on the Z axis the minimum of the source object was aligned with the maximum of the target object.

Align Orientation

If two objects are not properly aligned with respect to one or more axes, the Align Orientation group of the Align dialog lets you adjust the source's object orientation to match the target's.

The Align Orientation group on the Align dialog

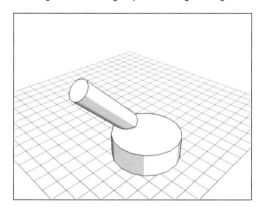

The two cylinders are oriented in different directions. The Z axes are not aligned.

Aligning the tilted cylinder to the base's Z axis produces the illustrated result. It is important to note that Align Orientation does not displace the object in space.

Quick Align

The Align flyout on the main toolbar provides a number of tools for different types of alignment. One such tool is Quick Align, the second icon on the flyout.

Quick Align works on the positions of the two objects' pivot points. It does not affect orientation.

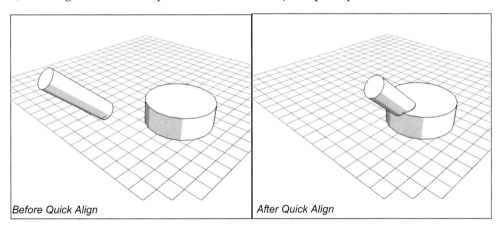

Before Quick Align *After Quick Align*

Exercise 4: Aligning Objects

In this exercise you will provide a bit more order to the layout of some pictures.

1. Open the file *Pictures01.max*.

A randomly spaced set of picture frames

2. Select the Tall Frame object on the right.

3. Click the Align button on the main toolbar.

4. Click the Regular Frame object on the left side.

5. On the dialog that opens, make sure only Y Position is on (turn off X and Y Position if necessary), set both Current Object and Target Object to Maximum, and then click OK to exit the dialog.

Because you aligned the maximum values on the Y axis, the top edge of the Tall and Regular frames are now at the same level.

6. Select the Elliptical Frame object and then click the Align Tool 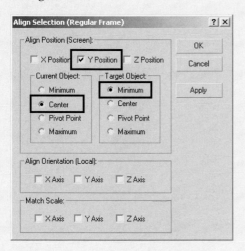.

7. Select the Regular Frame, on the left.

8. On the Align Selection dialog that opens, make sure only Y Position is on.

9. Set Current Object to Center and Target Object to Minimum, and then click OK to close the dialog.

The Elliptical Frame is now centered on the bottom edge of the Regular frame.

10. Select the Small Frame object and then click the Align Tool.

11. Click the Regular Frame object.

12. In the Align Position group, turn on X Position only, set both Current Object and Target Object to Minimum, then click OK to close the dialog.

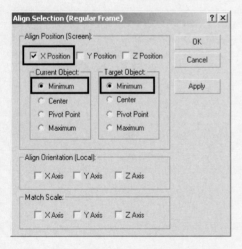

The Small Frame object is now left aligned with the Regular Frame object.

13. Make sure the Small Frame object is still selected, and then click the Align Tool .

14. Click the Tall Frame object.

15. On the Align Selection dialog, turn on Y position only and set both Current Object and Target Object to Minimum. Click OK to exit the dialog.

The picture frame layout is complete.

Cloning Objects

You use cloning to duplicate objects. One way to clone an object is to hold down the SHIFT key while moving, rotating, or scaling an object. Another is the Clone Selection command on the Edit menu. In 3ds Max you can create a clone in one of three states: Copy, Instance, or Reference. The differences are explained below.

The behavior of cloned objects when modified differs depending on which clone option is chosen.

Copy

When you make copies of objects the new objects and the source objects are completely independent of one another.

Objects that are copied when cloned have complete independence. In the above illustration, each cylinder's Radius and Height values were adjusted affecting the others.

Instance

When you choose to instance objects as you clone them, all the objects are linked together. Any change to one is reflected in the others.

Objects that are instanced when cloned have complete dependence on one another. If you change the Height or Radius value of one cylinder, the others change as well.

Reference

When you choose to reference objects as you clone them, you create a link between objects that allows some flexibility in the cloned objects.

Objects that are cloned with the Reference option display a grey horizontal bar in the modifier stack, in this case just above the cylinder.

Modifiers applied when the grey bar is highlighted appear above the bar and are unique to that object.

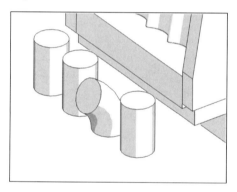

In this case a Bend modifier is added to one of the cloned cylinders.

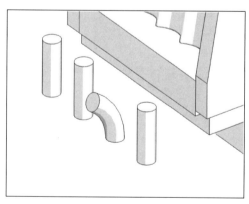

Modifications to the base object or modifiers applied below the grey bar will affect all objects. In this case the radius of the initial cylinder has been changed.

Make Unique

When you are working with instanced and referenced objects and you want to make a duplicate independent of the others again, you can use the Make Unique tool found on the Modify panel. Make Unique converts an instance or reference to a copy.

Select Dependents

When you work with instance and reference objects you might want to know which objects in your scene are dependent. You can check dependencies by using a check box on the Select Objects dialog.

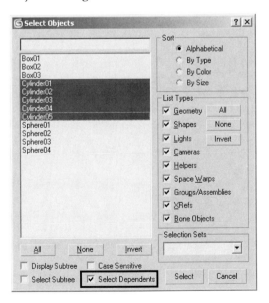

When Select Dependents is on, clicking any of the instanced cylinders highlights all of them.

Exercise 5: Cloning Objects

1. Open the file *Oil Can Rack 01.max*.

Using instanced clones, you will make a series of oil cans that are modifiable together.

2. Select the Oil Can object in the Top viewport.

3. ⊕ Click the Select And Move tool.

4. SHIFT-drag on the red (X-axis) arrow of the Move transform gizmo. Make the first clone touch the original object.

5. On the dialog that opens, choose Instance and set Number Of Copies to 4.

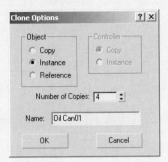

6. Click OK to exit the dialog.

You should now have five instanced clones of the Oil Can Object along the bottom.

7. Select any one of the Oil Can objects.

8. On the Modify panel, note the modifier stack of the Oil Can object. The Lathe modifier should be highlighted.

9. On the Parameters rollout, change the Segments value to 24. Note that the number of lines that controls the level of detail of the oil cans increases for all of the cans.

10. Select the center oil can.

11. Click the Make Unique button.

12. Change the Segments value to 12.

Only the center oil can is affected. Make Unique has made this oil can independent, like a copy.

13. Click the Select By Name tool 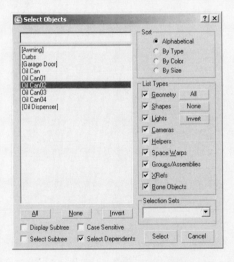.

14. Turn on Select Dependents.

15. Click Oil Can02. It should remain the only object highlighted.

16. Click Oil Can03. The remaining Instanced clones become highlighted.

Only the remaining instances are dependent.

Other Transforms

Mirror

The Mirror transform takes an object and creates a symmetrical object along a mirror plane. You can choose to mirror about a number of different axes.

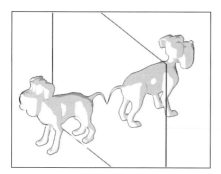

The Mirror tool creates a symmetrical object like that seen in a mirror.

Array

The Array tool makes multiple clones of objects in the X, Y, or Z direction. In more complex applications you can use it to create multiple copies when you rotate and scale objects. You can find the Array tool in the Tools menu.

Array can create multiple copies of objects based on displacement, rotation, or scaling.

Spacing

The Spacing tool allows you to create multiple objects along a spline object. The objects can be separated based on distance or number of copies along the spline. The Spacing tool can be found in the Tools menu.

Creating a regularly spaced object, like a picket fence, is easily accomplished with the spacing tool.

Clone and Align

The Clone And Align tool lets you distribute source objects to a selection of destination objects. For example, you can populate several rooms simultaneously with the same furniture arrangement by replacing 2D temporary symbols with 3D chair objects.

Temporary 2D symbols are placed around the dinner table as placeholders for the Clone And Align tool. This is done so the scene is less geometrically heavy (that is, it contains fewer polygons), potentially speeding up viewport interaction.

After the Clone And Align tool is applied, the 3D chairs are distributed around the table.

Summary

In this lesson, you have learned how to use a number of transform tools and utilities. You have seen how to use the basic transforms and the Transform gizmo. You also saw how to use different transform base points, and coordinate systems. You also used snapping tools to assist in the creation and transform of objects. You saw how to clone objects and use the different clone options. Finally you learned about a few advanced transform tools for further study.

Applying Modifiers

The modifier stack is one of the more powerful modeling tools in 3ds Max. It gives you the ability to model without destroying the original object. In addition, you can continue to tweak your model at any level of the modifier stack.

Objectives

After completing this lesson, you will be able to:

- Understand the concept of the modifier stack
- Manipulate basic controls in the stack
- Use some simple but powerful modifiers
- Collapse the modifier stack to simplify the object

Concepts of the Modifier Stack

Imagine a sculptor being able to add and subtract from a model without committing to any of the changes made to the model. Take a piece off here, add a piece there, and adjust this section over here. Hmmm, I don't like the piece I took away originally. I'll simply remove that action from the changes. Consider the following images, which show a series of changes or modifications to a head model made in chronological order.

The original head model | First change: original head with added dent in skull

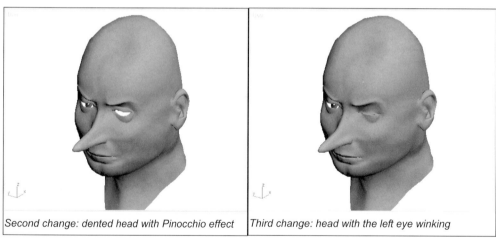

Second change: dented head with Pinocchio effect | Third change: head with the left eye winking

In 3ds Max, you can make each of these three changes to the basic head object with separate modifiers. 3ds Max combines the modifiers, "stacking" them one on top of the other. Illustrated, the way 3ds Max understands these modifiers would look something like this:

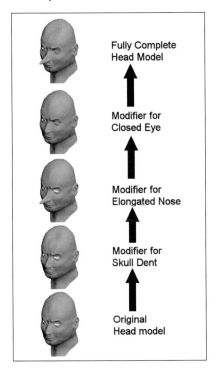

In 3ds Max, the resulting head model and the applied modifiers would look like the following. This sequence of modifiers is known as the *modifier stack*.

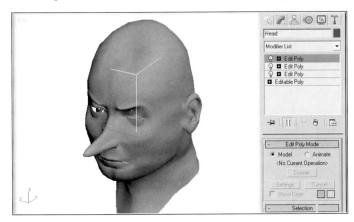

The modifier stack displaying the three modifiers applied to the original head. The stack works from bottom to top, adding modifiers to the already modified geometry.

As with objects, you can rename modifiers. Here is how the modifier stack might look with renamed modifiers that make it easier to remember what each modifier does.

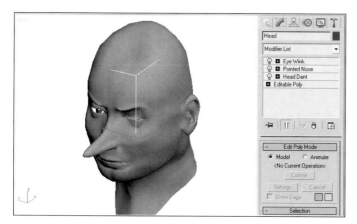

Modifier stack with renamed modifiers

Operations in the Modifier Stack

You can use a variety of tools when working with the modifier stack.

Navigation in the Modifier Stack

When you want to make a change to a modifier in the modifier stack, you will need to return to that level in the stack. For example, if you wanted to change the length of the character's nose, you would need to select the modifier named Pointed Nose.

Depending on the type of work you are doing, you might receive the following warning message when moving to a modifier lower in the stack:

It is a good idea to click Hold/Yes from this dialog. This saves your work to a temporary file using the Hold command from the Edit menu.

Many modifiers have a + button in the stack; you click this icon to expand the modifier, revealing its sub-components.

Showing End Result and Turning Off Modifiers

Frequently, when you work on an object with a number of modifiers, you might wish to see the result of the modifiers to a certain point in the stack. You may also like to temporarily disable the results of one or more modifiers in the stack.

The Show End Result toggle 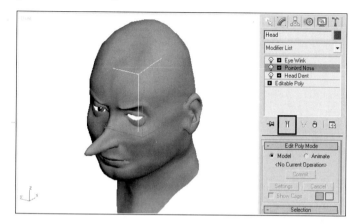 allows you to turn on and off the modifiers from the current position to the top of the stack.

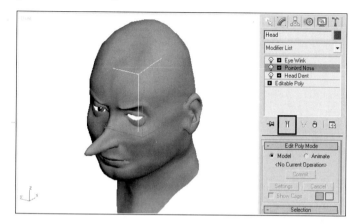

Turning off show end result when you are positioned at the Pointed Nose modifier removes the result of the Eye Wink.

Next to each modifier is a small light-bulb icon. This icon controls the visibility of the effect of a modifier on an object in the viewport. You click this icon to turn the respective modifier on and off.

Visibility icons for modifiers

With Show End Result on, removing the visibility on the Pointed Nose modifier allows you to see how the object appears with the Head Dent and the Eye Wink only.

Copying and Pasting Modifiers

You can copy and paste modifiers from one object to another. You copy modifiers though a right-click menu in the modifier stack or by dragging and dropping the modifier. The illustration below depicts copying and pasting modifiers on simple objects. The right-hand object is a box that has Taper and Bend modifiers, and the cylinder on the left has no modifiers. When you copy and paste the modifiers through the right-click menu, you have the option of pasting either a regular independent copy or an instanced duplicate of the modifier.

Highlight the modifier to copy and then right-click in the modifier stack to open the menu.

Select the target object, right-click the modifier stack, and then choose Select Paste or Paste Instance.

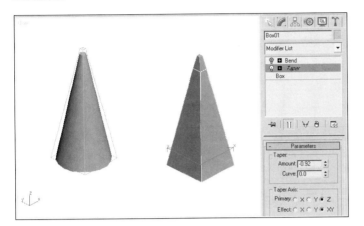

When a modifier is instanced, both the original and the instanced modifiers become dependent.

You can drag a modifier from one object to another. If you press the CTRL key and then drag, you create an instance of the modifier.

Drag the Bend Modifier from the box to the cylinder.

The Modifier Stack Buttons

The modifier stack uses a default list of modifiers that is quite long. The Configure Modifier Sets button 🔲 allows you to choose a predefined button set from a menu, and then toggle the display of the buttons. Using a predefined or customized set of buttons speeds access to commonly used modifiers.

Display Buttons menu

Shown below is the Modifier stack with the Parametric Modifiers buttons displayed.

Modifier Order

The order of modifiers in the modifier stack is important. Modifiers are added one on top of another, and the current modifier acts on the result of all evaluated modifiers before it. We'll use a simple example to illustrate this principle. Take two cylinders: one with the Bend modifier, the other with Taper.

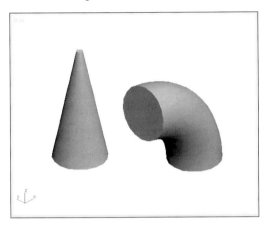

If you then proceed to bend the tapered cylinder and taper the bent cylinder you get completely different result.

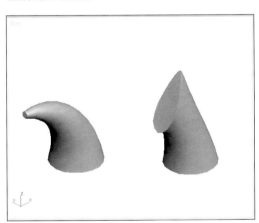

If you find that a modifier is not in the proper position you can move it by dragging in the modifier stack.

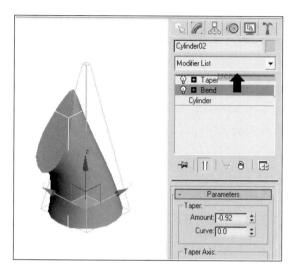

Exercise 1: Basic Manipulations of the Modifier Stack

1. Open the file *Basic Objects.max*.

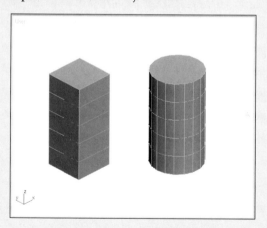

There are two simple primitive objects. Each object has five height segments.

2. Select the box object on the left.

3. On the Modify panel click the Modifier List.

4. Near the bottom of the list, click Taper. A new Taper modifier is applied to the base object.

5. On the Parameters rollout, decrease the Amount value to make the object narrower at the top.

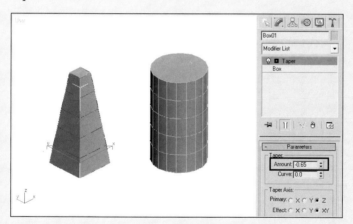

6. From the Modifier List choose Twist. A Twist modifier is applied on top of the Taper modifier.

7. Change the Angle value to approximately 45 degrees.

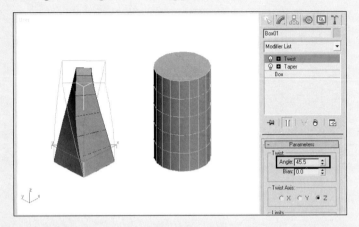

8. Add a Bend modifier to the top of the stack.

9. Change the Angle value to approximately –90 degrees.

10. Right-click the Bend modifier entry in the stack and choose Rename.

11. Rename the modifier to Bend 90, and then press ENTER.

12. Click the Twist modifier in the stack.

13. Increase the Angle value to 360.

A twist angle of 360 causes distortion in an object with this number of faces. The box needs more height segments.

14. Click the Box entry in the modifier stack.

15. Change the Height Segs value to 30.

The twisted form looks better now.

16. Click the Bend 90 entry in the stack.

17. Drag the Bend 90 modifier onto the cylinder.

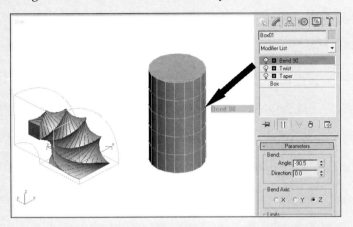

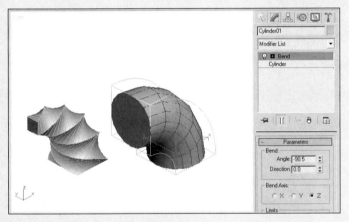

The Bend modifier is copied from the box object and applied to the cylinder.

18. Select the modified box object.

19. Click the Taper Modifier in the stack.

20. Right-click the stack and choose Copy from the menu that opens.

21. Select the cylinder object.

22. Right-click the stack and choose Paste Instanced from the menu.

The bent and tapered cylinder does not look right. You'll compare it to the bent and tapered box by turning off the box's Twist modifier temporarily.

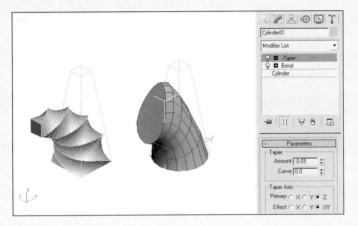

23. Select the box.

24. Click the light bulb icon next to the Twist entry. It will turn grey.

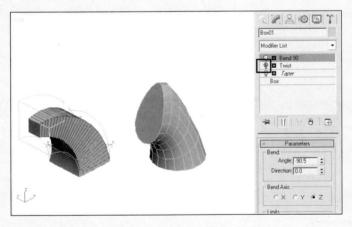

The Twist modifier now has no effect on the box.

The objects look different due to the order of the Taper and Bend modifiers in the stack.

25. Select the cylinder object.

26. Click the Bend entry and drag it above the Taper entry.

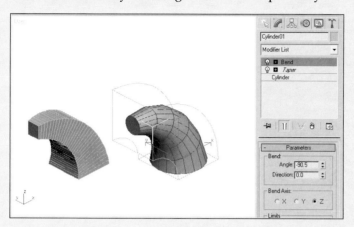

The Taper and Bend modifiers on the cylinder object are now in the correct order.

27. Select the box object and click the light bulb icon next to the Twist modifier to activate it.

28. Click the Taper modifier. Note it is italicized to remind you that this modifier is instanced in the scene.

29. Change the Amount value of the Taper modifier to 0.8. Both the box and cylinder objects are affected.

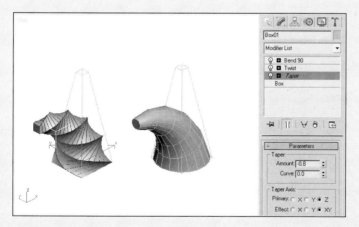

The Taper Amount changed on both objects because the modifier was instanced when it was pasted.

Modifiers

Several simple modifiers can be used to change and animate geometry. As the lessons in this book progress you will see the use of more complex modifiers.

Bend

Bend is a fairly straightforward modifier. As its name suggests, it allows you to bend an object. As with most modifiers, you can animate bend parameters. Simple applications might be to bend a cylinder or create a dancing can, although it can be used on any kind of mesh object representing geometry, such as an animal, creature, or human. You can limit the bending to only part of an object

A simple Bend modifier can create an animation.

Bend can be used on an animal model such as a bird. In this case, Bend is used to simulate flapping wings.

Taper

You can adjust the Taper modifier to create some interesting forms. You can apply a curve, and limit the effect to only part of an object.

The first cylinder has a straight taper applied. On the second cylinder, the taper has been curved. On the third cylinder, the taper is limited to the lower part of the object.

Noise

The Noise modifier is useful for introducing irregularity to your geometry. You can also apply Noise to animate irregular motion, such as a lighting bolt or the effects of an earthquake. Noise works on the vertices of an object, producing different results on low- and high-polygon-count objects.

A sphere primitive turned into an irregular form (a rock or an asteroid, perhaps) after the Noise modifier is applied

Twist

The Twist modifier is a fairly straightforward modifier. It applies a helical motion to an object's vertices about a chosen axis.

A basic application of Twist

You can adjust Twist parameters to produce more complex results. The first example, above, uses Limits settings to apply twisting to part of the box. Adjusting the Bias value produces the result on the right, shifting the twist effect away from or closer to one end of an object.

Shell

The Shell modifier allows you to take a "paper-thin" surface model and create a double-sided model, or "shell."

A surface model like the hemisphere on the left can be easily converted into a shell of the same form.

You can combine concentric spheres to create a cross-sectional model.

Lattice

The Lattice modifier places geometry at an object's edges and vertices. Struts are placed along the visible edges of the geometry and joints are placed at the vertices. You can use Lattice to create complex geometry from simple primitives.

Lattice applied to a half geosphere

Skeletal structure quickly modeled with the aid of Lattice, using struts only

Using joints without struts can produce interesting beaded results with any mesh object.

FFD

The Free Form Deformation (FFD) modifier family lets you change object shapes in a flowing manner and produce organic forms. The FFD modifier acts as a lattice with control points that you manipulate to push or pull a geometric form. You can use FFD to create complex shapes from simple objects.

A box is deformed to create this freeflowing object. Note the locations of the control points of the lattice.

A cylinder is deformed by a cylindrical FFD modifier.

Normal

The Normal modifier lets you flip the renderable side of a surface of a geometric object. By default the surface modeling in 3ds Max renders the outside of an object such as a box or sphere. If you positioned a view so that you were looking from the inside of the object, flipping the normals would be necessary.

When you construct a hemisphere, the normals are pointing out by default, as indicated by the blue lines pointing outward from the surface in the left-hand image. When you flip the normals the blue lines point inward, indicating that the renderable surface is now on the inside of the hemisphere.

The box on the left has no modifier; the one on the right has the Normal modifier applied.

A sphere is often used to create a domed sky for outdoor scenes. To make the inside of the sphere renderable, the Normal modifier is applied.

Collapsing the Stack

There might come a time when it is no longer necessary to maintain the complexity of an object's modifier stack. The process of converting an object and all its modifiers to a single object is called collapsing the stack. When you collapse an object, it becomes one of a few base object types. It should be noted that collapsing the stack removes the ability to control an object through its base and modifiers' parameters. Therefore this should be done only when you no longer expect to modify the object with those parameters.

Base Object Types

In this course we'll look at two base object types:

- Editable Mesh: This is the basic 3D mesh geometry in 3ds Max. It is a collection of vertices, edges, triangles, faces, and elements. It has no parameters that can be adjusted, as a sphere does. But unlike a sphere, you can edit the editable mesh object at the sub-object levels such as Vertex.

- Editable Spline: This is the basic object type for Shape elements such as lines, circles, and rectangles. Note that splines are entirely three dimensional and are not restricted to a plane in space.

Several additional base object types exist in 3ds Max that you should be aware of:

- Editable Poly: This object is similar to the editable mesh object but has some additional and very powerful features. Use Editable Poly when you need to use its specific features.

- Editable Patch: This base object type is derived from patch objects. Patches are surfaces that are generated from splines.

- NURBS: Similar to patches in the manner of their construction, non–uniform rational B–splines (NURBS) are mathematically different and produce surfaces with smoother transitions.

Collapsing the Stack

When collapsing the stack, you can combine modifiers to a given point in the stack or collapse them all. The following illustration shows a base editable poly object and three modifiers.

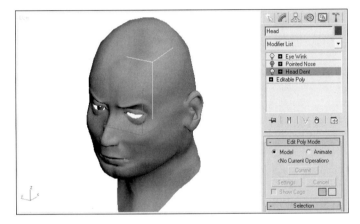

The Head Dent modifier is the highlighted level in the stack. Show End Result is off, so the effects of the Pointed Nose and Eye Wink modifiers are not visible.

If you choose to collapse to a given location in the stack, modifiers are removed up to that point, and a new base object is created.

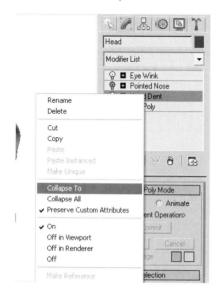

Right-click menu in the modifier stack

When you collapse to the first modifier in the stack, the Head Dent modifier becomes incorporated into the new base object.

The result of collapsing the entire modifier stack is a new base object, with all modifiers removed from stack.

Because the Pointed Nose modifier was off when the stack was collapsed, it was not incorporated into the new base object.

Converting Base Object Types

There are two different ways to convert a base object. One is to convert a parametric object to an editable object. For example:

- Converting a rectangle to an edible spline
- Converting a cylinder to an editable mesh
- Converting a compound object such as a Boolean into an editable mesh

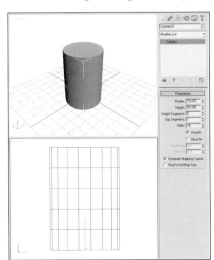

Cylinder before being converted to an edible mesh

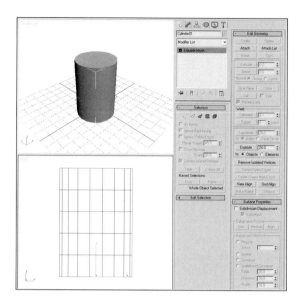

Cylinder after being converted to an editable mesh. Note the differences in the available controls on the Modify panel.

Another way to convert base objects is to convert one editable object type to a different one. For example:

- Converting an editable spline to an editable mesh
- Converting an editable poly to an editable mesh

A spline object forming a letter. After being converted to an editable mesh, it becomes a renderable surface.

A head as an editable poly

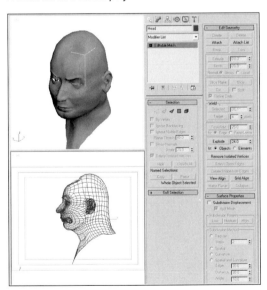

Head as an editable mesh. Note the differences in the available controls on the Modify panel.

To convert a geometric object to a base object type you can use the quad menu or the modifier stack right-click menu.

Quad menu for converting objects

Modifier stack right-click menu for converting objects

Exercise 2: Adding Modifiers to a Model

1. Open the file *Water Tower.max*.

 This scene contains is a basic water tower model. You will adjust the structure with modifiers to make it more realistic.

2. Select the WT Basin object on top of the platform.

3. On the Modify panel click the Modifier List.

4. Choose Taper from the list.

5. Adjust the Amount value to about 0.25.

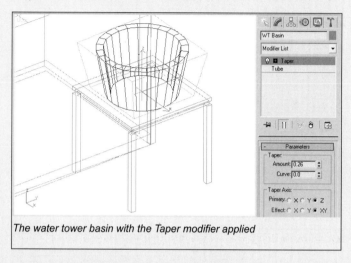

The water tower basin with the Taper modifier applied

6. Click the Tube entry in the modifier stack.

7. Change the Radius 1 value to 42.0.

8. Change the Radius 2 value to 40.0.

9. Change the Height value to 65.0.

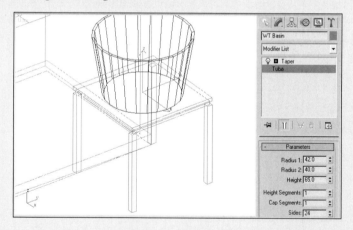

The thickness of the tower basin is now adjusted and the height is increased.

10. Select the leftmost post object, Post 01.

11. From the Modifier List, choose Skew.

Note that all the Post objects now have the Skew modifier applied to them. The Post objects are instanced, so applying a modifier to one applies it to all of them.

12. Change the Amount value to 3.0 and the direction to –45.0.

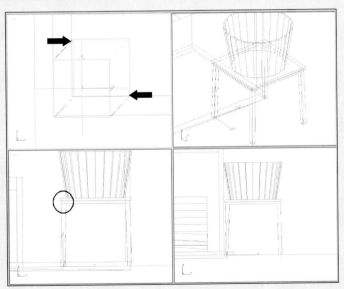

All four posts are tapered together.

13. Right-click in the viewport and choose Unhide By Name.

14. On the Unhide Objects dialog, click the All button to select all of the Brace objects, and then click Unhide.

15. Use Select By Name to select the Brace 01 object.

16. Apply a Skew modifier.

17. Change the Amount value to 90.0.

All eight braces were instanced when they were cloned. Applying the modifier once affects all braces simultaneously.

Exercise 3: Modeling with Modifiers

1. Open the file *Cactus.max*. The scene contains a basic cactus object. You will build a couple of tumbleweeds with a primitive and two modifiers. Also you will improve the cactus with a modifier.

2. On the Create panel click the GeoSphere button.

3. In the User viewport, drag out a geosphere of approximately 20 units in radius.

4. Turn on Base To Pivot.

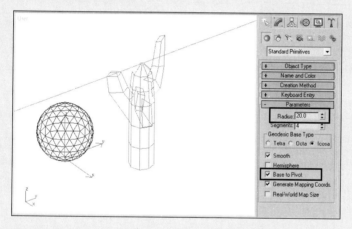

The geosphere with a regular, spherical shape

5. Go to the Modify panel, and from the Modifier List choose Noise.

6. Change the Seed value to 1.

7. Set the Strength > X/Y/Z values to about 30. You will begin to see distortion in the sphere.

The Noise modifier distorts the sphere.

8. Turn on Fractal.

9. Change the Roughness value to 0.2 and Iterations to 8.0.

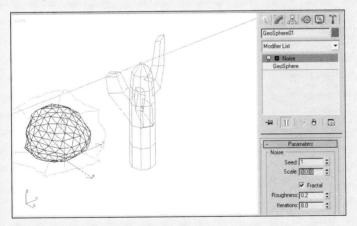

The Fractal mode and parameters make the noise pattern more irregular.

10. Rename this object to Tumbleweed.

11. Press the **F3** button to set the User viewport to Smooth + Highlights display.

12. From the Modifier List choose the Lattice modifier.

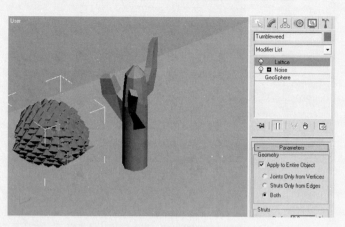

To make the distorted sphere look like a tumbleweed, you'll need to adjust the Lattice modifier.

13. On the Parameters rollout, choose Geometry > Struts Only From Edges.

14. Change the Struts > Radius value to 0.2.

15. Click the Select And Move tool and hold down the SHIFT key as you clone the Tumbleweed object to the right side of the cactus. Make sure the Clone type is set to Copy.

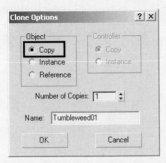

16. With the new object selected go to the Noise modifier in the modifier stack.

17. Change the Seed value to a value other than 1.

Using different seed values introduces variation in the cloned objects.

18. Select the Cactus object.

19. From the Modifier List choose TurboSmooth.

20. Change the Iterations value to 2 or 3 to see the result, then return the value to 1, which is adequate for this exercise.

Getting Started

Typically it's not a good idea to set an Iterations value larger than 3, as this dramatically increases the number of faces on an object.

Exercise 4: Creating a Sky Dome

1. Open the file *Sky Dome.max*. You'll create a dome for this scene and then apply a material with a sky image.

2. In the Top viewport, add a sphere approximately 8,000 units in radius, centered about the garage area.

3. Go to the Modify panel and set the Hemisphere value to 0.5.

4. In the Left viewport, select the sphere and move it down slightly so that the bottom of the hemisphere does not coincide with the ground plane.

Coplanar surfaces can cause rendering problems.

5. Make the Camera01 viewport active by right-clicking it.

6. Click the Quick Render button on the main toolbar.

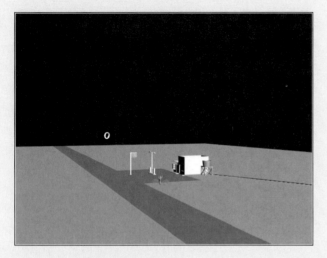

The default background shows through the sphere.

7. With the sphere selected, go to the Modifier List and add a Normal modifier.

You can now see the inside of the hemisphere.

8. Click the Material Editor button on the main toolbar.

9. Drag the first sample sphere in the upper-left corner to the hemisphere object in the Camera01 viewport.

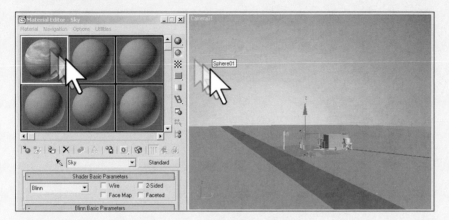

10. Render the Camera01 viewport.

Final sky dome with material applied

Summary

In this lesson you learned how to use the modifier stack and several modifiers. You saw how the stack works conceptually and in practice. You can now add and manipulate modifiers to geometric objects to change their appearance. You can use modifiers parametrically and you can collapse the modifier stack into a base object when required.

Modeling

This Modeling chapter contains three theory lessons and a lab. Topics covered include low-polygon modeling techniques, with a thorough explanation of what lies at the sub-object level.

Other techniques explained include spline modeling. Perform spline modeling by taking 2D elements and turning them into 3D volumes, with the help of modifiers and compound objects.

Also in this section, a practical lab illustrates several polygon modeling techniques to build an underwater scene.

Low Poly Modeling

Of the various 3D modeling techniques, low-poly modeling is the one that is perhaps most widely used in game production. Low-poly modeling poses a challenge to the modeler because models in a scene must not exceed a specific maximum polygon count. An environment for a video game with too many polygons can overburden the game engine, making gameplay unacceptably slow. This lesson covers techniques for properly building a game environment.

Objectives

After completing this lesson, you will be able to:

- Identify types of surfaces in 3ds Max 8
- Navigate the various mesh sub-object levels
- Understand mesh sub-object modeling versus modeling with modifiers
- Make selections at the sub-object level
- Use the Polygon Counter utility
- Use smoothing
- Create a simple 3D environment
- Use subdivision surfaces

Objects and Sub-Objects

Every scene in 3ds Max is built on a collection of objects; each of these objects is made up of components called sub-objects. Manipulating sub-objects is a modal process; once you begin editing an object's sub-objects, you cannot transform the object as a whole until you exit the sub-object level.

In the next exercise, you'll learn about the fundamental sub-objects that make up geometry in 3ds Max. When you model in 3ds Max, you can choose to create a complex object by refining a primitive object. An example of this is box modeling, a modeling technique that starts from a box primitive; the female character in the above illustration is an example.

Exercise 1: Accessing Sub-Object Levels

1. Open the file *LowPoly_Modeling_Start.Max*. If the Units Mismatch dialog appears, click OK to accept the default option and continue.

2. Select the object named Energy_Globe_04.

 This is a primitive sphere object.

3. 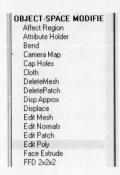 From the Modify panel > Modifier List, choose Edit Poly.

By applying this modifier your object is no longer a primitive sphere. 3ds Max now considers it a Poly object made up of sub-objects.

4. On the Modify panel > modifier stack display, click Sphere. The rollouts return to their previous state, back to the primitive object level.

As you learned previously, using modifiers allows you to go back to an earlier state if you need to adjust the parameters of an operation.

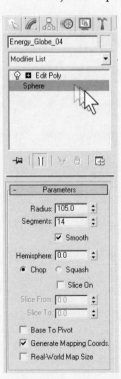

5. In the viewport, right-click Energy_Globe_04 to access the quad menu and choose Convert To > Convert To Editable Poly. By doing so, you have just collapsed the object into an editable poly object and the definition of the primitive sphere is lost. You can also collapse the modifiers in the modifier stack display by right-clicking the modifier stack display and choosing Collapse All.

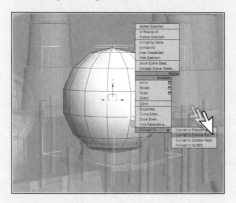

Sub-Object Levels

Each sub-object level in an editable poly object is appropriate for specific modeling tasks. Following are brief descriptions of the available levels:

Vertex: Vertices are points in space defined by XYZ coordinates. They make up the structure of an object at its most basic level. When you move or edit vertices, the faces they form are also affected.

Edge: An edge is a line that connects two vertices, forming the side of a face. Two faces can share a single edge and can be visible or invisible. Edges can be manipulated in much the same way as vertices, but have their own set of unique parameters.

Border: A border is a continuous series of edges that surrounds an open hole in geometry. This is usually a sequence of edges with polygons on only one side. For example, a box doesn't have a border, but if you create an object such as a box or a cylinder and then delete an end polygon, the adjacent row of edges form a border.

Polygon: A polygon is made up of all of the faces in an area surrounded by visible edges. Polygons offer a more robust method of dealing with object surfaces.

Element: An element is an individual poly object (that is, group of contiguous faces) that's part of a larger object. When a separate object is joined to a poly object with the Attach function, it becomes an element of that poly object.

Exercise 2: Working at Sub-Object Levels

1. Open the file *Low_Poly_Engine.max*.

2. Press the **H** key on your keyboard and select the Engine_Part_01 object.

3. Go to the Modify panel.

4. On the Selection rollout, click Vertex. There are several ways of making selections at the sub-object level. You can select a vertex in the viewport by clicking it, and you can select

multiple vertices by dragging a region selection around the vertices. You can add vertices to a selection with **CTRL**+click.

5. In the Front viewport, drag a region selection box to select the vertices at the rightmost edge of the object, as shown in the following illustration.

6. Move the vertices on the X axis to see how this action affects the mesh.

7. Press **CTRL+Z** to undo the last transform.

8. ◼ On the Modify panel > Selection rollout, click the Polygon button. Click a polygon to select it. Select additional polygons by holding the **CTRL** key and clicking to add polygons to the selection. You can also drag a region to select a group of polygons.

9. In the Perspective viewport, select the polygons that form the right end of the engine.

Polygons are selected.

10. Hold the **CTRL** key on your keyboard and click the Edges icon on the Modify panel Selection rollout. This converts the sub-object selection; in this case, from polygons to edges. This is a good way to quickly select components at the Sub-Object Level.

Note: 3ds Max 8 offers additional options for converting selections among vertex, edge, and polygon sub-object levels. For example, by using the **SHIFT** key, you can convert a polygon selection into an edge selection around the perimeter of the selected polygons. **SHIFT+CONTROL**

used simultaneously allow you to select the edges inside the perimeter defined by the polygon selection.

11. CTRL+click the Edge button to select all edges connected to the selected polygons.

Polygon selection converted to edge selection with CTRL+click

12. SHIFT+click the Edge icon to select all edges on the perimeter of the selected polygons.

13. SHIFT+CTRL+click the Edge icon to select all edges inside the perimeter of the selected polygons.

14. Go to the Polygon sub-object level. With the polygons still selected, click the Grow button on the Selection rollout. This expands your selection by adding adjacent polygons to the original. You can use the Shrink button to do the opposite, that is, removing the outermost polygons from the selection.

15. Click the Element button on the Selection rollout, and then click the small sphere on the body of the engine. You have selected an element in the same Poly object.

This object comprises four elements.

Exercise 3: Basics of Low-Poly Modeling

Now that you have a better understanding of the Selection rollout, you will add details by transforming some of the scene objects. Keep in mind that maintaining a low poly count is your main goal, because this geometry is to be used in a game.

1. Reopen the file *Low_Poly_Engine.max*. Do not save the changes from the previous exercise.

2. Press the **H** key on your keyboard to open the Select Objects dialog. Click Engine_Part_01 object and press Select.

3. Activate the polygon counter in the viewport by pressing the **7** key on your keyboard.

The polygon counter below the viewport label, showing the numbers of faces on the selected object.

4. Go to the Polygon sub-object level and select the front polygons in the Perspective viewport.

5. On the Edit Polygons rollout, click the Extrude button.

6. Place your cursor over the selected polygons, left-click and drag the mouse upward to set the extrusion height.

 You have created an extrusion of the selected faces.

7. With the polygons still selected, click Outline on the Edit Polygons rollout.

8. Place the mouse cursor over the selected faces, and then click and drag downward to perform the outline operation.

Note: The Outline operation essentially scales the selected polygons in their own plane. Be careful not to let edges cross.

9. Click the Settings button next to the Extrude button. This opens the Extrude Polygons dialog.

10. Set Extrusion Height to 50.0 and then click OK.

Note: Many functions have a Settings button. These dialog boxes are modeless, letting you test your work before committing to it. An extrusion using the Settings button can also be more precise than dragging in the viewport, because you can specify the exact value.

11. Click the Bevel button. Drag the selected polygons slightly as when performing an extrusion, release the mouse button, and then move the mouse vertically to outline the extrusion. Click to finish.

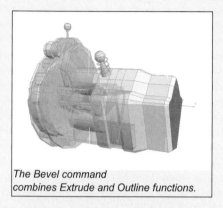

The Bevel command combines Extrude and Outline functions.

Adding Detail to the Engine and Optimizing the Mesh

1. Using the CTRL key, select the polygons as shown in the following illustration.

2. On the Edit Polygons rollout, click the Inset button, and then drag vertically on any polygon to inset it. With multiple polygons selected, dragging on any one insets all selected polygons equally.

Use the Inset button to perform a bevel with no height within the plane of the polygon.

3. Without deselecting the current selected polygons, click the Bevel button. Click and drag to create an initial extrusion, and then move the mouse gently to outline the selected faces.

Now that you've added some detail to the object, you might want to optimize it a little. Deleting faces you won't see is a simple way to reduce the polygon count of a model.

4. Go to the Edge sub-object level.

5. Select the edges on the side of the engine as shown in the following illustration.

6. On the Selection rollout, click Loop. This function extends your current edge selection by adding all the edges aligned to the ones originally selected.

7. Hold the **CTRL** key and click the Remove button on the Edit Edges rollout.

 Note: Holding **CTRL** performs a "clean" remove, deleting the edges and removing any superfluous vertices that would remain if you used the standard Remove function.

Removing edges without using the **CTRL** key (left) vs. using the **CTRL** key (right). Notice how unwanted vertices are cleaned on the right-hand illustration.

8. Right-click the Engine_Part_01 object in the viewport and choose Isolate Selection from the quad menu. This temporarily hides all other objects in the scene while you work on the selected one.

9. Orbit around the object to see the polygons that are in contact with the rest of the engine parts.

10. Go to the Polygon sub-object level, and with the help of the **CTRL** key, select the three inner polygons as shown in the illustration below.

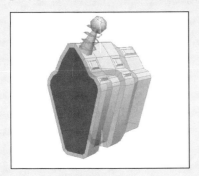

11. Expand the polygon selection to those around the perimeter by clicking Selection rollout > Grow.

12. Delete the selected faces by pressing **DELETE** on your keyboard.

13. Go to Border sub-object level and select the new border as shown below.

14. On the Edit Borders rollout, click the Cap button.

The border is now capped with a single polygon.

15. Go to the Element sub-object level.

16. Select the small sphere, spring, and cone elements.

17. Clone the selected elements by **SHIFT**+dragging the elements to the position shown below. On the Clone Part Of Mesh dialog, click OK to accept the defaults.

18. Exit the sub-object level and then exit Isolation Mode.

19. Use the Save As command to save your progress. Name the new file *My_Low_Poly_Engine.max*.

Exercise 4: Modeling with Modifiers

In the following exercise, you will add components to the engine by reshaping objects with the help of modifiers. Keep in mind that to obtain satisfactory results when deforming with modifiers, some objects might need additional subdivision.

1. Continue working on your file or open *Low_Poly_Engine_01.max*.

2. Go to the Create panel > Geometry > Standard Primitives category and click the Cylinder button.

3. Turn on the AutoGrid option.

 Note: AutoGrid lets you automatically create, merge, or import objects based on the surface of another object by generating and activating a temporary construction plane based on the normals of the face you click. This serves as a more efficient way of stacking objects as you create them, rather than building objects and then aligning them as a separate step.

4. Position the cursor on the octagonal plate in the Perspective viewport. Notice how the axis tripod adapts to the orientation of the various faces in that area.

5. Create a cylinder on that plate. Note the temporary construction grid that allows you to align the cylinder base to the face of the plate.

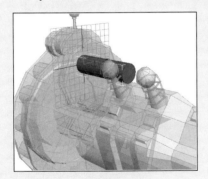

6. Go to the Modify panel and adjust the parameters of the cylinder. Set Radius to 20.0, Height to 250.0, Height Segments to 12, and Sides to 10.

7. Add a Bend modifier. Set Angle to 180.0.

 Note: The Bend modifier lets you bend the object about a single axis, producing a uniform bend in an object's geometry. You can control the angle and direction of the bend and you can also limit the bend to a section of the geometry.

8. Press **A** to enable Angle Snap. This lets you rotate the object in five-degree increments.

9. In the Perspective viewport, rotate the cylinder by –135 degrees on the X axis, represented by the red circle on the Rotate gizmo.

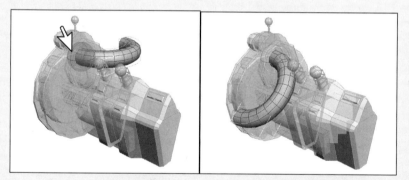

10. In the modifier stack display, click Cylinder to adjust the cylinder's creation parameters.

11. Set Radius to 15.0 and Height to 235.0.

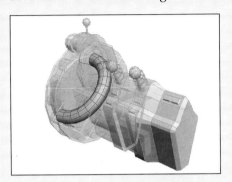

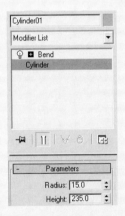

12. Click Bend in the modifier stack display.

13. Add an Edit Poly modifier.

14. Go to the Polygon sub-object level.

15. Change the Perspective viewpoint so it resembles the following illustration, and then select the top polygon of the cylinder.

16. Click the Extrude Settings button. Extrude the polygon by 20 units. Click OK to exit the dialog.

17. Press **DELETE** on the keyboard to delete the selected polygon.

18. In the Front viewport, select the newly extruded polygons.

19. Click the Extrude Settings button again.

20. Choose the Local Normal option and set Extrusion Height to 7.0. Click OK to exit the dialog.

21. Go to the Edge sub-object level and select the edge shown in the following illustration.

22. Click Loop on the Selection rollout to quickly select the edges around the cylinder.

23. On the edit Edges Rollout, click the Chamfer button. This tool lets you "chop off" the selected edges and create a new set of faces in their place.

24. Place the mouse cursor over the selected edges and click and drag gently upward.

25. Exit the sub-object level to return to editing the whole object, and then right-click in the Top viewport to activate it.

26. Activate the Mirror tool. In the Clone Selection group, choose the Copy option. This duplicates the object to the other side of the engine.

27. Set Mirror Axis to Y, and the Offset value to 45. Click OK to exit the dialog.

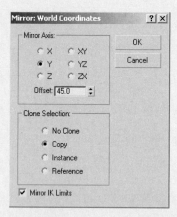

28. Select the Engine_Part_03 object.

29. On the Edit Geometry rollout, click the Attach List button and select Cylinder01 and Cylinder02. Click Attach to accept the changes and exit the dialog.

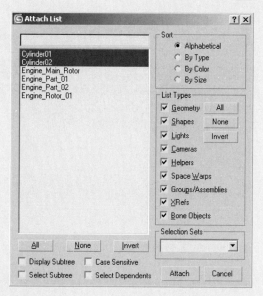

The two cylinders are now attached to Engine_Part_03.

30. Right-click in the viewport to activate the quad menu. Choose Unhide All to unhide the Pipes_Holding_01 object.

31. Save your progress. Name the new scene *My_Low_Poly_Engine_01.max*.

Exercise 5: Repairing the Broken Part

In the following exercise, you will encounter a small problem. The original engine mesh supplied for this lesson has a broken rotor. You will fix this broken part.

1. Continue working on your file or open *Low_Poly_Engine_02.max*.

2. Arc rotate around the object in the Perspective viewport to look at the left part of the engine. Select the Engine_Main_Rotor object.

3. Right-click the selected object and choose Isolate Selection from the quad menu.

4. ■ Go to Polygon sub-object level. In the Front viewport, region-select all the irregular polygons that make up the rotor cap.

5. Delete the selected polygons.

6. ⟲ Go to Border sub-object level and click a point on the circle that was left vacant when you deleted the polygons in the last step.

7. In the Front viewport, hold the SHIFT key and move the selected edges to the left (on the X axis) to extrude the rotor cap.

8. On the Edit Borders rollout, click Cap. This caps the entire selected border with a single polygon.

9. Go to Polygon sub-object level and select the new polygon.

10. On the Edit Polygons rollout, click the Bevel button.

11. Bevel the selected polygon as you learned to do earlier to add the finishing touches to the rotor part.

12. Exit the sub-object level, and then exit Isolation mode. The engine is now completed.

13. Save your progress. Name your new scene *My_Low_Poly_Engine_02.max*.

Smoothing Groups

Smoothing is a rendering trick that blends between faces to produce an even, curved surface from flat polygons. In the games industry, this is a concept that is used as an integral visual component, for example, when you model a character and want to give it a smooth appearance. This can be accomplished by applying smoothing groups to different parts of the model. The result is a better-looking model without additional geometry.

In the following exercise you will learn how to work with smoothing groups. As you model, you will notice that each time you create a new 3D primitive, the default object is smoothed. However, when adding polygon geometry with an Edit Poly modifier, the new polygons created are not automatically smoothed: They require manual intervention.

Exercise 6: Using Smoothing Groups Menu

1. Open the file *Girl_Model.max*. If the Units Mismatch dialog appears, click OK to accept the default option and continue.

The model is faceted as no smoothing has been applied yet.

2. In the Perspective viewport, select the Girl_Model object.

3. Go to the Modify panel.

4. Set the sub-object level to Element.

5. Select the model element by clicking on it.

The model is made of only one element.

6. On the Polygon Properties rollout > Smoothing Groups group, click the 1 button.

The smoothing on the model has changed.

7. In the viewport, click anywhere in an empty area of the viewport to deselect the element.

8. Set the sub-object level to Polygon.

Modeling

9. Arc rotate the viewport as necessary to see the polygon at the bottom of the right leg, and then select the polygon.

10. On the Edit Polygons rollout, click Extrude.

11. Drag the selected polygon to extrude it.

The new polygons are not smoothed. You must assign them to a smoothing group in order to make them smooth.

12. Set the sub-object level to Element.

13. Click the model to select the element.

14. On the Polygon Properties rollout > Smoothing Groups group, click 1 again.

The smoothing on the leg has changed; the new polygons are now smoothed with the rest of the leg.

Using Subdivision Surfaces

As you are build low-poly models for game levels, there will be occasions when you will want to create a high-poly model for pre-rendered cut-scenes. This brings up the question of what kind of surface you want to work with. You can use splines or patches, or start with a primitive and apply modifiers to model the shape you want. For many modelers, it is preferable to start modeling a low-resolution version and then add detail to generate a high-resolution version.

You can increase the resolution of a low-poly model by adding a modifier. The modifiers available to increase resolution are:

- MeshSmooth increases the resolution of geometry by adding faces at corners and along edges and blending them together.
- TurboSmooth is a condensed version of the MeshSmooth modifier. It is faster and more memory efficient, but has fewer parameters.
- HSDS (Hierarchal Subdivision Surfaces) is meant as a finishing tool. Use this modifier to add detail and adaptively refine the model in specific areas.
- Tessellate adds geometry by subdividing polygons.
- Subdivide subdivides the geometry into triangular faces. It is really meant to work as an aid for radiosity (global illumination) calculation rather than as a modeling tool.

Modeling

Exercise 7: Smoothing a Low-Poly Model

1. Reopen the *Girl_Model.max* file you worked on in the previous exercise. Do not to save the changes you have done so far as you need to work on the original model.

2. In the Perspective viewport, select the character.

3. Press **7** on your keyboard to activate the Face Count option. The character currently has approximately 3,600 faces.

4. Go to the Modify panel.

5. From the Modifier List choose MeshSmooth.

The Face Count has increased to almost 15,000 faces. The result is a rounder, smoother object.

Note: The MeshSmooth modifier smoothes the geometry it is applied to. It subdivides the geometry while at the same time interpolating the angles at vertices and edges. By default, the modifier applies a single smoothing group to all the faces in the object.

6. On the Subdivision Amount rollout, make sure Iterations is set to 1.

The Iterations value determines the number of times the mesh is subdivided.

Note: Do not try to increase Iterations to too high a value; 3 should be the maximum setting for most models. A high Iterations value will invariably slow down your computer and make it harder to work on your model.

7. Press **F4** to turn on Edged Faces in the viewport, and then on the Local Control rollout, turn off Isoline Display. In the viewport you can see the level of detail that corresponds to the Iterations setting. When Isoline Display is on, MeshSmooth adjusts the geometry to the Iterations amount while maintaining the visible edges of the low-poly model.

Model with Isoline Display turned off

Model with Isoline Display turned on

8. On the Local Control rollout, turn on Show Cage.

9. On the Local Control rollout, click the Vertex button.

10. Press **F** to switch to the Front viewport, and then select the vertices that define the upper-left arm muscles. Click and drag to create a region selection box to select the vertices.

11. Scale the vertices outward to affect the shape of the MeshSmoothed geometry.

Adjusting the geometry at the MeshSmooth level

Summary

In this lesson you learned the basics of low-poly modeling. Keep in mind that the key to low-poly modeling is maintaining an optimized scene. Video game artists have to pay special attention to number of polygons in their scenes, as well as for the size of the textures used in those scenes. While new technologies are loosening the requirements of low-poly models, letting us have a larger polygon budget for details, it will always be important to maintain a polygon count that suits the needs of the game engine and its associated hardware.

You covered the components of polygon sub-objects: vertices, edges, faces, polygons, and elements. You learned how to edit and transform an object both with and without modifiers, and that the Edit Poly modifier is useful for modeling complex objects, using tools like Extrude, Bevel, and Inset. You also learned how to quickly add resolution to a low-poly model with the MeshSmooth modifier.

Shapes

In this lesson you'll learn about shapes. The shape is a linear object type that can form an open or closed area. Shapes are mostly used in 2D graphics but can also be defined in three dimensions. You can use shapes as building blocks for 3D geometry with modifiers like Lathe, Bevel, and Extrude. Compound objects such as Loft and ShapeMerge also use 2D shapes to build 3D objects.

Objectives

After completing this lesson, you will be able to:

- Distinguish between the basic elements of a shape
- Create basic shapes
- Edit shapes and their sub-objects
- Use modifiers with shapes to create 3D Geometry

Shape Definitions

A shape is typically a 2D linear object. Some examples of shapes include:

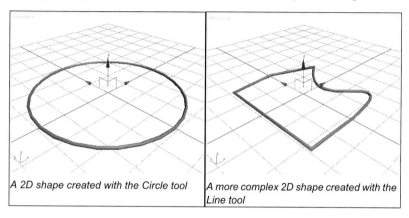

A 2D shape created with the Circle tool

A more complex 2D shape created with the Line tool

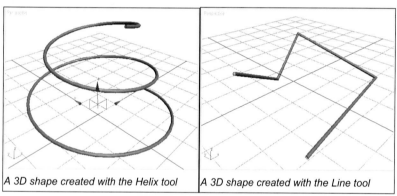

A 3D shape created with the Helix tool

A 3D shape created with the Line tool

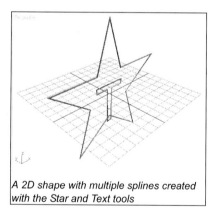

A 2D shape with multiple splines created with the Star and Text tools

Shape Components

A shape typically comprises multiple components. At the object level there is the shape itself. A shape can contain multiple splines. Each spline is defined by two or more vertices. Each adjacent pair of vertices in a line defines a segment. You can manipulate each of these components at different sub-object levels.

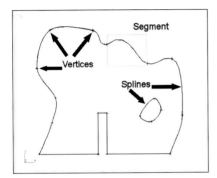

A 2D shape showing the components of a shape: one or more splines and curved or straight segments between vertices

In addition to the sub-objects listed above there is the concept of vertex type. Vertices can take on the properties of one of four types: Bezier Corner, Bezier, Corner, and Smooth.

With one or more vertices selected, the quad menu gives you options to change the vertex type.

Basic Shape Creation Functions

There are several different ways of creating shapes. Typically, you would use the Shape creation tools available on the Create panel.

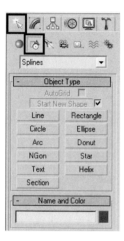

Basic Shape tools on the Create panel

Line Tool

The most fundamental shape-creation tool is Line. You will have a considerable amount of control on the form of your shape when you use this tool. Line uses two different creation methods to determine the vertex type of each vertex.

When creating lines, the Creation Method rollout lets you to control the types of vertices created. Initial Type determines the vertex type produced when you create a vertex with a simple click. Drag Type sets the vertex type produced when you create a vertex by dragging the mouse.

When creating shapes with a Corner vertex type, straight segments are created.

When you create vertices in a shape with the SHIFT key down, new segments are constrained to horizontal and vertical directions.

Creating a shape with Bezier vertices forces curved segments to be drawn.

To create a complex shape with more than one spline, turn off Start New Shape on the Object Type rollout. This creates one shape object with multiple splines.

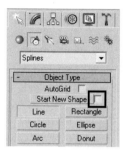

Parametric Shape Tools

Most of the remaining shape-creation tools produce parametric objects that are easy to create and edit.

These include Circle, Star, NGon, Ellipse, and Text.

Shape Steps

When you create a shape, 3ds Max displays curved segments with straight-line components called steps. The greater the number of steps, the smoother the curve. You adjust the number of shape steps on the Interpolation rollout.

The default Steps value of 6 produces fairly smooth results, but the segmentation is evident when you zoom into the model.

Note the difference among these three concentric circles. The inner circle has a Steps value of 2, while the outer circle uses a Steps value of 12. The center circle uses the default (6).

Shape steps are calculated between vertices. A shape with many vertices looks smoother than a shape with more steps. In the illustration, the inner circle shows four vertices with a Steps value of 2, while the outer circle contains two vertices with a Steps value of 4.

The Interpolation rollout contains two check boxes worth noting:

- Optimize – This check box removes shape steps where they are unnecessary, usually on a straight-line segment. Optimize is on by default.
- Adaptive – When on, this option essentially take control of the distribution of shape steps. It removes steps in linear segments and distributes steps in curved segments based on the angle of the curve. Adaptive is off by default. When enabled, both Steps and Optimize are unavailable.

Identical splines: The left one has a Steps value of 6, while the right one has Adaptive turned on.

Rendering Values

By default, splines display in the viewport but do not render. You can set rendering values on the Rendering rollout.

A Helix spline enabled for rendering turned in the viewport and in the renderer. You can adjust the Thickness value, and control the radius of the profile of the spline.

3D Splines

As you can see with the Helix spline, shapes are not limited to a single plane. The Helix is inherently a 3D spline, created automatically in 3D. Other shapes are generally created in a 2D plane and can then be edited to make them 3D.

Editing Splines

You can create splines quickly using parametric shapes that provide a basic level of functionality for splines. The real power of splines, however, becomes more apparent when you edit them at the sub-object level.

Editing Parametric Shapes

After creating a parametric shape such as a circle or text, you can edit the values of the shape on the Modify panel.

You can quickly change the font, size, and even content in a Text shape on the Modify panel.

The Base Spline Object – The Editable Spline

Shapes generally exist in two forms: as parametric objects and as editable splines. Although a parametric object is more "intelligent" and easier to edit, the editable spline form gives you total control over the shape. Regardless of how you create a shape, you can convert it to an editable spline at any time. In most cases, spline operations are unavailable until you convert a shape to an editable spline.

A circle is created as a 2D parametric shape. You can change Rendering and Interpolation values and the circle radius but at this point have no control over vertex type, segments, etc., if you wish to deform the circle.

Converting the circle to an editable spline exposes the editing parameters at all sub-object levels: Spline, Segment, and Vertex.

Converting a parametric object to an editable spline can be accomplished through the quad menu, or by right-clicking the modifier stack.

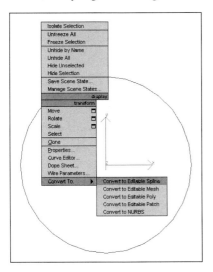

Using the quad menu to convert a shape to an editable spline

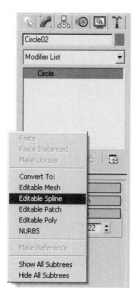

Right-click menu in the modifier stack

Converting a parametric object to a base object prevents you from editing the parametric values later. For example, once you convert a Circle spline to an editable spline object, you can no longer edit its Radius value parametrically. One solution to this is to use the Edit Spline modifier.

Edit Spline Modifier

The Edit Spline modifier, found in the Modifier List, is added on top of a spline object. When you add the modifier to a parametric object, it allows you to edit the base object with ease, using the same workflow as the editable spline base object.

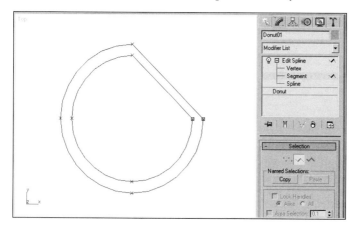

A Donut object with an Edit Spline modifier applied. The Edit Spline modifier was used to convert a segment to a straight line.

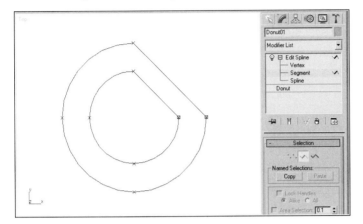

The Donut's radius modified. The change added by the Edit Spline Modifier is maintained.

The drawback to using the Edit Spline modifier is the overhead of keeping all the information in the stack. This can produce larger file sizes and slower interaction.

Spline Manipulations

The editable spline tools offer a plethora of functionality. You will explore some of the basic tools in this lesson.

The Shape and the Spline

A shape is a collection of one or more splines, whereas a spline is an open or closed linear or curvilinear element. In the previous example of a Donut, the Donut is the shape and the inner and outer circles are each splines. Splines can be added or removed from a shape.

When you create shapes you can turn off Start New Shape. Once you draw more than one spline you will have created a multi-spline shape.

Exercise 1: Creating a Simple Shape

In this exercise you will create shapes that represent a logo.

1. Start or reset 3ds Max.

2. Right-click the Front viewport to make it active.

3. Press the G key to remove the grid.

4. On the Create panel, click the Shapes button.

5. Click the Circle object type button.

6. In the Front viewport, drag out a circle.

7. Click the Star object type button.

8. Drag out a star centered on the circle, as illustrated.

9. Select the circle and then go to the Modify panel.

10. On the Parameters rollout change the Radius value to 60.0.

11. Select the Star object.

12. On the Parameters rollout change the Points value to 5, Radius 1 to 50.0, and Radius 2 to 21.0.

13. With the Star object still selected, click the Select And Rotate button .

14. Rotate the star until one of the tips is pointed up.

15. Right-click the Snaps Toggle button .

16. On the Grid And Snap Settings dialog, turn on Vertex and turn off any other options.

17. Dismiss the dialog by clicking on the X button in the upper-right corner.

18. Click the Snaps Toggle button to enable it. The button turns yellow.

19. On the Create panel, click the Shapes button .

20. Click the Line object type button.

21. Set both Initial Type and Drag Type to Corner.

22. Draw a line connecting the outer points of the star.

23. After you have drawn the line to each star point, click the first point again.

24. You are prompted to close the spline. Click Yes.

25. Click the Select tool and then go to the Modify panel.

26. Select the star and set Radius 1=45.0 and Radius 2=17.0.

27. Select the circle.

28. From the Modifier List, choose Edit Spline.

29. Click the Segment sub-object button; it turns yellow.

30. Select the two lower arcs of the circle. You can use the CTRL key to make multiple selections.

31. Right-click to open the quad menu, and then choose Line to turn the arcs into linear segments.

Result of changing the bottom segments of the circle to lines

32. On the Modify panel switch to the Vertex sub-object level.

33. Click the Select And Move button ⊕ on the toolbar, and then select the vertex at the bottom of the shape.

34. Turn off Snaps Toggle 🧲³.

35. Drag the vertex downward until the shape resembles the following illustration.

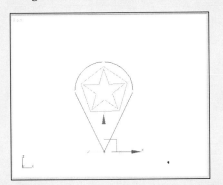

36. Click the Vertex sub-object button to turn it off. It turns gray.

37. In the modifier stack, click the light bulb icon next to the Edit Spline modifier.

The modifier's effect is turned off.

38. Click the light bulb icon next to the Edit Spline Modifier Spline again to turn the modifier back on.

39. Save your file as *mylogo.max*.

Adding Splines from a Shape

When a shape is in editable spline form or has an Edit Spline modifier applied to it, you can add splines to the selected shape with the Attach tools found on the Geometry rollout.

Before and after attaching the inner Donut and circles to the original Shape. The attached splines take on the color of the shape they are attached to.

Detaching Splines from a Shape

When you select a spline in a multi-spline shape, you have the option to detach it from the shape.

When you detach a spline you can keep the original and make a copy. The spline must be selected before these tools become available.

Basic Transformations of Sub Objects

You can edit shape sub-objects (Vertex, Segment, and Spline) with the Move, Rotate and Scale transforms.

Rotating a segment about its midpoint	*Rotating the inner vertices of a Star shape*

Mirror

You can use mirroring to create symmetrical splines within a shape. After selecting a shape and accessing the Spline sub-object level, you use the Mirror tool found on the Modify panel.

Before and after using the Mirror tool on the face-profile spline

Boolean

Booleans let you create geometry by combining 3D geometry and 2D splines in various ways. Using Booleans can make complex modeling tasks easier than with conventional methods. With splines you can use Union (add), Subtract (remove), and Intersect (common area) Boolean functions. First, all of the splines must be part of the same shape. Booleans work at the Spline sub-object level.

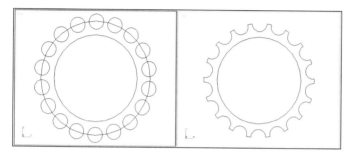

A shape before and after a Boolean operation. Subtracting the outer circles creates a gear shape.

Outline

Outline is a tool that allows you to create a duplicate spline parallel to the one selected. It can be used to quickly create an identical object parallel to another, walls, paths or creating the inner side of a bottle object as shown below.

A single curvilinear profile can be quickly converted into the inner and outer walls of a bottle using the Outline tool.

Segment Editing

A segment can be detached from a shape. This is accomplished with the same Detach tool you use with splines, only here it is used at the Segment sub-object level.

A segment of the inside of the gear has been detached and scaled. It is no longer part of the original shape.

Connecting Vertices

To close the gap between open segments, you can use the Connect tool at the Vertex sub-object level. You can connect two vertices with the Connect tool by clicking and dragging from one open vertex to another.

Line segments are added between the endpoints of the arcs when you connect the vertices.

Refining a Segment Through the Addition of Vertices

When you create a shape, you might need to add detail at some point in time. For example, the inner circle on the illustrated gear has four vertices by default: one at each quadrant. The Refine tool at the Segment or Vertex sub-object level provides you a quick way of adding vertices to add detail to the shape.

Additional segments in the lower of the inner arc provide the possibility of further editing at the Vertex level.

Vertex Editing

The vertex is the most fundamental of spline elements. A considerable amount of editing is possible at the Vertex sub-object level. In fact, reshaping splines is easiest at this level.

Deleting Vertices

When you delete a vertex, you remove it. 3ds Max then creates a segment between the two adjacent vertices.

You can find the Delete tool near the bottom of the Geometry rollout.

Both the circle and the star have had a vertex deleted at the top of the shape. The circle creates a curved segment while the star creates a straight segment between the two inner radius points.

Welding Vertices

Welding vertices is different from deleting a vertex When you weld, you take two or more vertices and make them a single vertex. This usually results in a reduction in the number of vertices.

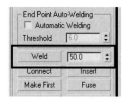

The Weld tool is found on the Geometry rollout. The numerical value to the right is a threshold value; vertices farther apart than this value are not welded.

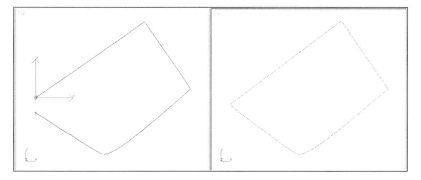

Welding the two open vertices creates a single vertex at the midpoint between them and closes the shape. The vertices to weld must be selected and they must be closer than the defined weld threshold value.

When you select vertices on a spline, the number of selected vertices is displayed on the Selection rollout.

Vertex Controls

Each spline vertex can take on the properties of one of four types: Bezier Corner, Bezier, Corner, and Smooth. Switching vertex types is done through the quad menu.

After selecting one or more vertices, choose a new type from the quad menu.

Often a vertex is created as the Corner type. This type is characterized by a sharp linear change in direction at any angle.

Changing the vertex to Smooth type will smoothes the spline curvature at that vertex location.

A Bezier vertex provides a curved shape that can be controlled with handles. With the Bezier vertex type, you can adjust the length of the handles and their directions symmetrically.

A Bezier Corner vertex lets you control the tangents going into and out of the vertex asymmetrically.

Fillet/Chamfer

Occasionally you might need to round off or slice off corners of a shape. This is easily accomplished with the Fillet tool for rounded corners and Chamfer tool for straight edges.

Filleting the vertices at the corners of the gear's teeth produces a rounded effect.

Chamfering the vertices produces an angular effect.

Modeling

Importance of the First Vertex

The first vertex, as its name suggests, is the first vertex on a spline. It is important because the first vertex is used as a starting point in the creation of geometry. In animation applications such path constraints, the first vertex is the starting point of the path.

The first vertices of the inner and outer splines are indicated by small squares.

You can change the location of the first vertex by selecting a vertex and then clicking the Make First button.

The Make First tool resets the first vertex. On a closed spline the first vertex can be anywhere. On an open spline it has to be at either end.

Exercise 2: Creating a Profile for an Oil Can

1. Open the file *Oil Can.max*.

2. In the Create panel click the Shapes button and click the Line button.

3. Draw a spline in the Front viewport following the approximate size determined by the grid.

 Don't forget the angled bead in the corner. Hold down the SHIFT key when you want to draw horizontal or vertical lines.

4. Press **G** on the keyboard to turn off the grid.

5. Zoom in to the angled bead area.

6. Go to the Modify panel and expand the Line base object entry.

7. Go to the Vertex sub-object level.

8. Select the vertex at the tip of the angled bead.

9. Right-click to open the quad menu and then choose the Bezier option.

Switching to the Bezier vertex type produces a curve that needs adjusting. To change the curve you adjust the curve handles.

10. Click the Move tool on the main toolbar.

11. Move the bottom vertex handle so that the entire handle is approximately vertical.

12. Click the Vertex entry in the modifier stack to exit the sub-object level.

13. In the Front viewport zoom out to see the entire spline.

14. Click Spline in the modifier stack to access the Spline sub-object level.

15. Select the spline in the view. It turns red.

16. On the Modify panel turn on Copy below the Mirror button.

17. Choose the Mirror Vertically option, and then click the Mirror button.

18. Move the newly created spline upward so that it just meets the existing spline at the middle.

19. Go to the Vertex sub-object level and select the two vertices created at the juncture of the top and bottom of the can.

Note the existence of two vertices at the center of the profile. No automatic welding occurred during the mirror process. Note as well that there are two first vertices in this shape, indicating that these must be two separate splines.

20. Increase the Weld threshold value to 0.5.

21. Click the Weld button.

Now only one vertex exists at the center of the profile. In addition, because the weld process converted two splines into one, it also left only one first vertex.

22. Save the file and name it *My Oil Can Profile.max*. In a later exercise you will use the Lathe tool to create a 3D object.

Exercise 3: Creating a Profile for a Bottle

In this exercise you will draw the profile of a bottle to create the inner and outer edge.

1. Open the file *Bottle.max*.

2. Use the Line tool to start drawing your profile. Position the cursor near the center of the bottom of the bottle and click the first point.

3. Hold down the **SHIFT** key to draw a horizontal line, and then click the second point.

4. Place your third point at the curved edge of the base, but this time click and drag to create a small curve.

5. Click a fourth point to complete the base.

You do not need to be very precise as you create your curve; you can make adjustments later.

6. Proceed up the side of the bottle, picking up the detail of the smooth center area and the cap top. If you wish, you can open the file *Bottle01.max* to continue from this point.

Your profile should look something like this.

7. Make sure the line is still selected.

8. On the Modify panel, expand the Line entry.

9. Go to the Vertex sub-object level.

10. The first three vertices look pretty good, so select the fourth vertex at the top of the base.

11. Right-click and choose Bezier Corner from the quad menu.

12. Adjust the Bezier handles so that they look similar to the illustration.

13. Pan the Front viewport down and zoom in to the fifth and sixth vertices.

14. Select both vertices and convert them to Bezier Corner.

You might need to adjust both the vertex locations and the tangent handles to get the desired form. Zoom in more if necessary.

15. Move up the profile making adjustments where necessary and stop when you arrive at the top of the bottle.

The profile displayed without the background for clarity

16. In the Modify panel > Modifier stack, access Segment sub-object level.

17. Select the third segment from the top.

18. At the bottom of the geometry rollout, click the Divide button, leaving the default value at 1. This will insert a vertex in the middle of the segment.

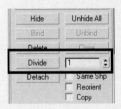

19. Go back to the Vertex sub-object level.

20. Continue to adjust the vertices curvature until the top of the bottle is complete.

Modeling

The completed curve at the top of the bottle.

21. Continue working on the bottle profile or open *Bottle02.max*.

22. Make sure the bottle profile (Line01) is selected.

23. On the Modify panel go to the Spline sub-object level, if necessary.

24. Select the spline.

It turns red in the viewport.

25. In the numeric field next to the Outline button enter the value 0.075 and press ENTER. (It's not necessary to click the Outline button.)

26. Go to the Vertex sub-object level of the shape.

27. Zoom in to the top of the bottle.

After outlining the profile, the inside of the bottle has some distortion and is excessively detailed.

28. Select the four vertices on the inside, as shown in the following illustration.

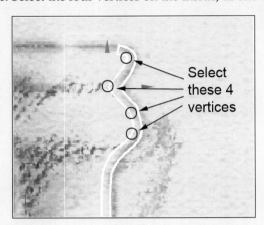

29. Click the Delete tool in the geometry rollout.

After deleting the extra vertices, adjustments to the curvature are necessary.

30. Select the second vertex from the top on the inside of the bottle.

31. Move the bottom vertex handle so the inside profile looks something like the following:

32. Pan down the profile until you get to the first notch in the bottle, just below the bottle neck. It has two vertices.

The notch on the outside of the bottle has created a notch on the inside that should not be there.

33. Select the upper vertex on the inner notch and delete it.

34. Convert the remaining vertex to a Bezier type and adjust it as shown.

35. Repeat this process for the notch located above the base.

36. Save your file as *My Bottle Profile.max*.

Using Shape Modifiers

Several modifiers can be used with shapes. Here are some of the more common modifiers and the results they produce.

Extrude

Extrude is a fairly straightforward modifier. It allows you to take an open or closed shape and create a 3D object with a thickness.

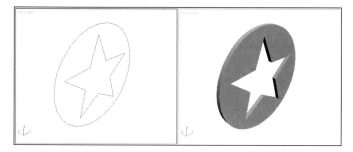

A medallion created with Extrude

Lathe

Lathe is also a fairly straightforward modifier but normally requires some adjustment to get the desired result. Lathe takes a profile, such as that of a bottle, and rotates it about an axis.

Lathe rotates about an axis that goes through the pivot point of the shape. You can set the axis of revolution to X, Y, or Z, and adjust the location of the axis in the modifier.

Bevel

You can use the Bevel modifier instead of Extrude when you need to produce geometry with angled or curved edges. Objects in reality that might appear to be simple extrusions do in fact have subtle rounded or angled edges at their ends. Beveled edges conveniently catch highlights generated by light sources in the scene.

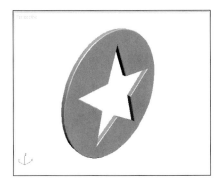

A medallion created with Bevel

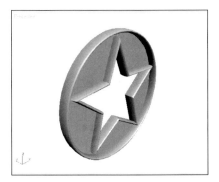

From the same shape used in the medallion above, a curved medallion with a recessed area can be created with changes to the values of the Bevel modifier.

Modeling

Bevel Profile

Bevel Profile works like Bevel but uses a profile or path instead of entered values to generate a 3D object.

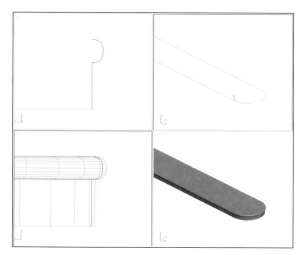

Bevel Profile can be used to create a relatively simple form like this gas bar island. The rounded rectangular base is shaped to fit the profile.

An organically shaped basin can also be created with Bevel Profile.

Sweep

The Sweep modifier takes a profile and extrudes it along a path. You can use built-in profiles or draw a profile of your own.

A complex floor structure platform is quickly created with the Sweep modifier.

Exercise 4: Using the Lathe Modifier

1. Open the file *Bottle and Can Profile.max*.

These profiles were previously created; you'll turn them into 3D geometry using Lathe.

2. Select the Can Profile object on the left side of the Perspective viewport.

3. Go to the Modify panel, and from the Modifier List choose Lathe.

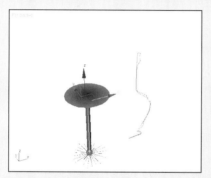

The Lathe modifier has been applied but did not produced the anticipated results. Lathe has rotated the profile about the Z axis of its pivot point, where the desired axis is the minimum edge (left side) of the profile.

4. Click the Min button in the Align group of the Parameters rollout (Min is short for Minimum).

The top of the can is distorted as a result of the core vertex of the can not being welded.

5. Turn on the Weld Core option to remove the rendering problem at the top of the can.

6. Select the Bottle Profile object.

7. Apply a Lathe modifier.

8. Click the Min button in the Align group of the Parameters rollout.

9. Verify that Weld Core is on.

The two geometric objects are complete.

10. Make the Perspective viewport current and press **F3** to switch to wireframe mode.

11. Select the lathed can and then press the **7** key on the keyboard to make the face counter active in the viewport.

The face counter shows the number of faces that the selected object uses. It is better to keep the face count low while preserving good rendering quality.

12. With the can still selected go to the Line level in the modifier stack.

13. Click the Show End Result button . This lets you see the completed 3D object as you edit the profile.

14. On the Interpolation rollout change the Steps value to 2.

15. Go to the Vertex sub-object level.

16. Select the vertex at the middle of the profile of the can.

17. Click the Delete button on the Geometry rollout.

18. In the modifier stack select the Lathe level of the can.

19. Change the Segments value to 24.

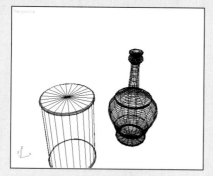

The face count should now be 672. You have managed to reduce the number of faces and improve the appearance of the object. If this object was in the distance you would make further adjustments to their values to further reduce face count.

If you have time, make similar adjustments to the bottle object.

Exercise 5: Creating a Medallion with Bevel

1. Open the file *Bevel Medallion.max*.

2. Select the shape and go to the Modify Panel .

3. From the Modifier List choose Bevel.

4. Under Level 1 set both Height and Outline values to 1.0.

5. Turn on Level 2 and enter a Height value of 8.0, leaving the Outline value at 0.0.

6. Finish by turning on Level 3 and entering a Height of 1.0 and an Outline value of -1.0.

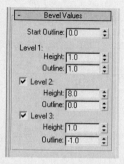

7. Zoom in on the Left viewport to see the profile of the medallion more clearly.

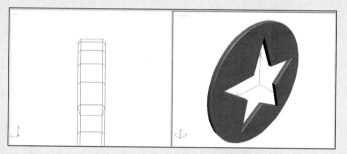

Compare the profile to the level values you entered. Positive Height values produce added thickness; positive Outline values produce a larger radius; and negative Outline values produce a smaller radius.

8. Reset all the level values to 0.0. You will try another bevel that will produce an relief medallion.

9. Set the Level 1 Height value to 10.0 and leave Outline at 0.0.

10. Leave the Level 2 Height value at 0.0, and set the Outline value to -5.0.

11. Set the Level 3 Height value to -8.0, and leave outline at 0.0.

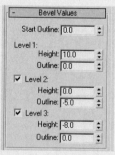

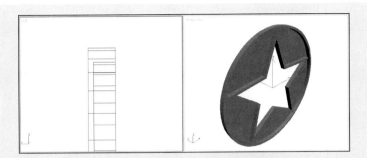

12. In the Surface group of the Parameters rollout, choose the Curved Sides option.

13. Change the Segments value to 4.

14. Finish by turning on Smooth Across Levels.

The changes to the parameters produce an interesting curved form.

Exercise 6: Re-creating the Gas Station Island with Bevel Profile

1. Open the file *Gas Station Island Curb.max*.

 In this exercise you'll replace the existing gas station island with a more-detailed object that has a bull-nosed edge at the top. You'll use Bevel Profile to create the new object.

 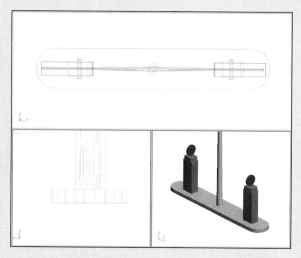

2. On the Create panel, click Shapes > Rectangle.

3. In the Top viewport drag a rectangle to approximately encompass the existing island.

4. Go to the Modify panel and adjust the Corner Radius value so it rounds off the two ends of the island. A value of about 20 units should work well.

The new rectangle with its rounded corners approximately follows the existing island base.

5. In the Left viewport, zoom in on the right side of the base of the island.

6. Draw a line with three corner vertices: one at the bottom, another two-thirds of the way to the top, and the last at the top.

 Use SHIFT to help you draw the line straight.

7. Go to the Modify panel, and go to Vertex sub-object level.

8. Select the two top vertices of the new line.

9. Right-click the vertex and choose Bezier Corner from the quad menu.

10. Select the topmost vertex, and activate the Select And Move tool.

11. Adjust the handles as shown in the following illustration.

12. Click the second vertex from the top and adjust its handles as shown in the following illustration.

13. Exit the sub-object level.

14. Select the Gas Island Curb object and delete it.

15. Select the rectangle shape you just created, and from the Modifier List choose Bevel Profile.

16. Click the Pick Profile button.

17. Click the profile you just created in the Left viewport.

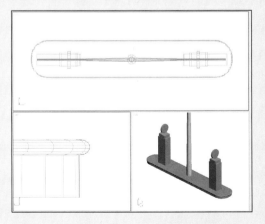

The new gas island base with bull-nosed top is complete.

Exercise 7: Using the Sweep Modifier to Create a Wainscoting

1. Open the file *Walls Doors and Windows.max*.

In this file you will draw a spline and use Sweep to create wainscoting along the wall.

2. Activate the Line tool from the Create panel > Shapes category.

3. Right-click the Snaps Toggle on the main toolbar.

4. On the dialog that opens, turn on Vertex only and then dismiss the dialog by clicking the X button on the title bar.

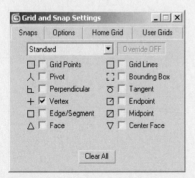

5. Click the Snaps Toggle on the main toolbar to turn on Snaps mode. The button turns yellow.

6. Draw a line along the inside base of the wall to create a straight L-shaped line. When setting the corner of the L, be sure to pick the vertex at the inside corner of the wall.

7. Expand the Top viewport to fill the viewport area. An easy way to do this is to activate the viewport and then press ALT+W.

8. Press **S** to turn off the Snaps Toggle.

9. On the Modify panel, go to the Segment sub-object level.

10. Select the segment along the long wall.

11. Click the Refine tool and select points along the wall where the spline intersects the window and door frame.

12. Click the Refine tool again to exit the Refine mode.

13. Select the two segments under the door and window and delete them.

14. Exit the Segment sub-object level and return to a four-viewport configuration (press ALT+W again).

15. Click the Select And Move button on the main toolbar.

16. Right-click the Select And Move button. The Transform Type-In dialog opens.

17. Enter 42 in the Absolute World Z value field to move the line up to a height of 42 units.

18. If you have trouble creating the spline you can open the file called *Sweep.max*.

19. Make sure the line is selected. From the Modifier List, choose the Sweep modifier.

20. On the Section Type rollout, open the Built-In Section list and choose Half Round.

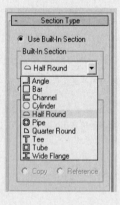

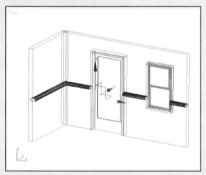

You'll need to make some adjustments to orient and size the Half Round preset properly.

21. On the Parameters rollout change the Radius to 1.0.

22. On the Sweep Parameters Rollout change the Angle value to -90.0.

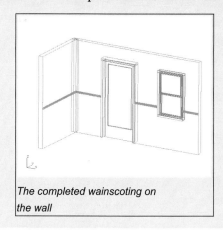

The completed wainscoting on the wall

Summary

In this lesson, you learned about creating and modifying shapes, splines, and modifiers that use shapes as a basis of geometry creation. You have learned about the basic elements that make up a shape. You have worked though several exercises that have developed your skills in shape creation, and modifying shapes at the object and sub-object levels. Finally, you saw how to put shapes to work in the creation of 3D geometry, by applying modifiers such as Lathe, Bevel, and Sweep.

Modeling

Using Compound Objects

In this lesson, you'll learn about a set of creation tools known as compound objects. Typically, a compound object is created by combining two or more objects. The compound object types covered in this lesson are Boolean, Loft, and Scatter.

Objectives

After completing this lesson, you will be able to:

- Union, subtract, and intersect objects using Boolean operations.
- Create complex forms using the Loft tool.
- Use the Scatter tool to distribute one object over another.

Booleans

Booleans are compound objects that work with operations based on the volume of the objects being used. In this lesson you'll explore three types of Boolean operations:

- Subtractions – the intersecting volume of one object is removed from the other.
- Intersections – the common volume of two objects create a resultant geometric object.
- Unions – the whole volume of both objects becomes one object. Edges and faces of the two objects are clearly defined.

The Boolean object is found on the Create panel, under Geometry > Compound Objects.

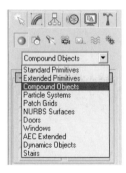

Subtraction

You use Boolean subtraction to remove part of an object's volume.

Three volumes were subtracted from this beveled shape shown above: the square hole in the center and the two cylindrical holes on the side.

Intersection

You use Boolean intersection to find the area common to two objects. It can be used to create a new object that is the resultant of two objects. You can also use it for interference checking.

Volumes before a Boolean intersection

The result of Boolean intersection. Only the common volume is retained.

Modeling

Union

A Boolean union combines two or more separate volumes and removes excess faces. In addition, it creates correct edges where the volumes intersect.

Shown below are two intersecting volumes before a Boolean union operation. Note the rendering artifacts where the top faces intersect and the irregular rendered line along the inside edge.

The two volumes render much better once they are unioned.

Exercise 1: Using Booleans to Create a Building Shell

1. Open the file *Gas Station Shell.max*.

The scene contains two wall shells extruded from 2D splines. In this exercise you'll use the box objects in the scene to subtract window and door openings.

2. Select the Upper Walls object on the right side of the User viewport.

3. Go to the Create panel and in the Geometry category choose Compound Objects from the drop-down list.

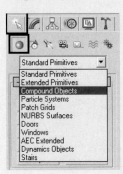

4. On the Object Type rollout, click the Boolean button.

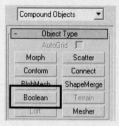

5. Make sure Operation is set to Subtraction (A-B).

6. Click the Pick Operand B button.

7. Select the Open01 object that defines the positive volume of the garage door opening.

The positive volume of the garage door opening now forms a negative space in the wall: the opening.

8. Click the Select tool ⬚ to exit the Boolean operation, and then select the Lower Walls object.

9. Click the Boolean button and verify that Subtraction (A-B) in the Operation group is active.

10. Click Pick Operand B and select the Open2 object (box). You now have a door opening in the lower section of the building.

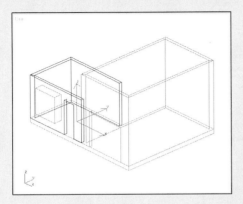

11. Click the Select tool again to exit the Boolean operation.

12. Make sure the Lower Walls object is still selected.

13. Click the Boolean tool and verify that Subtraction (A-B) in the Operation group is active.

14. Click Pick Operand B and select the Open3 object (box), which defines the window opening.

15. Click the Select tool again to exit the Boolean operation.

Note: you can also press **Esc** to exit the Boolean operation.

16. In the User viewport press **F3** to switch to Smooth+Highlights display mode.

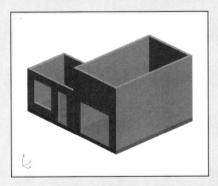

The openings in the two walls parts have been successfully completed.

17. Select the Lower Walls object and click the Boolean tool.

18. Change the Operation to Union.

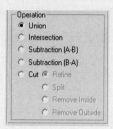

19. Click the Pick Operand B button.

20. Select the Upper Walls object. The two wall objects are now combined into one.

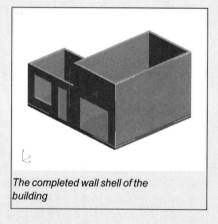

The completed wall shell of the building

21. Press **Esc** to exit the Boolean operation.

Lofts

A Loft object is a compound object that uses existing shapes to generate 3D geometry. A Loft operation requires both a path and a shape. Lofts can produce objects with a high degree of complexity.

The power of Loft objects lies in the ability to change shapes in their construction process. In following illustration, a screwdriver blade is created by transitioning from a circle to a rectangle.

Another example where a Loft can create an unusual form which would be difficult to create otherwise. In this case both a square and circle are used as shapes. A scale deformation is used to adjust the size of the profile.

The Loft tool is found on the Create panel, under Geometry > Compound Objects.

Drawing Paths and Shapes

When you create a Loft you will need to first create a path and one or more shapes. Following are several considerations when creating these objects:

- Paths and shapes can be open or closed.
- When drawing a straight path set Drag Type to Corner; this avoids accidentally creating a Bezier vertex.
- Your path should generally not have corners with a sharper radius than the radius of your shape. Otherwise a corner with overlapping vertices is created.
- A Loft can use multiple shapes along the path.
- Shapes used in a loft can have multiple splines.

A simple loft with a curved path. The indicated areas show overlapping vertices that would probably not render well.

A Loft with a multiple spline shapes

Alignment and Pivot Points of Shapes

When you create a shape for a loft and use transformation commands and/or spline editing commands, the alignment of the shape and the location of the pivot point may be altered. You may find that you need to rotate or move the shape or it's pivot point once it is part of the loft.

A Loft passes through the pivot point of the shape.

Multiple Shape Lofts and the First Vertex

When you work with multiple shapes in lofts, you inevitably encounter situations where the shapes on a loft are not properly aligned. You can fix those problems using the Compare tool.

A twisted Loft usually points to a problem where the two shapes in the loft have misaligned first vertices.

Once a Loft is created you can use the Compare Tool at the Shape sub-object level to check the locations of first vertices.

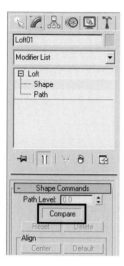

The Compare tool shows the locations of the first vertex for each shape. When the vertices are not aligned, the Loft becomes twisted.

The multi-shape loft with first vertices properly aligned

Shape Steps and Path Steps

The Skin Parameters rollout allows you to control the number of faces used in the creation of Lofts. Other important parameters can also be found in this rollout.

Shape Steps controls the number of faces around the loft, while Path Steps controls the number of steps along the path.

Deformation Grids

You can use deformation grids in lofts to produce interesting 3D geometry. There are five deformation grids: Scale, Twist, Teeter, Bevel, and Fit.

Modeling

The Scale Deformation grid is particularly powerful and will be discussed in this lesson.

The Scale deformation grid allows you to change the shape size along the length of the path.

The scale deformation grid becomes even more flexible when you scale differently in the X and Y directions.

Exercise 2: Creating a Lofted Lamppost

1. Open the file *Lamppost.max*. The scene contains a simple lamppost that needs to be replaced with a better model, which you'll build using the Loft tool.

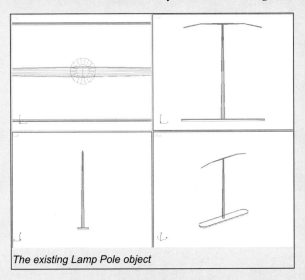

The existing Lamp Pole object

2. In the Top viewport, draw a Rectangle while holding down the CTRL key, to create a square the approximate size of the base of the post.

You'll use this shape the base of the post.

3. Still in the Top viewport, create a Circle the approximate size of the circle at the top of the existing post.

The Circle profile will be used at the top of the post.

4. Maximize the Front viewport.

5. Click the Line tool and on the Creation Method rollout set both Initial Type and Drag Type to Corner.

Setting these to Corner ensures the created spline will have no curves.

6. Click the first point at the base of the existing post.

7. Hold down the **SHIFT** key and click a point at the top of the pole. Right-click to end the creation process.

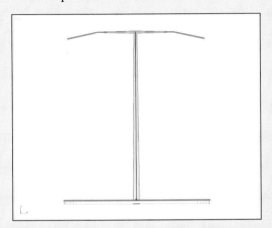

When you draw a path, the first point defines the first vertex and therefore the direction of the Loft.

8. Return to a four-viewport configuration.

9. Make sure the line you just created is selected.

10. Go to the Create panel > Geometry category and choose Compound Objects from the list.

11. Choose the Loft tool from the Object Type rollout.

12. On the Creation Method rollout click the Get Shape button.

13. Select the square shape you created previously.

The loft is displayed in the Front viewport.

14. Make sure the Loft01 object is still selected.

15. Right-click in the User viewport, and then click Zoom Extents Selected 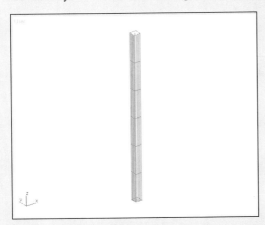 on the Zoom Extents flyout in the bottom-right corner of the screen.

The Loft is now displayed in the User viewport.

16. With the Loft object still selected, go to the Modify panel.

17. On the Path Parameters rollout change the Path value to 100.0.

The Path value establishes the location of the shape. The first shape acquired was placed at path location 0%, which is the start of the path. You will place the other shape at 100%, which represents the end of the path.

18. On the Creation Method rollout, click Get Shape again.

19. Click the Circle in the Top viewport.

20. Maximize the User viewport to see the new loft clearly.

The post looks pretty good but a few adjustments will make it better.

21. Open the Skin Parameters rollout.

22. Change the Shape Steps value to 3 and the Path Steps value to 10.

23. Minimize the User viewport, and right-click in the Top viewport to make it active.

24. Click the Zoom Extents Selected button to frame the selected object in the viewport.

The Top viewport showing the twisting of the mesh. This is usually a result of misaligned first vertices.

25. On the Modifier panel, go to the Shape sub-object level of the Loft.

26. On the Shape Commands rollout click the Compare button.

27. On the Compare Dialog click the Pick Shape button 🐦 .

28. Click the Circle at the top of the Loft object in the viewport. A circular shape appears in the Compare window.

29. Click the rectangle at the base of the loft.

30. Click the Zoom Extents ![icon] button at the bottom of the dialog.

The Compare dialog now shows both shapes used in creating the Loft and the first vertices of each.

31. Click the Select And Rotate button on the main toolbar.

32. In the Top viewport select the circle shape in the loft.

33. Click the Angle Snap Toggle ![icon] button.

34. Rotate the shape 45 degrees on the Z-axis, or until the first vertex of the circle in the Compare window is aligned with that of the square.

As you rotate the shape you will see the shape's position update dynamically in the Compare window. After you commit to the rotation the mesh will update.

Exercise 3: Creating the top of the Lamppost using a Scale Deformation grid

1. Open the file *Lamppost Top.max*. In this scene you will create the top part of the Lamppost. The Lamppost base has been properly positioned and the shape and path for the top are already drawn.

2. Select the spline named Top Path 01, go to Create panel > Geometry, and choose Compound Objects from the drop-down list.

3. Click the Loft button.

4. Click the Get Shape button and select the circle in the Top viewport.

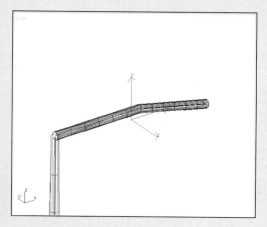

The basic Loft has been created. You will now use a deformation grid to adjust the size of the shape.

5. Go to the Modify panel. At the bottom of the panel, expand the Deformations rollout.

6. Click the Scale button. A floating dialog appears.

The Scale Deformation grid shows you a Scale Percentage line along the length of a path.Intermediary vertices on the path are indicated on the graph by green vertical dashed lines. In this case, there's only one.

7. Click the Insert Corner Point ⊬ button on the Scale Deformation dialog.

8. Click the Red Line where it intersects the green vertical dashed line.

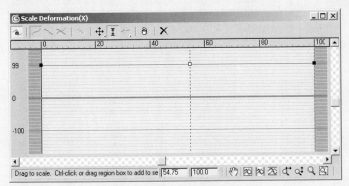

An inserted point along the scale deformation line

9. Click the Scale Control Point button ⏉ .

10. Drag the point you just created down to the 70% line.

With the changes made on the center control point, notice how the size of the lamppost arm is noticeably smaller.

11. Drag the rightmost control point down to approximately 30%.

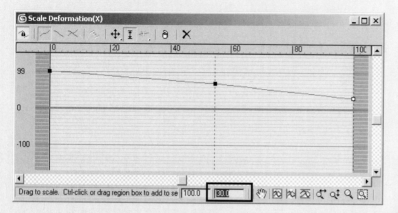

You can modify control points more accurately by entering values in the edit boxes at the bottom of the dialog.

12. Dismiss the Scale Deformation dialog.

13. You can complete the Lamppost by mirroring the right arm to the left.

Scatter Tool

The Scatter tool is used to distribute one object over another. It can be used whenever a multitude of objects are required over the surface of another object, such as rocks or trees over a landscape.

Distributed conifer trees over an uneven terrain

Distributed sphere object over the surface of a head.
Here, a sphere is placed on each vertex and the distribution object (head mesh) is hidden.

A random distribution of spheres on the surface of the head with the head mesh still visible

The Scatter object is found in the Create panel > Geometry > Compound Objects.

Modeling

Exercise 4: Distributing Cactus Trees on a Terrain

1. Open the file *Gas Station Surroundings.max*. In this scene you will distribute cactus trees over the ground surrounding the gas station.

2. In the User viewport select the object Cactus01. It is the cactus on the right side of the viewport.

3. Go to the Create panel > Geometry > Compound Objects and click the Scatter button.

4. Click the Pick Distribution Object button.

5. Click the Ground object.

In the shaded views, note that the ground takes on the color of the cactus. In fact the Scatter tool has created a new object called a distribution object, which is part of the Scatter object and can be hidden.

6. Scroll down to the bottom of the command panel, expand the Display rollout, and turn on Hide Distribution Object.

Hiding the distribution object allows the original object to show through. It makes it easier to apply materials, or if you desire to hide the original object as well.

7. On the Scatter Objects rollout > Source Object Parameters group, change Duplicates to 100.

Note: It is important to keep the number of duplicates to a reasonable level. Using Scatter can rapidly increase scene complexity.

8. Zoom out of the Top viewport until you see the entire ground area.

The cactus trees at this scale look like small dots. Note the distribution pattern is mostly regular.

9. In the Distribution Object Parameters group, set Distribute Using value to Random Faces.

The distribution of cactus trees is much more random now.

10. In the Uniqueness group of the Display rollout, click the New Seed button a few times to change the random locations of the cactus trees.

It might be attractive to have a cactus in the foreground in the Perspective viewport. Scatter does not allow control of individual objects but you can change the Seed value until you get something satisfactory.

You can change the Seed value with the spinner, by numerical entry, or with the New button.

11. Set the Seed value to 12412.

12. In the User viewport zoom and pan around the scene until you find a cactus on a hill of the Ground object.

The cactus trees are perpendicular to the surface where they are located.

13. In the Distribution Object Parameters group, turn off Perpendicular.

14. On the Transforms rollout, change the Z rotation to 60 degrees.

Changing the Rotation value allows variety in the rotation of the cactus trees, in this case on the Z-axis.

15. Change the X Scaling value to 25, and turn on Lock Aspect Value.

Changing the X value produces a variation in the size of the cactus trees.

After a few changes the cactus trees are well distributed.

Summary

In this lesson, you learned how to use compound objects to create some relatively complex objects. First, you looked at the Boolean tools to create objects through adding, subtracting and intersecting objects together; then you created objects using the Loft tool. Finally, you used Scatter to distribute an object over a landscape.

Modeling Lab

3D modeling is a difficult process that takes practice to master. Depending on the subject you are trying to model, whether it is a character, or a complete environment the difficulty level will vary. When modeling you need to decide what type of modeling technique or surface type to use. You might start with a basic primitive and edit it with the help of an Edit Poly modifier. Alternatively, you might choose to use patches because of their Bezier curve controls, useful for modeling objects such as cars.

In this lesson, you will use various modeling techniques to build an underwater scene. As you work through the steps in this lesson, you will experience how to develop a project like this.

Objectives

After completing this lesson, you will be able to:

- Create simple 3D environments.
- Use different modifiers to affect objects.
- Build objects from simple geometry.
- Name objects.
- Merge objects from one scene into another.

Creating an Underwater Scene

In this lab, you will create an underwater scene. This is a useful exercise in learning how to create this kind of environment. In addition to modeling, creating a convincing underwater scene requires the proper lighting. At the end of the exercise, you will merge a light setup from another scene into the environment. The lights will illuminate the scene and simulate the effect of caustics, adding realism to the scene.

The completed geometry for the underwater scene

Exercise 1: Creating the ocean floor

1. Start or reset 3ds Max.

2. Open the file named *Underwater_Start.max*.

 The file shows a dummy object in the scene. There is also a camera that is hidden from view.

3. Right-click in the Top viewport to make it active.

4. On the Create panel > Geometry group, click the Plane button.

5. In the Top viewport, drag out a plane object that fits inside the dummy object.

 Don't worry about the size; you will adjust that in the next step.

6. Go to the Modify panel 🖊 . On the Parameters rollout, set Length to 250, Width to 250, Length Segs to 50, and Width Segs to 50.

7. With the plane selected, choose the Quick Align tool 🖐 from the Align flyout on the main toolbar, and then click the dummy object.

 This matches the position of the plane to that of the dummy.

8. Right-click the Perspective viewport to activate it, and then press **C** on your keyboard to switch it to camera view.

 Your Camera viewport should resemble the following illustration.

9. Select Plane01, if necessary, and then go to the Modify panel and rename it *Ocean_Floor_01*.

10. From the Modify panel > Modifier List drop-down, choose Noise.

11. On the Parameters rollout, set Scale to 50 and Strength > Z to 20.

12. From the Modify panel > Modifier List drop-down, choose Edit Poly. In the next steps, you will add some interesting details to the sea floor to make it more irregular.

13. On the main toolbar, choose Paint Selection Region from the Selection flyout.

14. On the Modify panel > Selection rollout, click Vertex .

15. Right-click the Top viewport to make it active, and then press F3 to display the viewport in shaded mode.

16. On the Main toolbar, choose the arrow icon representing the Selection tool .

17. In the Top viewport, drag with the left mouse button held down and start "painting" to select vertices.

If you release the mouse button but still want to add vertices to the selection, be sure to press **CTRL** when dragging again.

18. On the Modify panel > Soft Selection rollout, turn on Use Soft Selection.

Note: This affects the action of Move, Rotate, and Scale at the sub-object level of the modifier. When Use Soft Selection is on, 3ds Max applies a falloff from the selected sub-objects to the unselected sub-objects.

19. If you click the Shaded Face Toggle button, 3ds Max displays a color gradient corresponding to the soft selection weights on faces within the soft selection range. The viewport should be set to a shaded view (**F3** toggle) for this to take effect.

20. On the Modify panel > Paint Deformation rollout at the bottom of the panel, click the Push/Pull button.

In the Camera viewport, note that your cursor has changed into a light blue circle. start painting on selected vertices by clicking and dragging on the plane. This moves the vertices on the surface in the direction of the brush icon (pull). The direction and extent of the push or pull effect is determined by the Push/Pull Value setting.

21. Set the Push/Pull value to 2.0.

Note: You can also control the deformation by a click and paint (Pull) or holding down the keyboard **CTRL** key while performing a click and paint (Push). You can also change the radius of the circular brush with the Brush Size setting or holding down the Keyboard **CTRL+SHIFT**

keys. Only the sub-objects under the brush circle are deformed. Try adding some detail to the plane to obtain a more irregular terrain.

At the object level, Paint Deformation affects all vertices in the selected object. At sub-object levels, it affects only selected vertices and recognizes soft selection.

22. From the Modify panel > Modifier List drop-down, choose the TurboSmooth modifier. This smoothes the result by adding faces and blending the result.

23. In the TurboSmooth modifier > TurboSmooth rollout > Main group, Amount rollout, set the Iterations to 2.

The Ocean Floor mesh is complete.

Exercise 2: Adding Rocks

When modeling an environment, it is important to maximize your productivity. For example, if you are modeling rocks, you do not want to model dozens of rocks if you don't have to. Instead, you can create duplicates or "clones" of objects. After cloning an object you can add variety by transforming an object or adding a modifier.

1. Continue working on your scene or open the file *Underwater_WIP_01.max*.

2. On the Create panel, choose Geometry > Sphere.

3. In the Top viewport, click and drag to create a sphere.

4. With the sphere selected, go to the Modify panel and rename the sphere *Rock_01*.

5. Set the Radius to 20.0 and the Segments value to 60.

6. From the Modify panel > Modifier List drop-down, choose Noise.

7. On the Noise Parameters rollout set Noise > Scale to 50.0.

8. Turn on Fractal, and set Strength > X/Y/Z all to 20.0.

9. On the main toolbar, click to activate the Select And Scale tool [icon].

10. In the Camera viewport, click and drag downward on the Z axis to scale the sphere to a more flattened shape.

 You have built the first rock. At this point it is time to make clones of the flattened rock and begin building the basic scene.

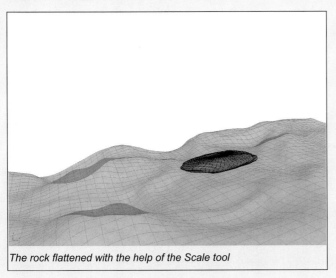

The rock flattened with the help of the Scale tool

11. On the main toolbar, click to activate the Select And Move tool ⟡.

12. With the rock selected, hold the **SHIFT** key down, and then click and drag upward on the Z axis.

This creates a new rock on top of the existing one.

13. On the Clone Options dialog choose Instance and set Number Of Copies to 3.

By using the Instance method, you make sure that the newly created rocks maintain identical parameters. Adjusting the parameters of one rock on the Modify panel updates all other instances of that rock as well.

14. Use the transform tools—Move, Rotate, and Scale—to provide irregularity among the rocks as shown below.

15. Select the cluster of rocks you created. Use **SHIFT**+Move to clone the rocks using the Instance method to create a few more clusters scattered on the ocean floor.

As mentioned earlier, using instances creates a live link between the individual rocks. To change the shape of an individual rock without affecting its clones, you would need to make it independent.

16. Select any rock object. On the Modify panel, below the modifier stack, click the Make Unique button. The selected rock is now independent.

17. With the rock still selected, on the Noise modifier > Parameters rollout, change the Noise > Seed value to 3. Try other values and notice how the rock's shape changes each time you change the value.

Once you are done, you will have a scene that may look similar to the illustration below. It is good practice to make a selection set of all the rocks, making it easier to select them later. Doing so will help you hide or unhide the rocks quickly, or to apply a single material to a selection of objects.

18. Open the Select Objects dialog by pressing the **H** key.

Select all the rock objects in the list and then click the Select button to close the dialog.

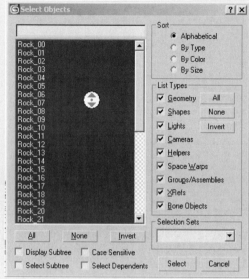

19. On the main toolbar, click in the Named Selection Set type-in, type Flat Rocks, then press **ENTER.**

From this point, 3ds Max will remember the Flat Rocks selection. Every time you need to select the rocks, you can do so easily by choosing the Flat Rocks entry from the Named Selection Set drop-down.

Exercise 3: Adding Complex Rock Formations

1. Continue from the previous section or open the file *Underwater_WIP_02.max*.

2. On the Create panel, choose Geometry > Torus.

3. In the Front viewport, create a torus with Radius 1=10.0, Radius 2=2.0, Segments=60.

4. On the Modify panel, turn on Slice On.

5. Set Slice From=90.0 and Slice To=270.0. This leaves half of the torus, as shown below.

6. Rename the object Big_Rock_01.

7. From the Modify panel > Modifier List drop-down, choose FFD 4x4x4.

8. In the modifier stack, expand the FFD 4x4x4 modifier and click the Control Points sub-object label.

9. Right-click in the left viewport and press **P** to change to Perspective view.

10. In the Perspective viewport, adjust your viewpoint to get a better look at the object.

11. Select the yellow control points as shown in the following illustrations.

 You can also select points using a region selection.

 Note: FFD stands for "free-form deformation." Its effects are used in computer animation for things like dancing cars and gas tanks. You can also use it for modeling rounded shapes such as chairs and sculptures.

12. From the Modify panel > Modifier List drop-down, choose Noise.

Modeling

13. In the Noise Modifier, Parameters rollout, Set the Noise Scale to 20.0, turn on Fractal, set Iterations to 6.0, and set the Strength > X/Y/Z to 5.0.

By adding the Noise modifier after the FFD 4x4x4 modifier, you have created a new kind of rock formation that you can clone and alter by moving FFD control points, or by changing the seed, scale and strength values of the Noise modifier parameters. Create one or two clones of the rock formation with different shapes to see what you can come up with. When cloning in this case, you will want to use the Copy option as opposed to the Instance option because you will then make the changes at the modifier level. You'll find a finished version of this scene in the file *Undersea_WIP_03.max*.

Exercise 4: Lighting Setup

Because of the nature of an underwater environment, the scene will need lighting that creates a realistic look. In this lesson, you will merge lights from another file to apply the finishing touch. The file from which you'll merge contains a setup of lights that simulates the effect of underwater caustics.

1. Continue from the previous section or open the file *Underwater_WIP_03.max*.

2. From the menu bar, choose File > Merge, and open the *Lights_Setup.max* file.

3. On the Merge dialog, highlight all the lights and click OK.

4. From the menu bar, choose Rendering > Environment.

5. On the Environment and Effects dialog > Atmosphere rollout, in the Effects list, click Volume Light Caustic.

When you click an entry in the list, more options are made available on the dialog. You will need to scroll down the Environment dialog to see the newly available rollouts.

6. On the Volume Light Parameters rollout, click the Pick Light button and then press **H** on your keyboard to access the Pick Object dialog.

7. On the Pick Object dialog, click Light_Direct01_Volume, Light_Direct02_Volume, and Light_Direct03_Volume.

8. Click Pick to accept the selection and exit the dialog.

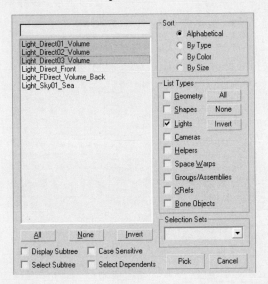

9. In the Atmosphere rollout > Effects list, click Volume Light Back.

10. On the Volume Light Parameters rollout, click the Pick Light button and press **H** on the keyboard.

11. In the Pick dialog, click Light_FDirect_Volume_Back and click the Pick button.

12. Render the scene 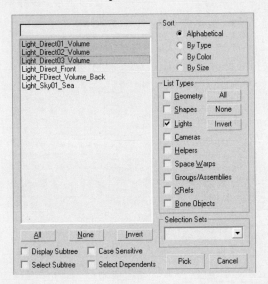.

Depending on your computer hardware it may take some time to render this scene due of the calculation of the volume light effects. Volume lights can significantly add to the render time of an image, so use the effect only where you feel it is absolutely necessary, as is the case here.

Summary

With minimal effort, you created a simple underwater environment. If you want, you can add more detail such as vegetation, plankton and other underwater life forms, using this lesson as a starting point. You learned that naming your objects properly when you are working makes it easier for you or someone else to work on your scenes. This is crucial in a collaborative environment. You have also learned that instancing objects that use similar shapes can make it easier to work with those objects. Using instances can help you change these objects quickly, changing them all by updating one instance.

Try to fill the environment with more detail. Keep in mind that a larger environment can take more time to fill. As a method of learning, start small and grow your scenes as your skills improve. Don't try to start too big; it might take more time than you have, resulting in scenes that don't meet your expectations.

In this lesson you created the basis of what will be a complete environment after materials and textures are applied to the models. In a later lesson, you will add textures to this scene.

Animation

The Animation chapter contains three theory lessons and one lab. The theory lessons explain some basic animation techniques and terminology, as well as hierarchies and relationships between objects. One lesson is dedicated to the use of Biped, a character animation tool included in 3ds Max. Biped automates the creation of a skeleton that goes inside the body of the character you want to animate.

In the animation lab at the end of the chapter, you will animate various pieces of a chess board.

- Lesson 10: Animation Basics
- Lesson 11: Hierarchies
- Lesson 12: Character Animation with Biped
- Lesson 13: Animation Lab

Animation Basics

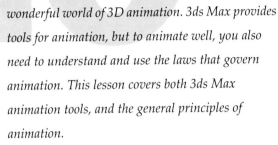

This lesson will help you better understand the wonderful world of 3D animation. 3ds Max provides tools for animation, but to animate well, you also need to understand and use the laws that govern animation. This lesson covers both 3ds Max animation tools, and the general principles of animation.

Objectives

After completing this lesson, you will be able to:

- Understand the process of animation
- Save and modify keyframes
- Animate different types of objects efficiently
- Work with the Track View editor
- Have a better understanding of animation principles

History of Animation

People have always told stories. Animation, like filmmaking in general, is one way of telling a story.

But what is animation? It is a sequence of images, with slight differences from one image to the next, that gives the impression of movement.

Here are some key developments in the history of animation:

- In 1826, one of the first animation gadgets was the thaumatrope. It consisted of a disc with an image painted on each side: a bird and a cage. You would crank it using a string, and when you released the disc it would spin, and the bird would appear to be inside the cage.

- Later, in 1874, Eadweard Muybridge was hired by a California governor to see whether or not a trotting horse ever had all four feet off the ground. The California governor needed the proof to settle a bet. Muybridge, with a series of photographs, proved that a trotting horse does indeed have all four hooves off the ground at a certain time. His photographic sequences were one of the origins of motion pictures.

- In 1913, Felix the Cat was one of the first animated cartoons to hit the big screen, and by far one of the most popular of its time.

- Then in the 1920s, Disney combined animation with sound; shortly after, Mickey Mouse was born. His studio also created feature-length animations.

- Much later, in 1974, computer animation was employed in "Hunger," a short computer-graphics (CG) movie.

- In 1995, Pixar Animation Studios, in collaboration with Disney, created Toy Story, the first full-length CG movie.

Today, 3D animation has taken the place of traditional, hand-drawn animation as a cheaper, faster, and more efficient way of animating characters. With specialized television cartoons broadcasting around the clock, along with the movie and the gaming industries, 3D animation seems to be the way to go.

The basic principles of animation remain the same, where slight differences in object position from frame to frame create the illusion of motion.

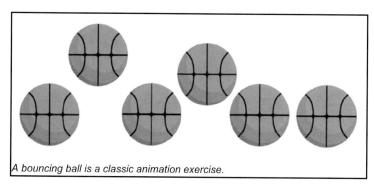

A bouncing ball is a classic animation exercise.

2D versus 3D Animation

3D animation differs from its elder sibling in that you have to deal with three dimensions instead of two. When you animate, you have to consider all angles in order to have a good understanding of your animation. Thus, the viewport configuration becomes very important.

Front and Left viewports layout

Perspective, Front, and Left viewports layout

You need to know where the positions of the limbs are going to be at all time, so they don't intersect with one another.

Time

Time is the essence of animation. When you move your hand to pick up a coffee cup, you need time to reach your goal. If the allocated on-screen time is too slow or too fast, it changes the whole meaning of the motion. Thus, time is a crucial element of animation.

In animation, the measure of time is a unit called a frame. More precisely, the measure of time is defined by the number of frames in a second of animation. Depending on your medium or geographical location, one second of animation can be equal to 24 frames (film), 30 frames (the North-American NTSC video standard) or 25 frames (the European PAL video standard). A second is still a constant measure of time, but the difference is the number of images that are shown in one second. By default, 3ds Max is set to work in NTSC mode at 30 frames per second or 30 fps.

Time is also very important to make your animation look right.

We call this timing!

The Concept of Keyframing

In the early days traditional animation, an artist would draw by hand all the images of a movie, from start to finish. Later on, the task was divided among several artists. The lead animator would draw the main positions of a character, or the "key" positions, and assistants would draw the in-between frames.

In 3D animation, the term "key" is still in use and is sometimes referred to as a keyframe. It is a value recorded on an object at a specific frame. In 3ds Max, a key is displayed as a small, colored rectangle. Red is for position, green is for rotation, and blue is for scale.

Once you have created keyframes, 3ds Max acts as your assistant and creates the in-between frames by interpolating automatically from key to key.

Exercise 1: The Bouncing Ball

1. Open the file *Basketball_Start.max*.

2. On the main toolbar, click the Select tool 🔲 to turn it on, and then click the basketball in any viewport to select it.

3. Right-click the Front viewport to activate it.

4. Near the bottom of the 3ds Max window, turn on the Auto Key button. The border of the front viewport turns red and so does the timeline. This is a reminder to let you know that you are in record mode. Now when you make a change to the scene, such as transforming an object or adjusting a numeric parameter, the change is recorded and used for animation.

5. Move the time slider by dragging it to the right until you reach frame 30.

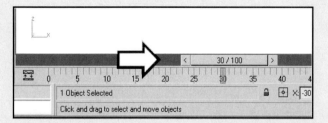

6. Activate the Front viewport and maximize the view by pressing **ALT+W**.

7. Select the basketball and then right-click it and choose Properties from the quad menu.

8. In the Display Properties group, turn on Trajectory. Click OK to close the dialog.

Trajectory displays the path of the basketball in the viewports. This can be helpful while you animate.

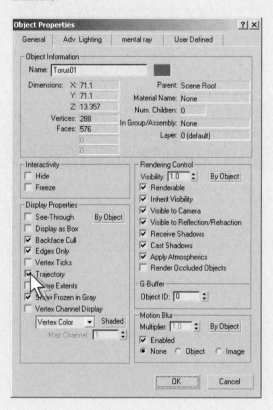

9. On the main toolbar, click the Select And Move tool ✛ to turn it on. In the Front viewport, move the ball to a point above the hoop, as shown in the illustration below.

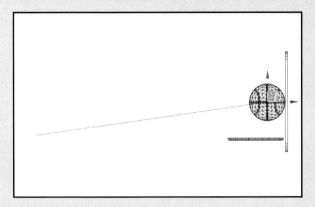

10. Drag the time slider back and forth. The basketball is now moving in a straight line. On the track bar just below the viewport, you will notice two red rectangles: these are the keys that recorded the ball's movement. In the viewport, the straight red line shows the ball's trajectory.

 Note: The trajectory is a red line with white dots. Each white dot represents a frame. A white box around a dot represents a keyframe.

11. Drag the time slider to frame 15, and then move the basketball upward so that the trajectory is more like an arc.

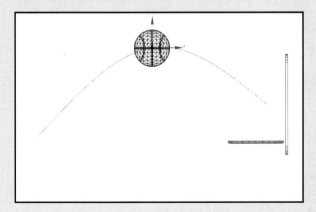

12. Go to frame 45, and move the basketball so it's just touching the floor, as shown in the illustration.

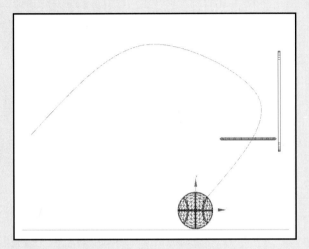

13. Now you will create the bouncing effect on the floor. Go to frame 55 and move the ball slightly up and to the left, and then go to frame 65 and move the ball down to the floor and slightly more to the left. This takes care of the first bounce.

14. Repeat the procedure to create additional bounces, each new one smaller than the previous one. Create a bounce at frames 73 and 80 (up and down), frame 86 and 92, and then finish

the sequence with a small straight line between Frames 92 and 100. Use the following illustration as a reference.

15. Turn off Auto Key mode.

16. Play the animation . The animation looks a little loose. Default interpolation sometimes results in animation that is overly smooth and looks artificial. You will adjust this in a moment.

17. Right-click the basketball and choose Curve Editor from the quad menu. The Track View window appears.

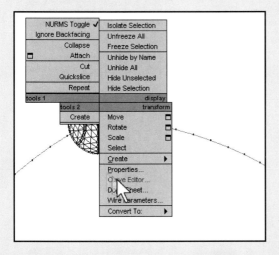

18. Reposition the Track View window so you can also see the action in the viewport.

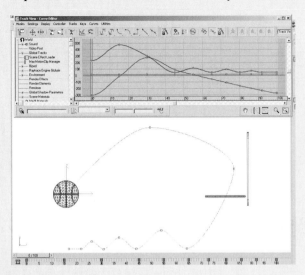

19. You will use the Track View - Curve Editor to ensure that when the basketball hits the panel or the floor, it appears to bounce off these surfaces, instead of the soft, unrealistic motion it is following currently.

On the left side of the Curve Editor window is the controller window. The controller window lists objects (and other entities) in the scene, along with their motion tracks and any controllers that have been assigned. A controller is a module in 3ds Max that controls animation.

On the right of the Curve Editor window are function curves. These show the motion of the basketball in three axes: red for X, green for Y, and blue for Z.

The first key you need to change is the X-Position key at frame 30. This is where the ball hits the backboard.

20. In the Curve Editor, scroll down in the controller window until you can see the three position tracks for the basketball. Then click the X-Position track so it is the only one highlighted in yellow. In the function curve window, only the red curve should appear.

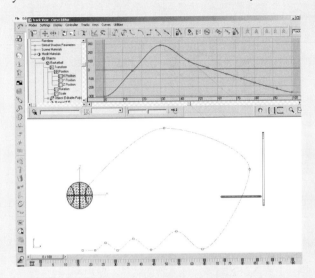

21. In the Curve Editor, click the key at the top of the curve (at frame 30) to select it. Two tangent handles appear on the key.

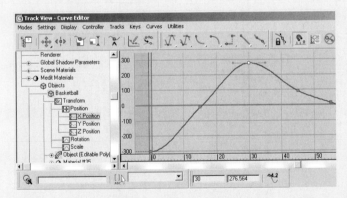

22. Hold down the SHIFT key on the keyboard, and then drag the handle on the left side and bring it down so that it points directly to the key at frame 15.

By moving the tangent, you create a break in the continuity of the movement. Now ball bounces off the backboard more rapidly, creating a sharper movement.

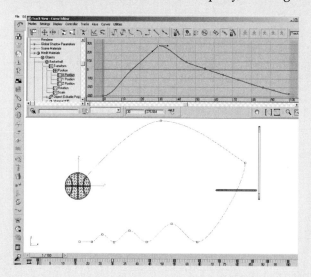

23. Drag the handle on the right side so it points at key 45. You don't need to hold down the **Shift** key any more. The trajectory at frame 30 now looks like an inverted "V" shape.

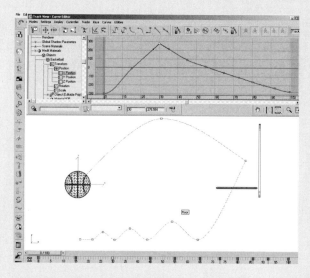

24. Play the animation.

25. Next, you need to fix the bounces off the floor. In the Curve Editor's controller window, click the Z Position track. Now a blue function curve appears, representing the Z-axis motion.

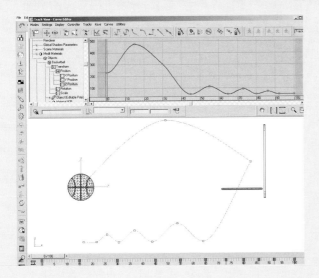

26. You need to fix the frames when there is contact with the floor. You will try a different method this time to create a "V" shape in the trajectory. Hold down **CTRL** and click the keys at frames 45, 65, 80 and 92. These keys represent the position of the ball as it hits the floor.

Hint: Selecting keys in Track View works like selecting objects in a viewport. Clicking a key selects it. **CTRL**+click adds or removes keys from a selection, and **ALT**+click removes keys from a selection. You can also drag a rectangular region to select multiple keys at once.

27. In Track View, on the main toolbar of the Curve Editor, change the type of tangent to Fast.

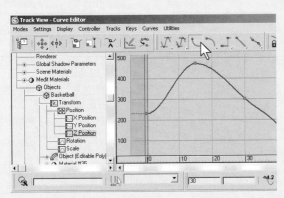

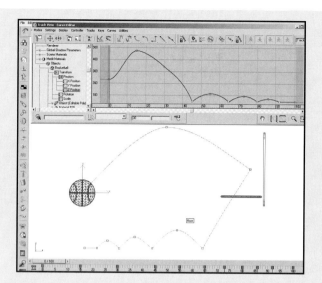

28. Close the Curve Editor, press **P** to change the viewport to Perspective, and then play the animation.

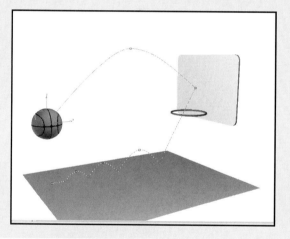

Track View

As you can see, Track View is a very important feature: It is the animator's special tool for fixing and adjusting animation. There are two types of Track View: the Curve Editor and the Dope Sheet. The Curve Editor is useful for correcting the trajectory of an animated object and to adjust timing, while the Dope Sheet is more useful for copying and pasting keys.

Timing

Timing is arguably the most important aspect of animation. Timing is the number of frames it takes to make a certain movement or the time it takes to hold that movement.

Take a really energetic character, almost too energetic. Picture him in your head, the way he walks, moves, talks. All motion emanating from this character is going to be really fast and snappy.

Now picture an old, weary character. The same brisk walk would be impossible for him to achieve. On such a character, the timing should be slow—really, really slow—like walking on the moon.

Please play the *Timing.avi* video, included on the accompanying CD in *Scene Files \ 11 - Animation Basics *.

Ease in / Ease out

The principle of ease in/ease out is also known as cushioning. It is the art of accelerating and decelerating an object so its motion does not look too mechanical.

For example, a bouncing ball slows down before it reaches its peak in midair, and then accelerates as it begins to descend.

Please play the *Ease.avi* video, included on the accompanying CD in *Scene Files\11 - Animation Basics*.

Arcs

There is almost no uniform linear motion in real life. Almost everything moves in some sort of curved motion. Arcs are important for the esthetics of movement. In particular, the joints of people and animals work like hinges, and cause our limbs to describe arcs as they move.

(Even when motion is linear in real life, as when a heavy object falls, there is almost always some acceleration, as the following exercise illustrates.)

Please play the *Arcs.avi* video, included on the accompanying CD in *Scene Files\11 - Animation Basics*.

Exercise 2: The Bowling Ball and the Golf Ball

1. Open the file *Bowling_Golf_Start.max*. The scene shows a heavy bowling ball and a light, bouncy golf ball. You will animate them falling, and use the Curve Editor to give them the illusion of weight.

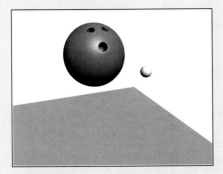

2. You will work on the bowling ball first. Maximize the Front viewport. Select the golf ball and then right-click it.

3. From the quad menu that appears, choose Hide Selection.

4. Select the bowling ball and turn on Auto Key.

5. Move the time slider to frame 6.

6. Move the bowling ball down to floor level.

7. Go to frame 10 and move the bowling ball slightly upward, around 55 units on the vertical axis as in the illustration. Keep your eye on the coordinate values at the bottom of the screen for reference.

8. You will need two more bounces. Go to frame 13 and move the bowling ball down to floor level again.

9. At frame 16, move it up to about 40 units.

10. At frame 18, move it down to the floor again.

11. At frame 20, move it up about 35 units.

12. Finally, at frame 22, move it down to the floor one last time. The timeline should look as follows:

13. Turn off Auto Key. Play the animation. You can already feel the weight of the bowling ball, but the animation is still a bit loose. You will adjust this in the Curve Editor.

14. Select the bowling ball, right-click it and select Curve Editor from the quad menu.

15. Click the Z-Position track. A blue curve appears.

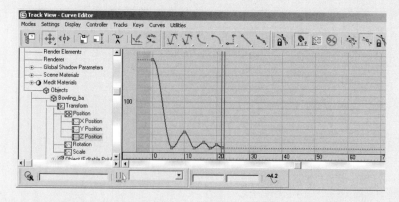

16. Select the keys where the ball hits the floor: at frames 6, 13, 18, and 22.

17. With the keys selected, change their tangent type to Fast as you did earlier, so they are in an inverted "V" shape.

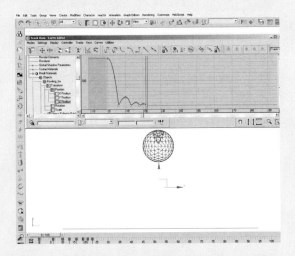

18. Next, you will animate the golf ball. Unhide the golf ball and then hide the bowling ball.

19. Select the golf ball.

20. Turn Auto Key back on.

21. You will animate the golf ball from frame 0 to 60, with eight hits on the floor.

 The golf ball is very light and bouncy, so it will go higher vertically than the bowling ball does. It will also hang longer in the air.

22. Go to frame 8 and move the golf ball down to the floor.

23. At frame 16, move the golf ball about 120 units up.

24. At Frame 22, move the golf ball back to the floor.

25. At frame 28, move the golf ball about 95 units up.

26. At frame 34, move the golf ball back to the floor.

27. At frame 38, move the golf ball about 70 units up.

28. At frame 42, move the golf ball back to the floor.

29. At frame 46, move the golf ball about 30 units up.

30. At frame 50, move the golf ball back to the floor.

31. At frame 52, move the golf ball about 15 units up.

32. At frame 54, move the golf ball back to the floor.

33. At frame 56, move the golf ball about 11 units up.

34. Finally, for the last bounce, go to frame 58 and move the golf ball back to the floor.

35. At frame 59, move the golf ball about 8 units up, and finish off the animation at frame 60 by moving the ball down to the floor one last time.

36. Turn off Auto Key.

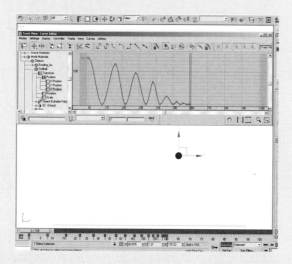

37. Adjust the keys at the floor level so their tangents are set to Fast mode, as you did earlier for the bowling ball.

38. Play your animation in the viewport. If you wish, unhide the bowling ball and play the animation to compare the apparent weights of the two objects as they bounce off the floor.

Exercise 3: The Gelatin Cake

1. Open the file *Jelly_Start.max*. The scene shows a gelatin cake that you will animate to jump off a ramp.

2. Activate the Front viewport and maximize it.

3. Turn on Auto Key.

4. Select the cake and go to frame 10.

5. Right-click the time slider. A Create Key dialog appears in the viewport.

6. Turn off Rotation and Scale, and then click **OK**.

Hint: The Create Key dialog lets you create keys for an object's position, rotation, or scale only.

Next you'll create a bouncing effect for the cake at frame 20, along with anticipation and squash effects, starting with a big bounce.

7. Go to frame 40, and then move the cake to coordinates X: 175, Z: 245. Keep an eye on the status bar for reference.

8. Go to frame 60, and move the cake to coordinates X: 245, Z: 80.

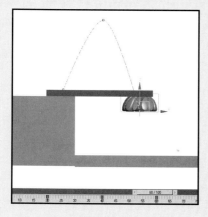

9. Now you will animate the board. Make sure you are still at frame 60.

10. Select the board and go to the Modify panel.

11. Change the Bend modifier Angle value to 26.5 so that half of the cake does not intersect the board.

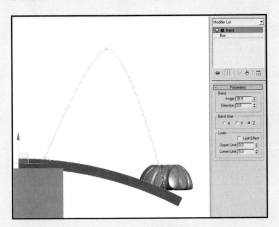

12. This animates the Bend angle between frames 0 and 60.

13. On the track bar, select the keyframe at frame 0 and drag it to frame 51.

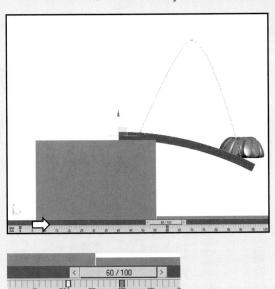

Next, you will animate the rebound of the cake.

14. Select the cake and go to frame 70. Move the cake to coordinates X: 320, Z: 300.

15. Go to frame 82 and move the cake to coordinates X: 380, Z: 0. It should look like this:

16. Go back to frame 60. Right-click the cake and open the Curve Editor.

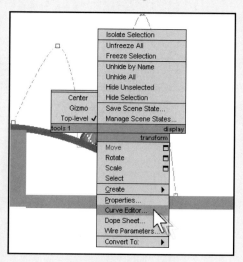

17. In the Curve Editor, select the Z-Position track.

18. Select the key at frame 60 and change the tangent to Fast.

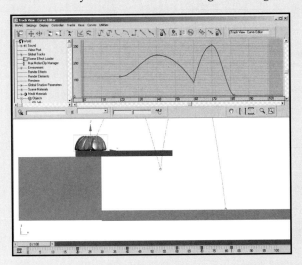

19. Play the animation. Notice that because the timing has changed, the board animation is incorrect. This is because changing the tangent type changed the cake's timing. In this case, it might have been better to finish the cake animation before animating the board. This also includes changing the tangent.

20. Select the board and then on the track bar, select the keyframe at frame 51. Move the key to frame 57.

21. Play the animation. The motion is much better now.

22. Now you need to rotate the cake. Select the cake and go to frame 57. Right-click the time slider to create a rotation key.

Animation

23. Go to frame 60, and rotate the cake to match the bending of the board.

24. Go to frame 70, and rotate the cake back so that it is horizontal. In the next exercise you will animate the stretch to anticipate the first jump and make the animation more lively.

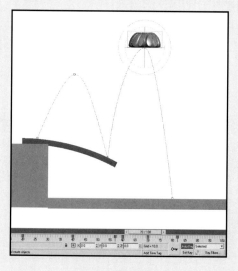

Anticipation

Anticipation is another important aspect of animation. It sets the stage for the action to follow. Consider a golfer's backswing: you know it will be followed by the forward action of hitting the ball. Anticipation is exactly that; preparing the action to follow.

In the golfer's example, the backswing is the anticipation, the ball getting hit is the action, and the follow-through is the movement that follows after hitting a ball. There is an interesting coincidence here, as the term "follow-through" is used in both animation and golf.

Without anticipation, animation does not have the same punch.

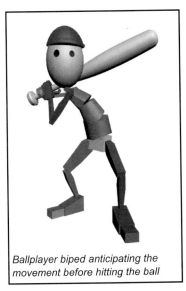

Ballplayer biped anticipating the movement before hitting the ball

Please play the *Anticipation.avi* video, included on the accompanying CD in *Scene Files\11 - Animation Basics*.

Follow-Through and Overlapping Action

As mentioned earlier using the golf swing example, follow-through is the gradual ending of the action. Another example would be driving a car: If you come to a sharp stop, the follow-through would see your head bending forward with the car's momentum. Overlap is the action that long hair would have as your head moves forward.

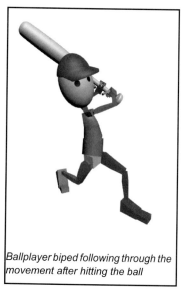

Ballplayer biped following through the movement after hitting the ball

Please play the *Followthrough.avi* video, included on the accompanying CD in *Scene Files\11 - Animation Basics*.

Squash and Stretch

Used mostly in cartoon-style animation, squash and stretch is the technique of deforming an object (or character) to show how rigid it is. For example, a water balloon hitting the floor will stretch more than a bowling ball following the same action.

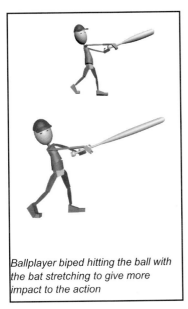

Ballplayer biped hitting the ball with the bat stretching to give more impact to the action

Please play the *Squash.avi* video, included on the accompanying CD in *Scene Files \ 11 - Animation Basics *.

Exaggeration

You use exaggeration to emphasize a movement or reaction, in order to give an action more importance. This can greatly improve the personality you give to a character.

Exercise 4: The Gelatin Cake: Anticipation, Stretch, and Follow-Through

1. Open the file *Jelly_jump.max* or continue using the scene from the last exercise.

2. Turn on Auto Key.

3. Go to frame 5, and on the Modify panel, change the Stretch value to 0.1.

4. At frame 12, set the Stretch value to -0.4.

5. On the track bar, hold down the **SHIFT** key and drag the key at frame 12 to frame 18. This makes a copy of the key.

Next, you will animate the squash and stretch effect of the jelly cake.

6. Go to frame 26 and change the Stretch value to 0.4.

7. Copy that key to frame 34 using **SHIFT**+drag as before.

8. Go to frame 40, and set the Stretch value back to 0.

9. At frame 46, change the Stretch value to 0.4.

10. Copy the key at frame 46 to frame 57.

11. Go to frame 60, and set the Stretch value to -0.3.

12. At frame 80, set the Stretch value to 0.8.

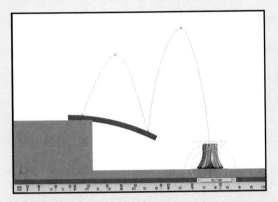

13. Now you will animate the follow-through once the cake touches the floor. Go to frame 85, and change the stretch value to -0.5.

14. At frame 88, change the Stretch value to 0.4.

15. At frame 91, change the Stretch value to -0.1.

16. At frame 94, change the Stretch Value to 0.1.

17. Finally, at frame 96, set the Stretch value back to 0.

 One last step remains: You need to animate the follow-through of the board.

18. Select the board and go to frame 61. Change the Bend Angle to 2.5. This prevents the board from going through the cake.

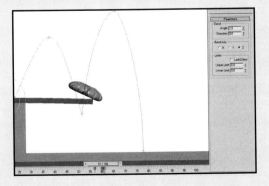

19. Continue with the upper movement. Go to frame 63, and change the Bend Angle to -8.5.

20. Go to frame 66, and change the Bend Angle to 11.

21. Go to frame 69, and change the Bend Angle to -3.5.

22. At frame 72, change the Bend Angle back to 0.

23. Turn off Auto Key.

24. Change the viewport to a Perspective view.

25. Turn off the Trajectory display, and then play the animation.

Secondary Action

As its name implies, secondary action is action that is not part of the main action, but that gives you a sense of what goes through the mind of a character or an animated subject.

For example, consider a man at a bus stop leaning against a pole. His main action is looking from side to side. His secondary action is tapping his foot on the sidewalk because he is impatient.

Straight-Ahead Animation and Pose-to-Pose Animation

When you animate, you can use two overall strategies. Straight-ahead animation is when you animate "as you go along," which is what you did in the previous exercises with the help of Auto Key. Pose-to-pose animation involves planning the main animation from one important pose to the next, and then coming back to adjust the intermediate action. Typically, pose-to-pose is the method of choice for character animation. You can also use a combination of the two strategies.

Staging/Appeal/Personality

Finally, you are left with three principles to learn about: appeal deals with the esthetics of a character; staging deals with the silhouette, the camera angle and the background or set; and personality brings your characters to life.

You will learn more about these principles in the Character Animation lesson.

Summary

In this lesson, you learned about the concept of keyframing, how to create keys using Auto Key and the track bar, and how to adjust timing using the Track View Curve Editor.

You also learned about the basic animation principles:

- Timing
- Ease in/ease out
- Arcs
- Anticipation
- Follow-through and overlapping action
- Squash and stretch
- Exaggeration
- Secondary action
- Straight-ahead versus pose-to-pose animation
- Staging, appeal, and personality

You learned how to apply these principles to simple objects to put more spark in your animations. You learned how to make your animations more interesting and nicer to look at using various techniques.

Animation

Hierarchies

In the previous lesson, you learned the basics of animating simple objects. Now you will learn about the mechanics behind multi-object animation.

In this lesson you will learn how to create a hierarchy of objects and how all the objects that make that hierarchy interact with one another.

Objectives

After completing this lesson, you will be able to:

- Create your own hierarchies
- Use different tools to create and select hierarchies
- Understand the use of proper tools to help in your animations
- Understand the difference between Transform and Modify
- Use helpers during your animation process
- Build an animation rig

Mechanics of Movement

The term "mechanics of movement" sounds intimidating but it simply relates to the way things move around you. As you discovered in the previous lesson, single moving objects are easy to understand, but things work differently with more complex objects such as a door. You need some sort of order. In the language of 3D graphics, that kind of order is called "hierarchy."

Let's take a simple door example.

The door can't open without hardware.

Try to open a door in real life without any hardware. It is impossible. It needs to be attached to hinges. But hinges alone are not enough; it also needs a frame.You can open the door only when the door and the hinges are attached to the frame.

Linking Objects

The process of creating relationships between objects is called "linking" or "parenting."

Parenting is done in 3ds Max by linking a "child" to its "parent." It's always done in that order. The child is an object controlled by its parent. In the case of a door, the door would be the child of the hinges and the hinges (considered as a single object in 3ds Max), the child of the frame. If the hinges rotate, the door opens, following the action dictated by its parent.

An example of hierarchy in 3ds Max

Pivot Point

One of the most important concepts when dealing with hierarchies is the pivot point position of an object. You want to ensure that the pivot point is where the center of rotation occurs. In the case of a wheel, it is right in the center.

Linking vs. Groups

From an animation standpoint, it is always best to use linking instead of grouping. Linking still allows you full control of the individual parts that make your model, and you are therefore free to animate them any way you see fit.

Grouping lets you combine two or more objects into a single grouped object. The grouped object is given a name, and then treated much like a single object. You can still access the individual components that make a group, but the process is somewhat tedious.

If you choose to animate an object inside a group, you need to:

a. Select the group
b. Open the group
c. Select the object you want to animate
d. Animate the object
e. Close the group

Linking lets you create hierarchies in such a way that children inherit transform commands from their parents.

If you choose to animate an object that is part of a hierarchy, you need to;

f. Select the object
g. Animate the object

You link objects using the Select And Link tool on the main toolbar.

You can remove a link by selecting a child object and clicking the Unlink Selection button next to Select And Link.

Exercise 1: Linking the Robot Arm

1. Open the file *Robot_Arm_start.max*.

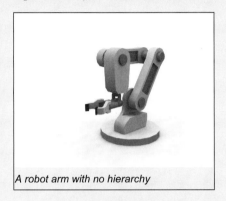

A robot arm with no hierarchy

2. Maximize the Perspective viewport so it looks like the following illustration.

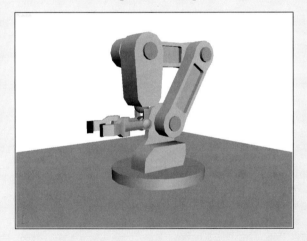

Maximize the Perspective viewport using the **ALT+W** shortcut.

3. Press **H** to access the Select Objects dialog.

4. Highlight the Clamp01 and Clamp02 objects and then click the Select button to exit the dialog.

5. Choose the Select And Link tool from the main toolbar.

6. Place your cursor on one of the selected objects, and then click and drag so that you see two rubber bands appear. Do not release the mouse button yet.

There is a dashed line coming from each clamp object's pivot point.

7. Position the cursor over the horizontal orange rod (named 360_head_pivot) that connects the selected objects and release the mouse button. The parent object flashes for a second, indicating it has accepted the link command.

Click, drag and release over the 360_head_pivot object. A flash indicates that the action was successful.

You'll use the Select And Rotate tool to test the link.

8. Make sure that the Reference Coordinate System on the main toolbar is set to Local.

9. Rotate the 360_head_pivot object about the Z axis. Notice how the child objects react to their parents.

For the next link, you will link the 360_head_pivot object to the Vertical_head_pivot object to its right. Thus, the object you used as a parent a moment ago will in turn become a child of its own parent. Instead of using click and drag, this time you will use the Select By Name function to achieve the same results.

10. Click the Select tool on the main toolbar.

11. Select the 360_head_pivot object in the viewport. That's the horizontal rod you used as a parent a moment ago.

12. With the 360_head_pivot object selected, click the Select And Link tool.

13. Press **H** to access the Select Objects dialog. Select the Vertical_head_pivot object and click the Link button at the bottom at the bottom of the dialog.

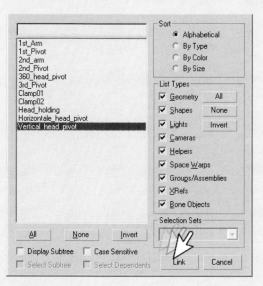

When you are in link mode, the button of the Select Objects dialog changes from Select to Link.

14. Exit Select And Link mode by choosing the Select tool.

15. Press **H** to open the Select Objects dialog.

16. Turn on Display Subtree to have a look at your hierarchy so far.

Every child is indented from its parent in the list.

17. You can link the entire robot arm using this method. You can also use a tool called Schematic View to achieve the same results, as outlined in the next exercise.

If you save your changes, be sure to change the file name, because you'll use the same original file in the next exercise.

Exercise 2: Linking the Robot Arm using Schematic view

1. Open the file *Robot_Arm_start.max*.

This is the same file you used in the previous exercise.

A robot arm with no hierarchy

2. On the main toolbar, click the Schematic View button.

A floating dialog appears. Schematic View is an effective tool for creating and manipulating hierarchies. You can select and link object nodes without having to use the viewports.

3. Using the navigation tools in the lower-right corner of the window, alternate between zoom and pan to get closer to the individual nodes. Make sure you can see the nodes named Clamp01, Clamp02, and 360_head_pivot.

Note: If you are using a mouse with a wheel, you can turn the wheel to zoom in and out and press the wheel down and drag to perform a pan.

4. Select the nodes clamp01 and clamp02. They become white.

Note: you can select multiple nodes using region selection or with the CTRL key.

Two nodes selected

5. On the Schematic View toolbar, click the Connect tool. Connecting nodes in Schematic View is equivalent to linking objects in the viewports.

6. With the Connect tool active, drag from one of the selected nodes to the 360_head_pivot node. Release the mouse button to make the connections.

Schematic View now shows the two clamps as children of the 360_head_pivot node.

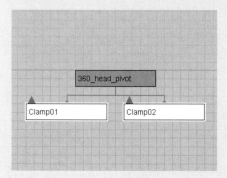

7. Select the 360_head_pivot node. Drag and drop it onto the Vertical_head_pivot node.

8. Drag from the Vertical_head_pivot node to the Horizontal_head_pivot node.

9. Continue connecting nodes as shown below. The order of a hierarchy is very important. Be careful not to select the floor. Your Schematic View should look like this.

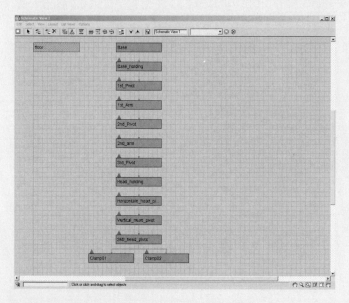

10. Save the scene and name it *My_Robot_Arm.max*.

Schematic View

As you can see, Schematic View can save you time when linking object together. But it is also an excellent tool to select and animate objects.

You can customize Schematic View using images of your character to help you animate; you will try this in the next exercise.

Exercise 3: Linking the Robot Arm Using Schematic View

1. Continue working on your scene or open the file *Linked_Robot_Arm.max*.

The robot arm with a linked hierarchy

2. On the main toolbar click the Schematic View button to open its window.

3. From the Options menu, choose Preferences.

Animation

4. In the Preferences dialog > Background Image group, click the None button.

5. Load the file *Schematic_Robot.png*.

6. Turn on Show Image.

7. Click the OK button to exit the dialog. You now have an image for a background.

8. Press the **G** key to turn off the grid so the background image is easier to see. The background image is too big; you'll fix it in the next step.

9. Zoom into the image.

Notice how only the nodes are affected by the zoom function but that the background remains static. This is because you have not yet locked the zoom and pan functions in the Preferences.

10. Zoom in until the nodes are reasonably sized in reference to the background.

11. Return to the Options > Preferences dialog and turn on the Lock Zoom/Pan option. Click OK to exit the dialog.

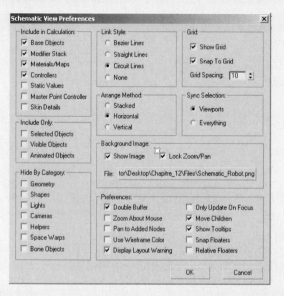

12. Reposition the nodes over each object they represent as shown in the following illustration.

Hint: It is easiest to start with the top most parent and move down the hierarchy. In this case, start with the Base object.

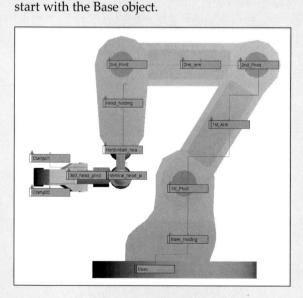

13. Select a few of the nodes in Schematic View. Notice how the corresponding objects are selected in the viewports.

14. Select a rotational joint node and rotate the corresponding object in the viewport. Note how the child objects react to that motion.

15. In Schematic View, select the nodes that do not represent rotational joints.

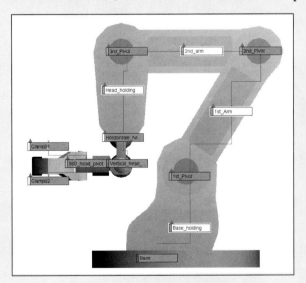

Animation

16. Right-click in the Schematic View window and choose Shrink > Shrink Selected. This simplifies the display of the nodes you are less likely to manipulate.

17. Rename the Schematic View window Robot Arm.

18. Close the Schematic View window. When you need to recall it, you will be able to access by choosing Graph Editors menu > Saved Schematic Views > Robot Arm.

A Little Bit About IK

Earlier in this lesson, you learned about hierarchies and how a child object inherits transforms from its parents. This process is known as forward kinematics, or FK for short.

Inverse kinematics, or IK, works the opposite way. It uses a goal-oriented method where a child object is used to calculate the position and orientation of the parents. The final position of the hierarchy after all of the calculations have been solved is referred to as the IK solution.

Taking the example of a human leg:

To pose the leg using FK, you would need to apply rotations on the various objects that comprise the leg skeleton. This can be a tedious task that does not always offer the best type of control when animating.

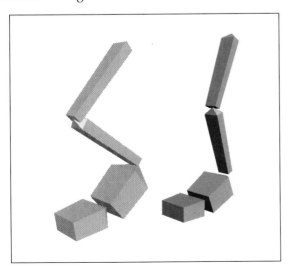

With inverse kinematics, instead of using multiple rotations to animate the knee bending, you use an IK solution that extends from the foot to the thigh and a goal object that, when animated, drives the deformation of the leg in a simple and realistic manner.

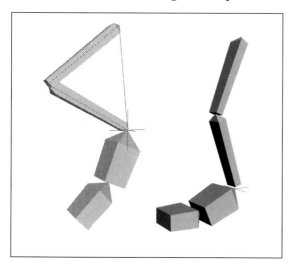

Exercise 4: Inverse Kinematics

1. Open the file *Leg_IK.max*.

2. Select the IK Chain01 object.

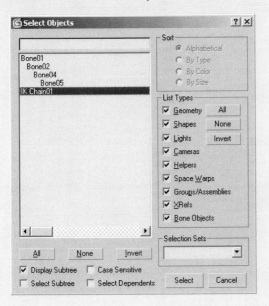

3. Activate the Move tool and move the leg in the XZ plane. The whole leg reacts to this motion.

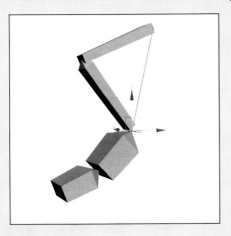

Hierarchy

You use the Hierarchy panel to edit parameters such as pivot points, IK values, and parent/child relationships.

Pivot

Each object has a pivot point. You can think of the pivot point as an object's local center. The pivot point of an object is used for the following:

- It serves as a center for rotation and scaling when you select the Pivot Point transform center.
- It sets the default location of a modifier center.
- It defines the transform relationship for the object's linked children.
- It defines the joint location for inverse kinematics (IK) solutions.

You can adjust the position and orientation of an object's pivot point at any time using the controls on the Adjust Pivot rollout on the Hierarchy panel.

IK

The IK rollouts contain many different controls for interactive IK and the HD IK solver.

Link Info

This part of the Hierarchy panel contains two rollouts. The Locks rollout has controls to restrict the movement of objects on a particular axis. The Inherit rollout has controls to limit the transforms that a child inherits from its parent object.

Exercise 5: Link Info on the Locomotive Wheel

1. Open the file *Locomotive_wheel.max*. It contains three objects: a locomotive wheel, a pivot, and an arm. These three objects are already linked in a hierarchy.

2. Open the Select Objects dialog and turn on Display Subtree below the list. Note the hierarchy of objects in the scene.

When objects are linked they appear as an indented list, from parent to child.

3. Select the Loco_wheel object.

4. Rotate the Loco_wheel object about the Y axis.

The wheel rotates and the children follow, but this is not how the arm should behave.

5. Undo the rotation using CTRL+Z.

6. Select the Pivot object using **PAGE DOWN**.

 Hint: Using the **PAGE UP** and **PAGE DOWN** keys move you through the hierarchy. **PAGE UP** selects the parent of the selected object and **PAGE DOWN** selects its children.

7. Go to the Hierarchy panel and click Link Info.

8. On the Inherit rollout, turn off Rotate > Y.

9. Select the wheel and rotate it again. The arm stays parallel to the ground. You have forced the arm to inherit all but the Y-rotation transform values from its parent.

Summary

Hierarchies are vital in 3D animation. Without hierarchies, you don't have the structure to support your characters and other objects. It is a technical area that every 3D animator needs to understand well. As you pass through your environment, look around you, analyze moving objects, and try to figure out ways to reproduce their motion in 3ds Max.

Animation

Character Animation—Biped

Character animation goes beyond simply making a character move. It is also about giving feeling to the character. As a character animator, you need to understand the 3ds Max toolset and also to have a good sense for poses and timing. It also helps to be a good actor. In this lesson, you will attempt to achieve these goals with the help of the Biped object.

Objectives

After completing this lesson, you will be able to:

- Create and modify a biped
- Apply the Physique modifier to a model
- Understand basic functions of character studio
- Create a simple walk cycle
- Refine character animation by keyframing body parts

Character Animation

Animation is one of the later stages in a production pipeline. It is also where the project comes to life. The environment you create, including trees, grass strands, and clouds, would not look the same if some of these entities were not animated. The same is true of characters.

Character animation is often the highest goal for animators. It is the most demanding and the most difficult to achieve of all animation types. It requires excellent comprehension of the technical aspects as well as top-notch artistic skills.

Becoming a good animator does not happen overnight. This lesson introduces you to some character-animation basics using Biped, one of the most powerful character-animation tools available.

Biped

Biped is a complete hierarchy for character animation. It is a pre-built feature designed to make it easy to set up skeletons according to your character's proportions. It has inverse kinematics built into the arms and the legs, so you can rotate a body part or drag the hand or feet and the rest of the limb will react accordingly.

You create the default biped with a simple click-and-drag operation. It has human proportions but can be easily adapted to many different characters.

You can modify the biped into many different shapes.

You can even edit the geometry of biped bones to shape the biped in various ways.

Animation

Ultimately, the biped skeleton goes inside the character mesh, as shown below. When the skeleton moves, the character moves with it.

Exercise 1: Fitting a Biped Inside a Character

1. Open the file *Fitting_biped.max* The scene contains a body mesh object and two spheres for the character's eyes, as well as a biped object. You'll need to adjust the biped figure to fit the character's proportions.

2. Select any part of the biped.

3. ⊕ Go to the Motion panel.

4. ⚟ Turn on Figure mode, if necessary, to enable biped deformation.

5. In the viewport, double-click the left thigh object (Bip02 L Thigh, on the right side of the viewport) to select the complete leg. You will copy the left leg deformation and paste it onto the right leg.

6. On the Copy/Paste rollout, make sure Posture is active.

7. Click the Copy Posture button.

8. Click the Paste Posture Opposite button to copy the left leg parameters to the right leg.

Information can be copied and pasted between various limbs.

9. Double-click the left clavicle object (Bip02 L Clavicle) to select the arm.

10. Copy the posture as you did earlier.

11. Paste the information on the opposite (right clavicle) side.

Next you will create the ponytail and fit it to the character's head.

12. Press **L** to switch to the Left viewport.

Note: Pan and zoom as necessary to view the entire character.

13. Expand the Structure rollout at the bottom of the Motion panel.

14. Set Ponytail1 Links to 3.

15. Activate the Rotate tool and then set the Reference Coordinate System to Local, if necessary.

16. Zoom in on the character's head. Select the Bip02 Ponytail1 object (the ponytail bone closest to the head) and rotate it 100 degrees about Z.

Hint: You might want to set the viewport to wireframe mode (**F3**) to see the various components better.

17. Using the Move tool, move the Ponytail1 object so that it is aligned with the ponytail in the mesh.

18. Rotate the second ponytail bone -15 degrees about Z.

19. Rotate the third ponytail bone -25 degrees about Z.

20. On the main toolbar, click the Scale tool. With a biped part selected, this automatically sets the Reference Coordinate System to Local and makes the setting unavailable.

21. Scale the ponytail bones individually so that they better fit the geometry of the character.

22. Your biped is now ready for the second step, creating the physique.

Exercise 2: Creating a Physique

1. Open the file *Physique_Start.max* The scene contains a body mesh object name MeshBody and two spheres for character's eyes, as well as a biped object. The biped figure has already been adjusted to fit the character's proportions.

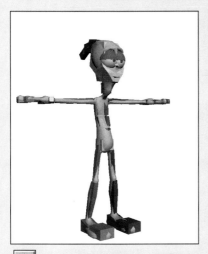

2. Select the object named Bip01 L Foot (biped's left foot) and move the foot up.

 As you can see, the MeshBody object is not attach to the biped.

3. Click the Undo button on the main toolbar or press **CONTROL+Z** to undo the move.

Animation

4. Select the MeshBody object.

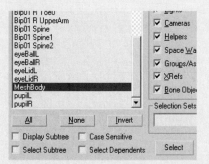

5. 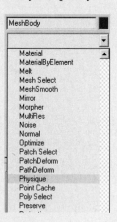 Go to the Modify Panel. In the modifier List choose the Physique modifier. Using the Physique modifier causes the vertices on your mesh model to follow any part of the biped that you specify.

6. Click the Attach To Node button on the Physique rollout.

7. Press **H** to open the Pick Object dialog and pick the Bip01 Pelvis object.

Animation

8. The Physique Initialization dialog appears. Click the Initialize button.

Note: When you initialize the Physique modifier, you will see a small coffee-cup icon for the time it takes to complete the initialization process.

9. Select the left foot again. Move the foot as you did earlier. As you can see the foot motion will deform the MeshBody object as it moves.

10. Undo the move.

11. Save the file for later use.

Motion Panel

Once you have created a biped object, the Motion panel provides a wealth of tools to help you manipulate your biped. Some of the tools you are likely to use often include keyframing tools on the Keyframing Tools rollout, which you can use to create keyframes in a variety of ways, including keyframes to pin limbs down (such as the biped feet) so that they remain in place as you move other body parts. You can also create multiple animation layers with the Layers rollout controls. Multiple animation layers can be useful for better control of the animated character. You can also create animation using a pose-to-pose approach, using the Copy/Paste rollout. This allows you to save and recall full-body poses, but also postures based on specific body parts. This approach helps tremendously for blocking out rough animations that you can fine-tune at a later time. There many more tools to choose from, although this lesson will only introduce basic manipulation of biped objects.

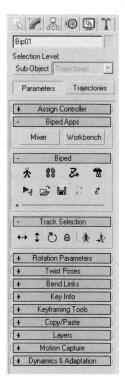

The Motion panel when a biped object is selected

Animation

Exercise 3: Setting up Biped for Animation

1. Open the file *Biped_Setup.max*.

When the biped and the mesh object share the same space, selecting biped parts can be more difficult.

2. From the Named Selection Set drop-down list, choose Biped. This selects all parts of the biped skeleton.

3. Right-click in the viewport and choose Properties from the quad menu.

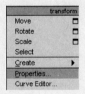

4. In the Display Properties group, turn on Display As Box.

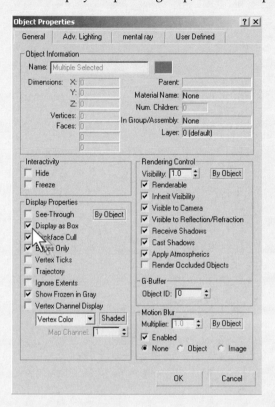

5. Click OK to accept the changes and exit the dialog.

6. Click an empty area of the viewport to deselect all objects. As you can see, the biped parts are now displayed as boxes. They are easier to select and you can also see the deformation on the character below.

Exercise 4: Animating a Walk Cycle

1. Open the file *Character_anim_start.max*. You will animate a walk cycle for this character using a pose-to-pose approach.

2. Turn on Auto Key.

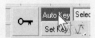

3. Select any part of the biped in the viewport.

4. Go to the Motion Panel and expand the Copy/Paste rollout. Make sure the Pose button is activated.

 This rollout lets you copy and paste different poses and limb postures for later use in your animation.

A small preview window shows when a pose is already available.

Animation

5. Make sure that you are on frame 0 and click the Paste Pose button. The biped adopts that pose in the viewport.

6. Go to frame 15 and click the Paste Pose Opposite button. As the name implies, this pastes the opposite pose to create the second step.

7. Go to frame 30 and click the Paste Pose button again.

8. Play the animation.

9. The feet of the character are sliding, but you have a rough draft of the walk cycle already.

10. Stop the animation.

11. Switch to the Left viewport (press **L**) and select Bip01 L Foot (the biped's left foot).

12. Go to frame 7.

13. Move the L Foot up and rotate it to create a crossing motion.

14. 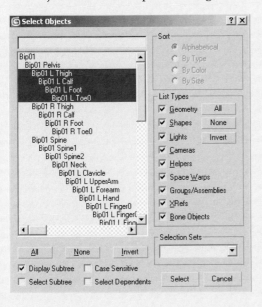 Open the Select By Name dialog.

15. Make sure Display Subtree near the bottom-left corner of the dialog is on and then select the four objects that make up the left leg.

16. Go to the Copy/Paste rollout on the Motion panel.

17. Click the Posture button.

18. Make sure you are still on frame 7 and then click the Copy Posture button. A snapshot of the leg appears in the preview window.

19. Go to frame 22 and click the Paste Posture Opposite button. The right leg now crosses the left leg.

20. Turn off Auto Key mode.

21. Press **P** to turn on Perspective view. Play the animation. You now have a good basis of a walk cycle.

22. Save the file for later use.

The Mechanics of a Walk Cycle

A pose-to-pose approach to animation, as seen in the previous exercise, is useful for blocking out an animation, but isn't the best way to produce highly realistic movements. Walking is a balancing act, where we push ourselves forward, fall and then catch our fall with every step we take. The mechanics of that motion goes beyond what can simply be captured by copying and pasting poses and postures.

 Once you have blocked out an animation with poses, you need to refine it to make it more realistic.

Exercise 5: Refining the walk

1. Open the file *Character_anim_tweak.max*. You will refine the walk on this biped by adding a bobbing motion to the biped's center of mass.

2. Select any biped part, go to the Motion panel > Track Selection rollout, and then click the Body Vertical button. This selects the Bip01 object, which is the biped's center of mass (COM). The Body Vertical track allows you to move the COM up and down.

3. With Body Vertical active, switch to the Left viewport (press **L**). Adjust the viewport, if necessary, so you can see the entire character.

4. Turn on Auto Key.

5. Go to frame 3.

6. Move the Bip01 object downward as shown in the illustration below.

7. Go to frame 11 and move the COM up into a more upright position. This creates a slight up and down movement, cushioning the fall moving down and throwing back the weight with the up position.

8. Repeat the procedure for the second step. Go to frame 19 and move the COM down slightly.

9. At Frame 27, move the COM back up again.

10. Turn off Auto Key mode.

11. Play the animation. You should be able to see a much more realistic animation with the changes you introduced.

Animation Principles

In a previous lesson, you learned about general animation principles. You will use these principles on the character you have been animating. You will use follow through to animate the character's ponytail. The secondary animation you add to the ponytail will make the overall animation more realistic.

Before you start, consider the possibilities: The ponytail is heavy at the tip, and the character drives it.

This will make the ponytail a little "lazy" and its motion will occasionally follow with a certain amount of drag.

The head moving down with the ponytail hanging up a moment longer.

The head moving up with the heavy pony tail still subjected to gravity.

Exercise 6: Follow through

1. Open the file *Character_anim_follow.max*.

2. Go to the Left viewport and turn on Auto Key.

3. Adjust the pan and zoom to view the entire character.

4. Go to frame 7.

5. Select the Bip01 Ponytail1 object.

6. Go to the Motion panel and expand the Bend Links rollout.

7. Activate Bend Links mode. This mode ensures any rotation you apply to a ponytail bone propagates to the other bones in that chain, creating a nice curve to the ponytail.

8. In the Left viewport, rotate the ponytail so that it is bent downward.

9. Go to frame 15.

10. Rotate the ponytail upward so that it is roughly straight.

11. On the track bar, SHIFT+drag the gray key at frame 7 to frame 22. This copies the keyframe data from frame 7 to frame 22.

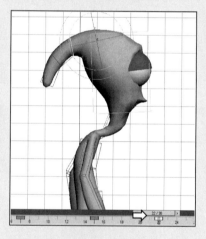

12. Turn off Auto Key mode.

13. Go back to the Perspective viewport and play the animation.

Summary

This lesson introduced you to character animation using bipeds. You have learned to create simple bipeds, adjust their figures and use them to drive meshes using the Physique modifier. You also learned to block out an animation by pasting poses, and then refine the animation by keyframing biped body parts, to create both primary and secondary animation.

Animation Lab

In this lab, you'll put all the animation concepts you've learned to good use as you animate a chess set in a variety of ways. You will keyframe simple position and rotation data, but you will also animate modifiers to give the chess pieces more character. Lastly, you will use the Curve Editor to control the animation and to keep the timer going throughout the animation.

As a side note to chess purists, please keep in mind that the chess pieces in this lesson are meant to move to accommodate the exercises rather than the actual motion in a real chess game. So if you see a knight moving in a straight line across three checker squares, try not to take offense.

Objectives

After completing this lesson, you will be able to:

- Animate object transforms
- Animate deformation
- Practice some basic animation skills

Getting prepared

Before you start, play the animation file *chess.avi* to get an overview of this lab's results.

Exercise 1: Animating the Chess Object

First you'll apply some basic movements to the chess pieces. Then you will give them a little personality using animated modifiers.

1. Open the file *Animation_Lab_Start.max*.

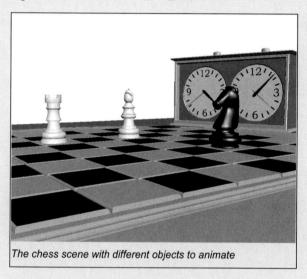

The chess scene with different objects to animate

2. Start by selecting the White_Rook object.

3. Click the Auto Key button to turn it on.

4. Go to frame 20.

| 20 / 100 |

5. Use the Move tool and move the rook three squares to the left as shown below.

6. Select the Black_Knight object. You will animate the knight to move in a L-shaped pattern and attack the bishop.

The knight is facing the wrong direction.

7. With the knight selected, activate the Rotate tool on the main toolbar.

8. Go to frame 30. At frame 30, right-click the time slider.

Animation

9. The Create Key dialog opens. Turn off Position and Scale and click OK. This creates a rotation key for the knight at frame 30.

10. Go to frame 32 and rotate the Knight -5 degrees about the vertical (Z) axis. The rotation amount shows on the Rotate gizmo as you rotate the object.

11. Go to frame 34 and rotate the knight an additional -80 degrees about Z.

12. Go to frame 36 and rotate the knight an additional -5 degrees about Z.

13. Now, when you play the animation, you have a quick 90-degree turn, but without an edgy feel to it.

The knight should be facing the bishop object from frame 36 onward.

Before you start moving the knight, you need to keyframe its position at frame 36 so that it doesn't start moving prior to that frame.

14. Make sure you are at frame 36.

15. Right-click the time slider.

16. On the Create Key dialog turn on Position and turn off Rotation and Scale. Click OK to create a position key and close the dialog.

17. Go to frame 56, activate the Move tool and move the Knight forward three squares.

18. Right-click the time slider and create a rotation key.

19. Make sure Auto Key mode is still on.

20. Go to frame 58 and rotate the knight 5 degrees about Z.

21. Go to frame 60 and rotate the knight an additional 80 degrees about Z.

22. Go to frame 62 and rotate the knight an additional 5 degrees about Z so that it is facing the bishop.

23. Turn off Auto Key mode.

24. At that point you can play the animation and enjoy the knight's quick, balanced turn.

25. Save your scene for later use.

Animation

Exercise 2: The Knight Attacks the Bishop

In this animation sequence, the knight attacks the bishop, and the bishop reacts with fear.

1. Continue working on your file or open the file *Chess-Attack_01.max*.

2. Go to frame 62. At this point, the knight is close to the bishop.

3. Select the White_Bishop object. It is time for the bishop to show fear as it rotates slowly.

4. Activate the Rotate tool. In this exercise, you will animate the rotation of the bishop using the Set Key method.

5. Turn on Set Key, just below Auto Key.

Set Key is a different animation method that lets you filter the data to animate. It records an animation key only when you click the Set Keys button or press K on the keyboard.

Next you'll change the filter.

6. Click the Key Filters button to the right of Set Key. This opens a dialog that lets you set the type of animation keys you want to create.

7. On the Set Key Filters dialog make sure that only Rotation is checked at this time. This ensures the animation you are about to create contains only rotation data.

8. Exit the dialog when done.

9. Click the Create Keys button to record a rotation key at frame 62.

10. Go to frame 70.

11. At the bottom of the screen, make sure the Coordinate Display is set to Absolute Mode.

12. Make sure the Rotate tool is active, and then enter a value of 125 in the Z field.

13. Click the Set Keys button to record a key.

14. Go to frame 73 and enter a rotation of 135 in the Z field.

15. Click the Set Keys button to create a key.

 It is very important that you record a key after each rotation so you don't lose the changes you introduced.

16. Go to frame 80 and create another key, using the current orientation for the bishop. The bishop will remain in this position, expecting the knight's attack.

17. At frame 82, enter 120 in the Z field. and record a key.

18. At frame 84, enter -20 in the Z field and record a key.

19. At frame 86, enter -35 in the Z field and record a key.

20. Preview the animation by clicking the Play Animation button.

21. Save your scene.

Animation

Exercise 3: The Escape

1. Open the file *Bishop_Escape_01.max*.

2. Select the White_Bishop object and go to frame 90.

3. Right-click the time slider and record a Position key at that frame. This ensures the bishop's position doesn't change before that frame.

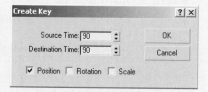

4. Turn on Auto Key mode.

5. Right-click the Left viewport to activate it.

6. Right-click the bishop and choose Properties from the quad menu.

7. In the Display Properties group, turn on Trajectory. This shows the path of the animated object once you start animating its position in space. Click OK when done.

8. Activate the Move tool and go to frame 95.

9. Move the bishop to coordinates X: -25, Y: -185 and Z: 35.

10. Go to frame 100 and move the bishop to coordinates X: -25, Y: -240 and Z: 0.

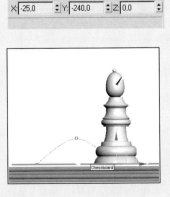

The animated bishop and its trajectory shown in the viewport

11. Go to frame 105 and move the bishop to coordinates X: -25, Y: -290 and Z: 35.

12. Go to frame 110 and move the bishop to coordinates X: -25, Y: -340 and Z: 0. This creates the bishop's second bounce.

13. Create two more bounces using the following data for timing and position in space.

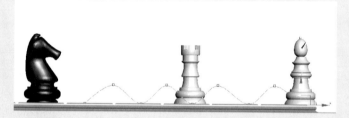

The final trajectory of the bishop shows four bounces.

14. Save your scene.

Exercise 4: Adjusting the Trajectory

1. Continue working on your scene or open the scene *Bishop_Escape_02.max*.

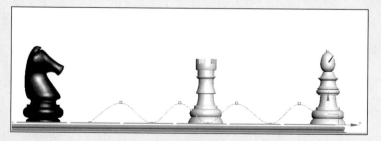

2. Select the White_Bishop object.

3. Right-click in the viewport and choose Curve Editor from the quad menu.

4. In the Curve Editor scroll down to the Z Position track of the White_Bishop object and click the track.

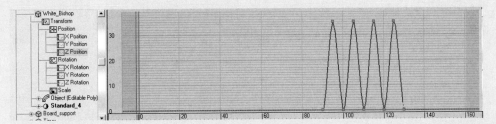

5. At the bottom of the Curve Editor window, use the flyout controls to apply Zoom Horizontal Extents Keys and Zoom Value Extents Range. This makes the curve easier to see.

6. Select all of the lowest keys.

Animation

7. Click the Set Tangents To Fast button to give a V shape look to the curve. This makes for a "snappier" bounce.

The trajectory of the bishop after changing the tangents

8. Press **C** to switch to camera view and preview your animation.

9. Save your scene.

Exercise 5: Animating Modifiers to Simulate Emotion

1. Open the scene *Bishop_Escape_03.max*.

2. Select the White_Bishop object and go to the Modify panel.

An FFD (Free Form Deformation) modifier is already applied to the object.

3. Expand the FFD modifier and go to the Control Points sub-object level.

4. Go to frame 73.

5. In the viewport, select the two rows of control points at the top of the FFD cage.

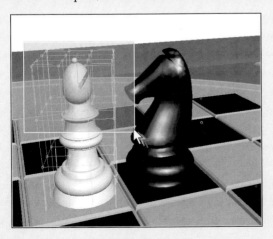

6. Turn on Auto Key mode.

7. Activate the Scale tool.

8. Place the mouse cursor on the Z axis (blue vertical axis) of the Scale gizmo in the viewport and drag upward to stretch out the bishop's head.

 This creates an exaggerated cartoon emotion meant to simulate surprise on the character's "face."

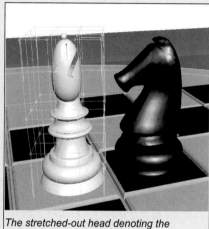

The stretched-out head denoting the bishop character's look of surprise

9. Go to frame 76 and scale the points slightly down on the Z axis. Keep an eye on the Coordinate Display area on the status bar to scale the points to about 95% of their current value.

10. Go to frame 80 and scale the points back down to roughly their original value.

11. On the Modify panel, click Control Points to return to the base modifier level.

12. Turn off Auto Key mode.

13. Press **C** to switch the viewport to a camera view and play the animation to test the results.

14. Save your work.

Exercise 6: Animating the Timer

1. Continue working on your scene or open the file *Timer.max*.

2. Press **H** and then select the object called Little hand from the Select Objects dialog.

3. Turn on Auto Key and go to frame 30.

4. Activate the Rotate tool and set the Reference Coordinate System to Local.

5. Rotate the Little hand object until it reaches the 6 position at the bottom of the timer.

6. Right-click the Little hand object and choose Curve Editor from the quad menu.

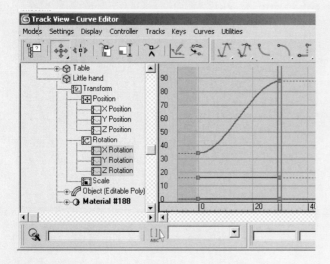

7. The Curve Editor displays three Rotation curves. Click the Y Rotation track so you see only the green curve in the graph display.

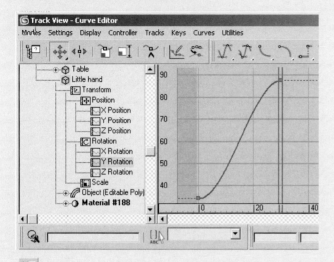

8. 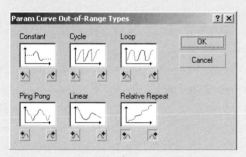 On the Curve Editor main toolbar, click the Parameter Curves Out-of-range Types button. A dialog opens.

9. On the Param Curve Out-of-Range Types Dialog click the Relative Repeat thumbnail, and then click OK. This makes the hand rotate indefinitely.

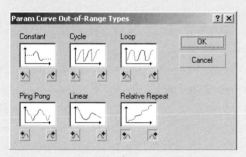

10. Minimize the Curve Editor and preview your animation before you adjust it. As you can see, there is a hesitation in the rotation of the hand. You will fix that in the next step.

11. Return to the Curve Editor and select the two keys on the Y curve.

12. Click the Set Tangents To Linear button to make a straight rotation curve.

13. Turn off Auto Key mode.

14. Preview the animation. The rotation is now more constant.

15. Close the Curve Editor and save your scene.

Summary

In this lab, you put into practice some of the animation tools you learned about in previous lessons. You animated the objects' position and rotation for basic motion, and you animated modifiers to give personality and emotion to those objects. You also learned to create animation keys in a variety of ways, and control the animation in the Curve Editor. You now have a good grasp of how to animate objects in 3ds Max and how to apply to your own projects what you've learned here.

Materials & Mapping

The Materials & Mapping chapter covers the Material Editor and the creation of simple and moderately complex materials.

The first lesson covers basic Material Editor manipulation and its user interface. The second lesson covers the use of maps and their importance in a material definition. The third chapter takes the level of difficulty a bit higher by discussing mapping coordinates and mapping types. Lastly, a lab illustrates how to create and apply materials to the underwater scene that you created in the modeling lab.

Introduction to Materials

In this lesson you'll learn about creating materials and working with the Material Editor in 3ds Max. This lesson introduces you to what a material is used for and why a good material is important. You will also learn how to create materials and work with several of the tools available.

Objectives

After completing this lesson, you will:

- Understand what a material is and its purpose.
- Understand the importance of good materials in a scene.
- See how lighting works with a material.
- Be able to work with the Material Editor.
- Learn to create basic materials and apply them.
- Understand the various tools available for working with materials.

Introduction to Materials

When you take a look around you, what do you see? Maybe a desk and a carpet? Perhaps you're outside; you might see grass and a stone wall. Materials are everywhere, from the floor to the sky and everything in between. A material is the combination of all the elements that make up the look and feel of a surface. Some materials can be simple, like a colored plastic ball, or more complex like an old wooden chest. Some materials are not even photorealistic; for instance, a cartoon cell is made up of solid colors and lines, and a photocopy is a simple monochrome image. Whatever your need, you can find a material to fill it. Real or imagined, materials make up the visible world we live in.

The Purpose of Materials

In 3ds Max, materials serve many purposes and can be used to portray different types of surfaces. For example, a steel urn has a very different look than does the same shape made of clay. Materials also help to portray an object's age, such as the difference between freshly cut, polished wood and a board that had been sitting on the beach for years. Even though the two objects are made of wood, there are visible differences that provide hints as to the age of the item.

Substance

Substance defines the look and feel of the material when it is applied to an object. An object made from red clay does not have the same substance as one made from metal.

With materials you can make objects such as these urns look unique.

Age

Materials can be used to show the relative age of an object.

Note the differences between the new, shiny, highly polished urn on the left and the aged, tarnished urn on the right.

Style

You can also create materials that fit whatever style you are looking to create in your images and animations.

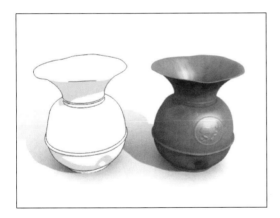

The urn on the left uses an Ink 'n Paint material, while the urn on the right uses a standard material.

Material Importance

A well-made material can make a difference in telling the story of an object or scene element. A scratch on the surface of a desk can tell a tale of what happened to the desk, who owns it, and what it is used for. While a simple scratch can tell a tale, the importance of a well-made material is visible to all who see the final image. Whether you are creating a photorealistic environment or taking a flight through a world of fantasy, the materials you use will make the difference between a good image and an image that sells your idea.

Materials and Lighting

Materials in 3ds Max and in the real world have one thing in common: Without light, they do not exist. When creating a material you must think about how it will look under various lighting conditions, as well as how the light will interact with the material. Is the material shiny or dull? Is it reflective or transparent? The answers to these questions all depend on lighting.

The lighting is the same, but the materials react very differently to the light. The urn on the left is shiny, showing the highlight where the light hits the object, while the urn on the right is dull and flat.

The Material Editor

The material editor is an essential tool in 3ds Max. With the Material Editor you can create rich environments or simple cartoon renderings. Whether your scene is a colorful photorealistic vision or simple color, the Material Editor allows you to create and edit the look of every object in your scene.

The User Interface

You will spend a good deal of time working in the Material Editor when creating your scenes. It is important that you become comfortable with the interface and how to navigate it.

There are three ways to access the Material Editor:

- Click the Material Editor button 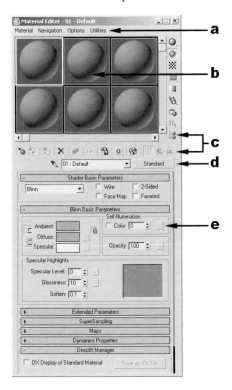 on the main toolbar.
- Choose Rendering > Material Editor from the main menu.
- Use the keyboard shortcut **M**.

The Material Editor Dialog

The Material Editor dialog comprises five sections:

 a. The menu bar.

 b. The sample slots.

 c. The toolbars.

 d. The material type and name.

 e. The material parameters.

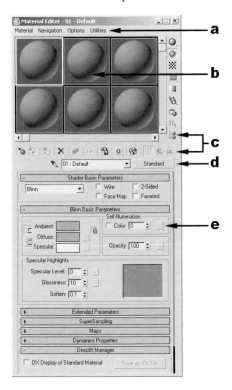

Material Editor Menu Bar

The Material Editor menu bar provides access to many Material Editor functions also available on the toolbars and the right-click menu, plus many options that are not. You can use the menu commands to apply materials, navigate through materials, and access options and utilities.

Material Sample Slots

The sample slots let you visualize your material as you create and edit it before you apply it to an object. By default you can see six sample slots at a time out of a total of 24 available slots.

You can view additional slots three ways:

- Pan the slots window.
- Use the scroll bars at the side and bottom of the sample windows.
- Increase the number of visible windows.

You can use the right-click menu to access more material sample slots.

All 24 material sample slots shown

Note: While the Material Editor shows a maximum of 24 materials at a time, the number of materials present in the scene is limited only by the computer memory.

Sample Window Indicators

The material sample window provides more than just a method of visualizing the current material; it also provides the status of each material. As your scenes grow, these indicators become more and more important, telling you the status of your material in relationship to the scene. When you assign a material to an object in a scene the material sample slot appears with small triangles in each corner. These triangles indicate whether a material is assigned to an object in the scene and if it is assigned to the currently selected object.

Material Editor Options

When you create material there will be times when you will need to modify the settings in the Material Editor. Some of the settings affect the sample window, such as toggling the backlight or changing the size of the sample object. Others help to optimize your workflow by turning off the continuous updating of the sample window, allowing you to update the window only as needed, saving valuable time.

You access the various Material Editor options through the menu bar, the vertical toolbar, and by right-clicking a sample slot.

Following are some commonly used options as shown on the vertical toolbar to the right of the sample slots:

Sample Type flyout – lets you change the shape of the object in the active sample slot.

Background – toggles display of the background image in the active sample slot. This is especially useful when you work with reflective or refractive materials.

Options – opens the Material Editor Options dialog.

Material/Map Navigator – opens the Material/Map Navigator dialog, providing a hierarchical view of your materials.

Materials
& Mapping

Exercise 1: The Material Indicators

1. Open the File *Saloon_Scene01.max*.

2. Press **M** on the keyboard to open the Material Editor.

3. In the Material Editor, click the first sample window.

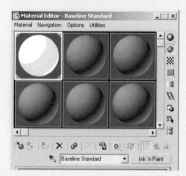

The border around this window is white, indicating that it is the active slot. Also, the corners contain gray triangles, indicating that the slot is assigned to an object in the scene.

4. In the Top viewport, select the object named Hitching Post 1.

The triangles in the corners of the sample slot change to white, indicating the material is applied to the selected object.

Exercise 2: Changing the Sample Shape

The default shape in the sample slots is a sphere, but not every object you will be working with is spherical. In many cases the sphere works well. However in some cases you might want to use a different shape, for instance if you are working on a coffee mug or a floor. Three standard types of shapes are available in the Material Editor.

- Sphere
- Cylinder
- Box

You can also specify a custom shape.

1. Open the file *Saloon Floor_Scene01.max*.

2. Press **M** on the keyboard to open the Material Editor.

3. Click Wood Floor, the first material sample slot.

4. From the Sample Type flyout choose the Box option, the rightmost button on the flyout.

The sample slot for the Wood Floor material now contains a box.

5. Select the material below the Wood Floor called Worn Brass.

6. From the Sample Type flyout choose the cylinder.

The Worn Brass sample slot now uses a cylinder.

Exercise 3: Using a Custom Sample Object

When working on a nonstandard object there will be times when you do not want to use one of the three predefined objects available for the sample slot. Instead, you can use a custom sample object. This lets you use the Material Editor to place a material on a more complex object without having to render the entire scene, saving you valuable time.

1. Open the file *Saloon Floor_scene01.max* or continue from the previous section.

2. Open the Material Editor.

3. Click the sample window named Brass Urn.

4. Click the Options button 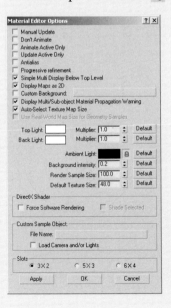 on the vertical toolbar.

5. In the Material Editor Options dialog > Custom Sample Object group, click the button to the right of the File Name label.

6. Use the Open File dialog to find and open *Urn01.max*.

7. Turn on Load Camera And/Or Lights, then click OK to close the dialog and accept your changes.

8. From the Sample Type flyout, choose the Custom type option.

The Urn model now can be used in the Material Editor's sample slots.

Exercise 4: Applying a Material to an Object

In addition to creating materials, you can use the Material Editor to assign materials to objects in the scene. 3ds Max offers several different ways to do this: One is to click the Assign Material to Selection button and another is dragging and dropping the material onto one or more objects.

1. Open the file *Saloon Floor_Scene04.max* or continue from the previous section.

2. Open the Material Editor.

3. In the Material Editor, click the Worn Brass material.

4. On the main toolbar, click the Select By Name button.

5. On the Select Objects dialog, choose the [Foot Rail] object and then click Select.

The Foot Rail group is selected.

6. In the Material Editor, click the Assign Material To Selection button ![icon] .

7. Click the Quick Render Button ![icon] to see the result.

8. In the Material Editor, click the Brass Urn material.

9. Right-click the sample slot and make sure the Drag/Copy option is active.

10. Drag the Brass Urn material from the Material Editor to the Spittoon object in the Camera01 viewport.

Note: When dragging a material onto an object in a wireframe viewport, you must drop the material onto a visible edge of the object.

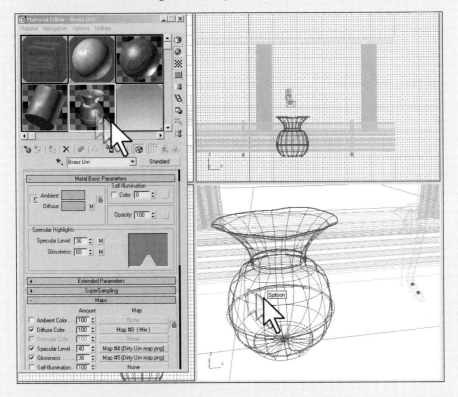

The sample slot changes to indicate the material is now assigned to an object in the scene.

11. Click the Quick Render Button to see the result.

Exercise 5: Creating a Simple Material

In this exercise you will use a Standard material to create a simple material definition.

1. Open the file *Urns_Scene01.max*.

2. Click the Material Editor button ⚏ on the main toolbar to open the Material Editor.

3. Select the top-left sample slot.

4. In the material name field, change the name to Blue Plastic.

5. On the Blinn Basic Parameters rollout, click the Diffuse color swatch. This represents the material color under direct lighting.

6. On the Color Selector dialog, set the values to R=5, G=64, B=187 to define a medium-blue color, and then click Close to accept the changes.

7. In the Blinn Basic Parameters rollout > Specular Highlights group, set Specular Level to 75 and Glossiness to 45. This makes the material shinier with a narrow highlight that simulates plastic.

8. Select the Urn 1 object in the Camera01 Viewport.

9. In the Material Editor, click the Assign Material To Selection button ![icon]. The newly created material is now applied to the urn.

10. Click the Quick Render button ![icon] to see the result.

11. In the Material Editor, drag the Blue Plastic material to an empty sample slot.

12. Rename the new material Yellow Glow.

13. On the Blinn Basic Parameters rollout, click the Diffuse color swatch.

14. Define a yellow color with R=187, G=176, B=5, and then click Close to accept the changes.

15. In the Specular Highlights group set Specular Level=45 and Glossiness=40. Because the Specular Level value is lower this time, this material is less shiny than the blue one you defined earlier.

16. In the Self-Illumination group set the value to 50. This will make the shadows on the yellow urn a little bit lighter.

17. Click the Urn 2 object in the Camera01 viewport.

18. In the Material Editor, click the Assign Material To Selection button.

19. Click the Quick Render button to see the result.

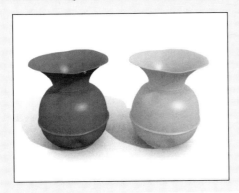

Material Types

Materials are all around you. Some are simple materials like a red ball, while others are much more complex like the waves on the ocean. 3ds Max offers several different types of materials that can be used for multiple purposes. The materials fall into two major categories: single materials and multiple materials. A single material is a material that works on its own; the Standard material is one example. Multiple materials like the Blend material are not meant to be used by themselves but in conjunction with single materials.

In 3ds Max there are two ways to choose a material type: You can click the Get Material button in the lower toolbar of the Material Editor or click the Material Type button to the right of the material name. Either option brings up the Material/Map Browser; however they perform getting a material in two different ways: The Get Material button replaces the material currently in the active slot with the new material. If the replaced material is assigned to an object in the scene, it is not affected. Only the material definition in the editor is replaced so you can create a new material for another object. On the other hand, if you have a material assigned to an object in your scene and you click the Material Type button, you replace the old material with the new one on all scene objects that are assigned that material.

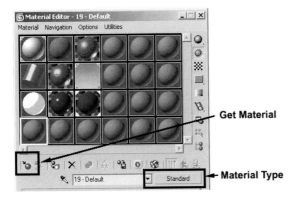

Get Material

Material Type

The Standard Material

While each material in 3ds Max serves a different purpose, they share many of the same parameters. Learning the default standard material will help you understand other material types in 3ds Max. The Standard material type is extremely flexible; you can use it to create an unlimited variety of materials.

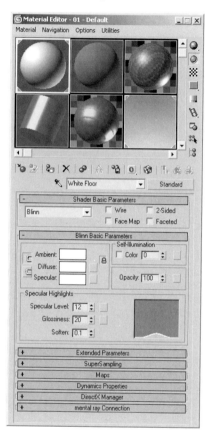

The Standard material uses the Shader Basic Parameters and Blinn Basic Parameters rollouts.

The Standard material provides an assortment of shaders that can be used to control how the surface looks. A shader is a mathematical formula that defines how a surface is affected by light hitting it. You can choose from eight shaders available on the Shader Basic Parameters rollout. Even though the Standard material has several common parameters, each shader has its parameters that are specific to that shader. When you choose a shader the Basic Parameters rollout controls change accordingly.

Shader Types

The list of shaders presents you with eight different choices. The Blinn shader is the default.

The Shader Basic Parameters rollout showing the eight shaders available

Shaders have several properties in common but each also has its own set of parameters.

Anisotropic - Creates a surface that can have non-round specular highlights. The Anisotropic shader can be used for surfaces like brushed metal.

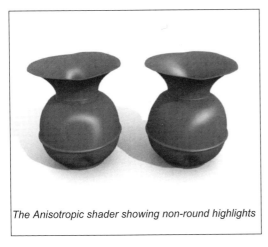

The Anisotropic shader showing non-round highlights

Note: Certain parameters such as Self-Illumination can be represented either by a color or an amount. With the check box to the left of the value turned off, you can enter a value. If you turn on the check box, you can use a color or map instead.

Blinn - Serves as a basic all-purpose shader with a round highlight. Blinn can be used for a wide range of materials, from rubber to stone to highly polished surfaces.

Metal - Simulates metallic surfaces

Multi-Layer - Contains two anisotropic highlights that work independently of each other. You can use Multi-Layer to create complex surfaces like satin, silk, and pearlescent paint.

Oren-Nayar-Blinn (ONB) - Creates Blinn-style highlights, but with a much softer look. ONB is often used for cloth, adobe-type clay, and human skin.

Phong - Remains from earlier versions of 3ds Max and functions similarly to Blinn. However, Phong highlights are looser than Blinn highlights and not as round. Phong is a flexible shader and can be used for hard and soft surfaces.

Strauss - Designed for quick creation of a wide variety of surfaces. It has few parameters and can create surfaces ranging from matte to metal. Strauss is an easy way to create any material, including glossy paint, brushed metal, and chrome.

Translucent—Similar to the Blinn shader but allows light to pass through an object. Use the Translucent shader to simulate backlight that illuminates an object.

The Raytrace Material

As with the Standard material, the Raytrace material lets you use Phong, Blinn, Metal, Anisotropic, and Oren- Nayar-Blinn shaders, but it also generates physically accurate reflections and refractions. Because of this, raytraced materials take longer to compute.

Ray tracing is a form of rendering that calculates rays of light from the screen to the lights in a scene. The Raytrace material uses this capability for additional features such as luminosity, extra lighting, translucency, and fluorescence. It also supports advanced transparency parameters such as fog and color density.

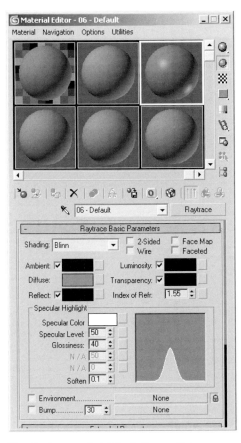

The Raytrace material Basic Parameters

The Architectural Material

The Architectural material type differs significantly from the two previously mentioned. It provides the greatest amount of realism when rendering with photometric lights and radiosity. Using the Architectural material with photometric lights and radiosity, you can create lighting studies with a high degree of accuracy. The settings for this material are actual physical properties.

The Architectural material provides physical base attributes for materials.

Templates – A unique feature of the Architectural material, the Templates rollout includes a drop-down list of preset materials. The templates give you a set of material values to get your material started, which you can then adjust to improve the material appearance.

The Ink 'n Paint Material

The Ink 'n Paint material type differs from the other materials in that it is designed to render non-photorealistic, cartoon-shaded images. It provides you with a great amount of flexibility for creating a unique style for your images and animations, creating anything from a simple hidden-line rendering to a complex, multicolor, cartoon-shaded image.

The Ink 'n Paint Material gives you controls for both the ink outline and the painted surface.

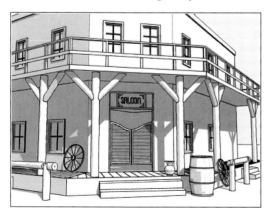

The Ink 'n Paint Material can give a rendered image a stylized, hand-drawn look.

Blend Material

The Blend material type is a multiple material, and therefore requires the use of other materials. With Blend you can combine two materials either by mixing them or by using a mask. The mask is a map such as a bitmap image or a procedural map like Noise. Blend uses the mask's grayscale values to control the blending. You can use Blend to create a variety of surface types such as peeling paint, wet floors, and rusted metal.

Exercise 6: The Wet Floor

Using a Blend material to create a wet floor can be as simple or as complex as you would like it to be. For instance, you might simply be going for a look that shows there is water on the floor, or you might to have the water pool in certain locations with ripples from drips and varying amounts of water. Those two examples show one way of using the Blend material in the same application with differing amounts of detail.

1. Open the file *Saloon Wet Floor_Scene01.max*.

2. Open the Material Editor.

3. Click the first material sample slot: Wood Floor.

4. Click the Material Type button.

5. From the Material/Map Browser, choose the Blend material and then click OK.

6. On the Replace Material dialog, make sure Keep Old Material as Sub-Material? is chosen, and then click OK to continue.

7. In the Material Editor move the mouse cursor over the third sample slot in the top row: Wet Wood Floor.

Materials & Mapping

8. Drag the Wet Wood Floor material onto the Material 2 button on the Blend Basic Parameters rollout of the Wood Floor material.

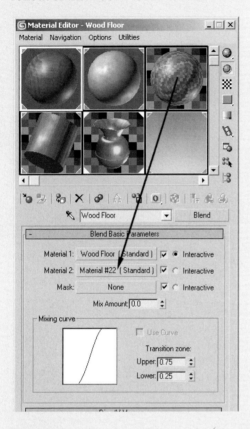

Note: It is important not to release the mouse button after you click the Wet Wood Floor sample slot or you will end up making it the active material.

9. On the Instance (Copy) Material dialog, choose Instance. Then click OK to continue.

10. On the Blend Basic Parameters rollout, click the Mask button.

11. On the Material/Map Browser, choose Browse From > Mtl Editor.

12. In the Material/Map Browser, choose the Wet Floor Mask map, and then click OK to accept the selection.

13. Choose Instance on the Instance or Copy? dialog. Click OK to continue.

14. Click the Go To Parent button to navigate to the top-level material.

15. Click Quick Render to render the scene.

Exercise 7: Saving the Scene Material to a Library

Now that your scene is complete you can save the material to a library for future use.

1. Open the file *Saloon Urn_Scene02.max* or continue from the previous section.

2. From the Rendering menu, choose Material/Map Browser.

3. On the Material/Map Browser, choose Browse From > Scene.

4. Click the Save As button in the File group of the Material/Map Browser.

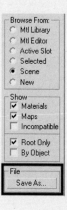

5. On the Save Material Library dialog, type in Saloon Floor and click the Save button.

Summary

In this lesson you have learned about the materials and their purpose, why they are important, and how they can be used. You have also learned about the Material Editor and how to use it to apply materials to objects in your scene. And, you have learned how to use the Material Editor to build simple materials and use the various tools available for working with materials.

Using Maps

When looking at two objects side by side, one with a burl oak finish and the other with a brushed aluminum finish, it is easy to see the difference in the texture of the objects. In this lesson you will learn about textures and the use of maps in 3ds Max. This lesson will show you what maps are used for and how to apply them to objects.

Objectives

After completing this lesson, you will:

- Understand what a texture is
- Understand the difference between a material and a texture
- Learn what map channels are
- Be able to use map channels to build a material
- Learn to create realistic real-world textures
- Understand the difference between 2D and 3D maps

Using Maps in Material Definitions

When you look at an old wooden desk or a newly polished wooden floor you are looking at the texture of the surface. For example, the difference between burl oak and knotty pine is the texture of the wood itself. In 3ds Max you can use image maps and procedural maps in a material to create textures for an object. These can create an infinite variety of textures and looks for the rendered object. A texture, however, is not just a map; textures can be simple, like the glass used in a bottle, or they can be very complex, like an old weathered pine fence. Whether you need to create high-tech sci-fi scenes or photorealistic real-world scenes, the texture of every surface can make or break the illusion.

Textures and Maps

By definition, a texture is the distinctive physical composition of an element with respect to the appearance and feel of its surface. Essentially, it is what you see when you look at something.

A real-world example of old peeling paint on a concrete barricade post

A close-up photo of weathered boards at the beach

In 3ds Max the texture is the end result of a material; whether the material uses maps or not does not matter. 3ds Max provides you a variety of maps that let you create textures that can be applied to objects for any purpose. Materials are able to define categories of textures. For example, you can create a wood material with properties that are common to various types of wood; however, wood is not a texture. If you were to ask someone to create "wood," they might not know what type of wood to create. That is where the texture of a surface comes in. If you tell someone to create highly polished burl oak, they will be able to deliver what you want.

Material: Steel Drum

The drum is rendered with a generic material.

Texture: Aged 55 gallon gray painted radioactive waste drum.

The drum is rendered with a material that results in a defined texture.

Materials
& Mapping

Maps

Textures in 3ds Max can be simulated without maps; however if you want to add any detail or other texture definition to the surface, a map is the way to do it. 3ds Max provides two types of maps that can be used in a material definition: a bitmap and a procedural map. Although the results can be similar, they function very differently.

Bitmaps

A bitmap is a two-dimensional image made up of individual picture elements (pixels) in a rectangular grid. The more pixels in an image, the higher its resolution (size) and the closer you can look at it without noticing the pixels. The size of the bitmap is important as you create animation where the camera moves close to a material containing a bitmap. A small- or medium-size bitmap works for objects that don't get too close to the camera. A larger bitmap might be needed if the camera zooms in on part of an object. The following example shows what happens when the camera zooms in on an object with a medium-size bitmap. This phenomenon is known as pixelation.

The bitmap image applied to the drum reveals its resolution when the camera zooms in.

In the above example, using a higher-resolution bitmap would reduce the amount of pixelation. Be careful, because higher-resolution bitmaps require more memory and take longer to render.

Procedural Maps

Unlike bitmaps, procedural maps are derived from simple or complex mathematical equations. One advantage to using procedural maps is that they do not degrade when you zoom in on them. You can set up procedural maps so that when you zoom in, more detail is apparent.

This palette of pink granite blocks is created using a series of procedural Noise maps.

The magnification reveals more details about the granite texture.

The flexibility of procedural maps provides a variety of looks. 3ds Max includes myriad procedural maps such as Noise, Tiles, Checker, Marble, and Gradient.

Map Types

When creating simple or complex mapped materials, you use one or more of the map types available in the Material Editor. You can use a bitmap or procedural map as the diffuse color, bump, specular, or any other available component of a material. You can use maps individually or in combination to get the look you want. Available map types vary among different shaders and materials, but several map types are relatively common. You can typically access a map type in any of several different ways.

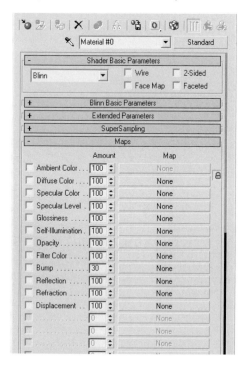

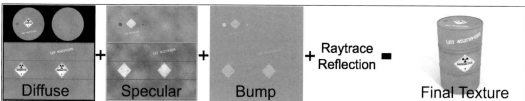

Map types can be used together to obtain a final result.

Accessing Map Types

To choose a map, click one of the small, square buttons on the Basic Parameters rollout for the shader or material. These map boxes appear next to the color swatches and numeric fields. However, not all map buttons are available in the Basic Parameters rollout. To access all map buttons, use the Maps rollout.

The Maps rollout provides access to all map channels.

Map Types

While many map channels are available for use, we will focus on the commonly used types.

Diffuse Color - This is one of the most frequently used map types. It determines the visible surface color of an object.

Specular Color - This determines the color of the specular highlight on a material. Using a map or changing the specular color provides a variety of special surface effects.

Specular Level - Using a map in this channel varies the amount of the specular level based on the grayscale value of the map. With this feature, you can add surface dirt, smudges, or scuff marks to a material.

Glossiness - Glossiness affects the size of the specular highlight; darker values spread it out while brighter values sharpen it and make the highlight smaller. You can create a variety of surface types, from flat to shiny, in the same material.

Opacity - Opacity determines the opacity or transparency of a material based on the grayscale values of the map. White is opaque and black is transparent. Opacity also presents several other options; it can be rendered with a filter color, as additive or subtractive.

Bump - The effect of bump-mapping on an object can be dramatic. Bump maps create the illusion of sunken and raised portions of a surface by setting a positive or negative value in the amount area. This effect allows you to fake geometry such as a rocky surface or dents.

Reflection - Use this parameter to create reflective materials, such as mirrors, chrome, shiny plastic, etc.

Exercise 1: Mapping the Drum

This exercise takes you through applying bitmap images to various material components to obtain a realistic result. The map types you'll use in this exercise are Diffuse, Specular Level, and Bump.

1. Open the file *Mechanical Scene01.max*.

2. Open the Material Editor.

3. In the Camera02 viewport, select the 55 Gallon Drum Texture object.

4. In the Material Editor, click the first sample slot.

5. Click the Get Material button .

6. In the Material/Map Browser double-click the Standard material type to get the new material and close the dialog.

7. Set the material name to Steel Drum.

8. On the Blinn Basic Parameters rollout, click the Diffuse map button.

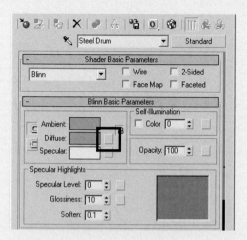

9. Choose Bitmap from the Material/Map Browser.

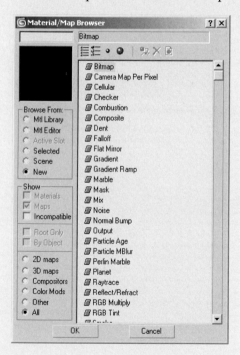

10. Use the Select Bitmap Image File dialog to find and open the *Drum Map.png* file.

11. In the Material Editor, click the Assign Material To Selection button ⛉.

12. In the Material Editor, click the Show Map in Viewport Button ⬡. This allows you to see the bitmap in the viewport.

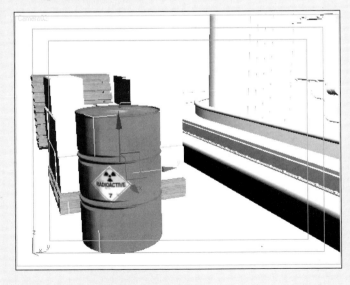

13. Click the Go To Parent button ⬆.

14. In the Blinn Basic Parameters rollout > Specular Highlights group, click the Specular Level map button.

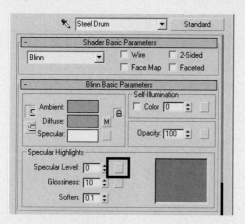

15. In the Material/Map Browser choose Bitmap.

16. Use the Select Bitmap Image File dialog to find and open the *Drum Map spec.png* file.

17. Click the Go To Parent button.

18. In the Blinn Basic Parameters rollout > Specular Highlights group set Glossiness to 35.

19. In the Material Editor, click the Maps rollout title to open it.

20. On the Maps rollout, click the Bump map button.

21. In the Material/Map Browser choose the Normal Bump map, and then click OK to accept the selection.

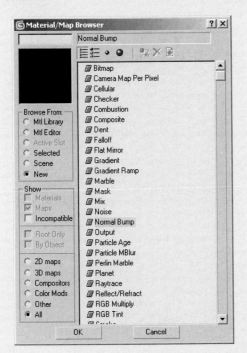

The Normal Bump map is an alternative to the standard Bump map.

22. On the Parameters dialog click the Normal map button.

23. In the Material/Map Browser choose Bitmap and click OK.

24. Use the dialog to open the *Drum Map normal.png* file.

25. Click the Material/Map Navigator button. The Navigator dialog provides an interactive method of working with your material, and provides a valuable tool for visualizing the hierarchy of your material.

26. On the Material/Map Navigator dialog, click the View List+Icons button.

27. In the Material/Map Navigator list, click the Steel Drum (Standard) material.

28. Click the Quick Render button to render the scene.

Mixing Maps

While simple materials sometimes suffice, most materials in the real world are fairly complex. In the next example, you learn to create a complex material that incorporates several different map types. Look around you; examine the texture of objects and surfaces in the real world. As you can see, virtually no surface has a simple texture. Some surfaces contain multiple layers and others are intricately designed. These aspects of material creation are important to keep in mind while working in the Material Editor.

Several available map types allow you to use several maps together. With the Mix and Composite maps you can combine multiple maps to generate a new map image. In addition, procedural 2D and 3D maps can use multiple maps in order to create textures that mimic real-world textures. Some of those maps include Checker, Gradient Ramp, Noise, and Tiles.

2D vs. 3D

Earlier in this lesson we showed how a 3D procedural map can simulate Pink Granite, and used a 2D bitmap map to make the texture for the steel drum. The difference between the two types of maps is easily demonstrated on the steel drum and granite blocks.

Procedural maps offer an advantage: They can be 3D. That means they fill 3D space, so a granite texture made from several Noise maps goes through an object as if it were solid.

Map Occupies Volume

The texture continues even though the block has been cut in two.

Bitmaps offer the flexibility of creating any texture you require, but they don't occupy 3D space. Bitmap maps require specific mapping coordinates in order to be rendered correctly. Because of this if you separate an object it will not show the same way as the 3D procedural map.

Incorrect Mapping

The material doesn't fill the drum properly because the mapping coordinates are not set up for the sliced polygons.

Exercise 2: Creating a Multi-Map Procedural Texture

In this exercise you will use multiple Noise maps to create a procedural pink granite texture. Noise is a 3D procedural map that provides a great deal of flexibility for creating textures. You can use the Noise map for materials ranging from ocean waves to the dirt on old metal pipes.

Ocean waves *Simple use of noise to age piping*

1. Open the file *Mechanical Scene02.max* or continue from the previous exercise.

2. In the Camera02 viewport, click the Pink Granite Blocks group.

Select Pink Granite Blocks

3. Open the Material Editor.

4. In the Material Editor, click the second sample slot.

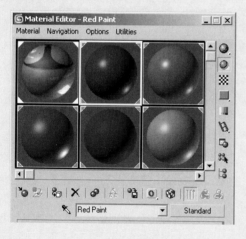

5. Click the Get Material button.

6. In the Material/Map Browser list double-click the Raytrace material to choose it and close the dialog.

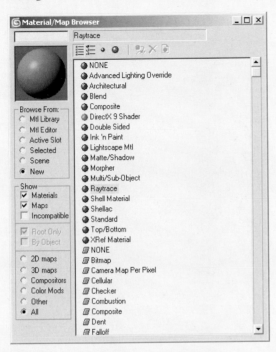

7. Name the material Pink Granite.

8. Click the Assign Material To Selection button.

9. On the Raytrace Basic Parameters, change the Shading option to Blinn.

10. Turn off the Reflect check box. This gives you access to the numeric value option.

11. Set the Reflect value to 5.

12. In the Specular Highlight group, set Specular Level to 90 and Glossiness to 50.

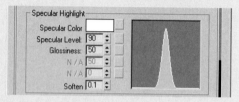

13. Open the Maps rollout.

14. Click the Diffuse map button.

15. From the Material/Map Browser choose Noise, and then click OK to use the map.

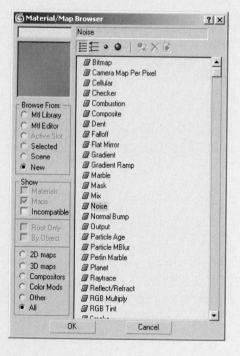

16. On the Noise Parameters rollout set Noise Type to Fractal.

17. Set Size to 0.5. This specifies the size of the noise pattern.

18. Set High to 0.69 and Low to 0.305. This setting allows you to adjust the contrast between Color #1 and Color #2.

19. Set Levels to 5.4. This value increases the apparent detail in the noise map.

20. On the Utility panel click Color Clipboard and then click the New Floater button.

21. On the Color Clipboard dialog, click the Open button.

22. Use the Load Color Clipboard File dialog to find and open the *Pink Granite.ccb* file.

23. Drag the top-left color from the Color Clipboard dialog to the Color #2 swatch on the Noise Parameters rollout.

24. In the Copy Or Swap Colors dialog, click the Copy button.

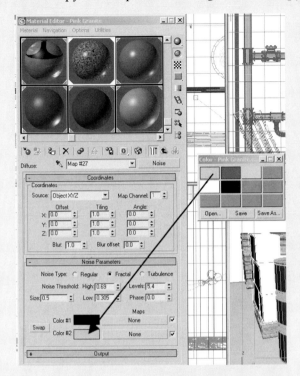

25. On the Noise Parameters rollout, click the Color #1 map button.

Access to map types within other maps makes it easier to layer maps for many different purposes.

26. On the Material/Map Browser double-click the Noise entry.

27. On the Noise Parameters rollout set Noise Type to Fractal.

28. Set Size to 0.3.

Materials & Mapping

29. Set Noise Threshold > High to 0.63 and Low to 0.45.

30. Set Levels to 8.1.

31. From the Color Clipboard dialog, drag the top row second swatch to the Noise Parameters > Color #1 swatch. Use Copy when prompted.

32. From the Color Clipboard dialog, drag the top row third swatch to the Noise Parameters > Color #2 swatch. Use Copy when prompted.

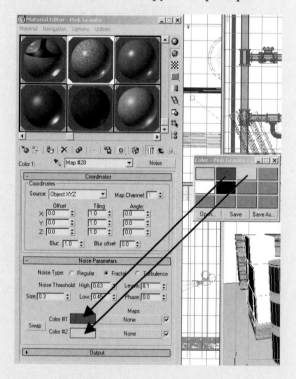

33. Click the Material/Map Navigator button.

34. On the Material/Map Navigator dialog, click the Pink Granite material if it is not already selected.

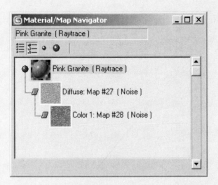

35. On the Maps rollout, drag the Noise map from the Diffuse map slot to the Translucency map slot.

36. On the Copy (Instance) Map dialog, choose Instance and then click OK to accept. This ensures that any changes to the Diffuse map are reflected in the instanced Translucency map.

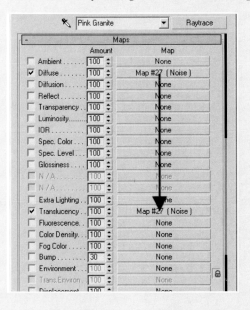

Materials & Mapping

37. Set the Amount value for the Translucency map to 26.

38. On the Maps rollout, drag the Noise map from the Diffuse map slot to the Bump map slot.

39. On the Copy (Instance) Map dialog, select Instance and then click OK to accept.

40. Set the Amount for Bump to 20.

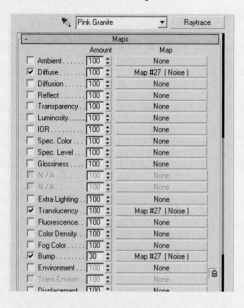

41. Click the Quick Render button to render the scene.

Summary

In this lesson you learned what a texture is and how textures and materials differ. You found out how a 2D map differs from a 3D map and how a bitmap differs from a procedural map. Lastly, you worked through using both bitmaps and 3D procedural maps to create realistic textures.

Mapping Coordinates

When applying textures to objects it is important that the mapping be appropriate for the object you have created. In this lesson you will learn about UVW mapping and applying the mapping to objects in 3ds Max. This lesson will show you what various UVW mapping types are used for and how you can apply them to objects.

Objectives

After completing this lesson, you will:

- Understand what mapping is
- Understand how UVW mapping coordinates function
- Learn the various UVW mapping types and work with real-world mapping
- Be able to work with the UVW Map modifier
- Understand the Unwrap UVW modifier
- Use the Render To Texture feature to render a map

Mapping

When you look at a rendered object such as a soda can or an office desk, the reason these objects look correct is the UVW mapping of the texture maps. Whether it's a round can, a box, or a non-uniform shape, UVW mapping tells 2D maps how to be applied to an object.

UVW Mapping

When using materials with 2D maps, it is important that objects contain UVW mapping information. This information tells 3ds Max how to project the 2D map onto the object. One way to apply UVW mapping coordinates to an object is with the UVW Map modifier. This modifier allows you to control how the mapping is applied.

Many 3ds Max objects have default mapping coordinates. Loft objects and NURBS objects also have their own mapping coordinates; however, their coordinates are controlled without adding a UVW Map modifier.

Mapping Coordinates

You use the UVW Map modifier to control mapping coordinates on objects. It offers several different mapping methods and a number of adjustable parameters.

The UVW Map modifier panel

Mapping Types

You use the mapping option to choose how to apply the UVW coordinates to an object. Some of the more common types are:

- Planar
- Cylindrical
- Spherical
- Box

Planar

This applies the UVW coordinates as a flat plane projected onto an object. It is used for flat surfaces such as paper, walls, or to apply a 2D map to any planar surface.

Planar mapping on the floor of the room

Cylindrical

This mapping type uses a cylinder to project a map onto an object. Potential applications include screws, pens, telephone poles, and pill bottles. Turning on the Cap option adds planar mapping projected onto the top and bottom of the cylinder.

Indicator lamps using cylindrical mapping

Spherical

This wraps the UVW coordinates around an object in a spherical projection, creating a seam where the sides of the map meet and singularities at the top and bottom where the corners unite.

The Plasma Generator texture spherically mapped

Box

A Box map is projected onto an object from six sides; each side is a planar map. The face normals determine the placement of the map on an irregular surface.

Box mapping applied to boxes

Exercise 1: Applying UVW Mapping

In the following exercise you will apply UVW mapping coordinates to several objects in a low-polygon scene. UVW mapping can be applied with the UVW Map modifier, and can be modified to work with many objects. This includes the ability to apply mapping coordinates that have a real-world size, so you can specify how large the bitmap you are using will be when it is rendered. You'll apply planar mapping using the Real-World Map Size option.

1. Open the file *Reactor01.max*. If the Units Mismatch dialog appears, click OK to accept the default option.

2. Click the Select By Name button.

3. On the Select Objects dialog highlight Floor and then click the Select button.

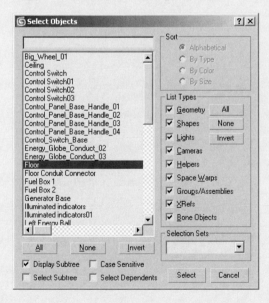

4. On the Modify panel, choose UVW Map from the Modifier List.

5. On the Parameters rollout, turn on Real-World Map Size.

The Real-World Map Size option lets you specify an actual size for the map in the Material Editor. So whether you are working in inches, feet, or millimeters, you can specify the dimensions of the map.

6. Open the Material Editor.

7. In the Material Editor, choose the third sample slot with the material named Planar Map.

8. On the Blinn basic Parameters rollout, click the Diffuse map button.

9. On the Coordinates rollout, turn on Use Real-World Scale.

10. Set the Width > Size to 2'0.0".

11. Set the Height > Size to 2'0.0".

12. Click the Assign Material To Selection button 🗐 .

13. Click the Go To Parent button 🔩 .

14. Click the Quick Render button.

Exercise 2: Box Mapping

1. Open the File *Reactor02.max* or continue from the previous section.

2. In the Camera01 viewport, select the Fuel Box 1 object.

3. On the Modify panel, choose the UVW Map modifier from the Modifier List to apply the modifier to the object.

4. On the Parameters rollout > Mapping group, change the Mapping option to Box.

5. In the Alignment group, click the Fit Button.

6. Open the Material Editor.

7. Click the sample sphere for the Box Map material. It has a radiation logo on it.

8. Click the Show Map In Viewport button .

9. In the Camera01 viewport select both boxes: Fuel Box 1 and Fuel Box 2.

10. In the Material Editor click the Assign Material To Selection button.

The map has been applied to all six sides of the fuel boxes.

Exercise 3: Spherical Mapping

1. Open the File *Reactor03.max* or continue from the previous section.

2. In the Camera01 viewport, select the Plasma Generator object. It is the lower of the three large spheres displayed in the view.

3. Add a UVW Map modifier to the object.

4. Set the Mapping to Spherical.

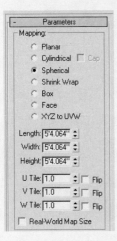

5. Open the Material Editor.

6. Click the Sphere Map material.

7. Turn on Show Map In Viewport and assign the material to the Plasma Generator object.

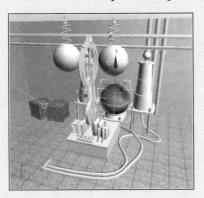

8. On the Modify Panel, in the modifier stack, click the + symbol to the left of the UVW Mapping entry.

9. Click the Gizmo sub-object.

10. On the main toolbar, click the Select And Rotate button.

11. In the Camera01 viewport highlight the Z axis and rotate the mapping gizmo approximately -60 degrees.

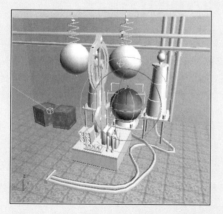

Rotating the mapping gizmo ensures that no mapping seams are visible to the camera.

12. In the modifier stack, click the Gizmo entry to exit that sub-object level.

13. Quick render the scene.

Unwrap UVW

Once you have an understanding of how materials in 3ds Max can be mapped onto objects, you are ready to move on to more advanced features of applying mapping coordinates. The Unwrap UVW modifier provides an advanced toolset for customizing UVW mapping, a process often used in the game industry to make a low-poly object look much more complex.

Unwrapping the UVW coordinates on an object means you are making a custom UVW map for your object. Rather than using one of the default UVW mapping options, you can specify where each polygon should be located on the map used in the material definition. The UVW map options work well for certain objects, especially those that are not easily mapped with the more conventional UVW Map modifier.

The Unwrap UVW modifier includes a specialized editor with many features to make the unwrap process easier.

You typically start off in the Edit UVWs dialog by dividing your object's polygons into clusters. Clusters are groups of attached polygons that make creating the bitmap much easier. Clusters are usually divided into groups of polygons that face a similar direction, or polygons that have the same material. The larger the clusters, the easier it is to make the map. However you want to make sure you can identify the clusters while keeping warped polygons to a minimum. Warped polygons cause streaking, where pixels from the bitmap look more like blurred lines.

These clusters are arranged in UVW space, which reflect the three directional axes of the map, much as X, Y, and Z directions work on objects. The letters U, V, and W are used so that you won't mix them up with the XYZ 3D space in your viewports.

When your object has an Unwrap UVW modifier applied, the outside edges of the various clusters are shown as green lines on the object surface in the viewports.

Unwrap UVW tools

The Unwrap UVW modifier and the Edit UVWs dialog offers several tools that are useful in helping you set up your map.

Transform Tools

The Edit UVWs toolbar includes the transform tools: Move, Rotate, Scale, and Mirror. They work as you would expect them to. Freeform Mode is different, and is probably the tool you'll use the most.

The Freeform Mode tool is active by default.

Mapping Tools

The Mapping tools, found on the Mapping menu of the Edit UVWs dialog, provide methods for automatically unwrapping a set of polygons. You can apply these tools to the entire mesh or to a sub-object selection in the editor. The three methods are Flatten Mapping, Normal Mapping, and Unfold Mapping.

An object shown with the mapping coordinates automatically unwrapped using the Flatten Mapping option

Render UVW Template

This handy tool, found on the Tools menu of the Edit UVWs dialog, allows you to render out a bitmap of the UVW mapping coordinates that you applied to your object.

The unwrapped bitmap allows you to paint directly onto the mapping coordinates in your favorite image-editing program.

Direct Mapping Options

The Map Parameters rollout of the Unwrap modifier offers access to standard mapping types and Pelt mapping. Pelt mapping lets you stretch out an object's mapping coordinates as if the surface were an animal pelt. This provides a simple way to apply mapping coordinates to complex objects.

A simple, low-poly object using the Pelt mapping option

Exercise 4: Using Unwrapped Mapping Coordinates

In this exercise you will apply a material with a custom texture to an object that uses an Unwrap UVW modifier.

1. Open the file *Reactor04.max*.

2. In the Camera01 viewport, select the Reactor_2 object.

3. Apply an Unwrap UVW modifier to the Reactor_2 object.

4. On the Parameters rollout, click the Edit button to open the Edit UVWs dialog.

5. On the Edit UVWs dialog, choose the Pick Texture option from the texture display drop-down list.

6. On the Material/Map browser in the Browse From group, choose Mtl Editor.

7. Click Diffuse Color: Map#8(*Reactor_Map.png*) and then click OK to accept the choice.

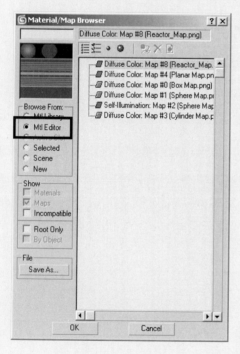

The map is applied.

8. In the modifier stack display, expand the Unwrap UVW entry and click the Face sub-object level.

9. On the Selection Parameters rollout, make sure Ignore Backfacing Option is off.

10. In the Front viewport, drag a selection around the faces on the bottom of the object.

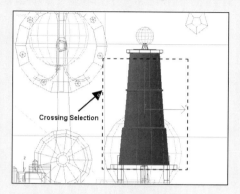

11. In the Front Viewport, zoom in to the top of the Reactor_2 object.

12. Press and hold the **CTRL** key, and then drag a selection through the top ring of the Reactor_2 Object.

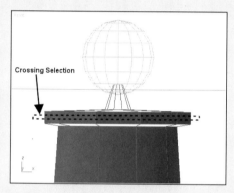

13. Still holding **CTRL**, drag a selection through the tip of the Reactor_2 Object.

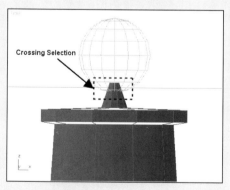

14. On the UVW Unwrap modifier > Map Parameters rollout, click the Cylindrical button.

15. In the modifier stack display, exit the Face sub-object level by clicking the Face entry again.

16. On the Edit UVWs dialog, click the Zoom Extents button .

17. Open the Material Editor.

18. In the Material Editor, choose the material named Unwrap UVW.

19. Click the Apply Material To Selected button .

20. Close the Material Editor.

21. On the Edit UVWs dialog, click the Options button in the bottom-right corner of the interface.

22. In the Viewport Options group, turn on Constant Update. This gives you real-time feedback as you adjust the mapping coordinates.

23. In the Edit UVWs dialog, select the upper cluster.

24. Using the Freeform Mode tool, place the cursor inside the selection and move the selected polygons to the center of the upper-left circle with the red-to-gray gradient.

The Freeform Mode tool lets you easily move polygons around the UVW mapping space.

Materials
& Mapping

25. Holding the **ALT** and **CTRL** keys, drag the lower-right-corner handle to scale the polygons uniformly about their center point and fit them inside the red-to-gray circle.

The Freeform Mode tool used with the modifier keys can make scaling simple.

26. In the Selection Modes group, turn on Select Elements.

27. Select the lower section of polygons by clicking the element.

28. Holding the **SHIFT** key, move the selected element to the left in order to line it up with the two strips of polygons above the element.

Holding the **SHIFT** key lets you move the selected element horizontally or vertically only.

29. With the **CTRL** key pressed, select the two elements above the currently selected one.

30. Holding the **SHIFT** key, move the selected elements up so the top line is at the top of the horizontal portion in the bitmap.

31. Click the Zoom Extents button.

32. Holding the **SHIFT** key, drag the bottom-right corner of the Freeform gizmo upward to fit the grid, as shown in the following illustration.

33. In the Selection Modes group, turn off Select Element and choose the Vertex Sub-object mode button.

34. Click the Zoom Extents button.

35. In the Edit UVWs window, select the vertices in third row/group from the bottom, as shown.

36. Holding the **SHIFT** key, drag the top-right corner of the Freeform tool gizmo upward to scale and align the top row of vertices with the top of the upper yellow bar.

37. In the Edit UVWs window, select the vertices in second horizontal group from the bottom.

38. Holding the **SHIFT** key, drag the top-right corner of the Freeform tool gizmo upward to scale and align the top row of vertices with the top of the lower yellow bar.

39. Close the Edit UVWs dialog.

40. In the modifier stack display, click the Vertex level to exit that sub-object level.

41. Render the scene to view the results.

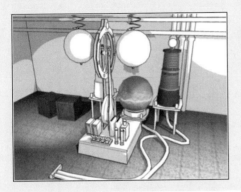

Render To Texture

Render To Texture takes various aspects of an object's appearance and "bakes" them into one or more maps for the object. The Render To Texture command is found on the Rendering menu.

Texture Baking

Texture baking is a method by which an object's texture and other attributes, such as lighting or surface normals, can be saved as a map for the object. This process is used in various 3D professions, including the games industry. Baked textures can be used to preserve lighting and shadows in a character's material and can also be used to create normal maps that transfer surface detail from high-poly models to low-poly models. You can also use baked textures to convert procedural maps to bitmaps, or multiple maps and other surface aspects into a single map. Texture baking is particularly useful for non-animated objects because it speeds up rendering considerably.

Two more common uses of texture baking are to bake advanced lighting or mental ray materials onto an object. Both can increase rendering time considerably, so baking them into the texture can save time if you are doing a lot of rendering.

Dependence on Mapping

For Render To Texture to work on an object, the object needs to have its UVW mapping coordinates unwrapped. If you have not already used Unwrap UVW to map your object, Render To Texture includes an automatic unwrap feature that works exactly like Flatten mapping in the Unwrap UVW modifier. The downside of using automatic unwrapping is that your unwrapped mapping coordinates are not combined into logical clusters, and if you have to edit the map later on, it might prove difficult.

It is also important that each face in the mesh occupy unique UV coordinates. If you have any overlapping faces, Render To Texture won't work properly and the final map will not look correct.

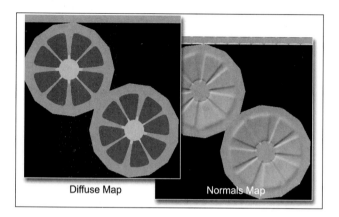

Rendering a normal map using projection mapping

The normal map is a powerful map type that has become extremely useful for 3D artists working in game development and other professions. Normal maps are used to make a low-poly object look much more complex by using high-detail model as a base.

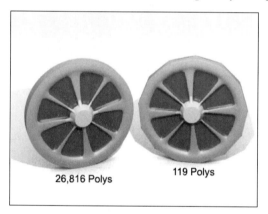

A normal map works similarly to a bump map in that it is used to make a flat surface look three dimensional. However, normal maps are much more powerful than bump maps. Normal maps use RGB data in the image to store the exact angle of the surface at a particular pixel. With this information, the low-poly object looks just as complex as the high-poly object, except at the edges, where you can make out the low-poly silhouette.

To make a normal map, you use Render To Texture in conjunction with a Projection modifier. You also need high- and low-poly versions of the same object. The high-poly object cannot be hidden or have its Renderable property turned off, otherwise the projection does not work because it cannot render the high-poly object.

Exercise 5: Rendering a Normal Map

1. Open the file *Flywheel01.max*.

 If the Units Mismatch dialog appears, click OK to accept the default option.

2. Select the Small_wheel_Lowres object.

3. From the Rendering menu, choose Render To Texture.

4. In the Render To Texture dialog > Projection Mapping group, turn on Enabled to activate projection mapping.

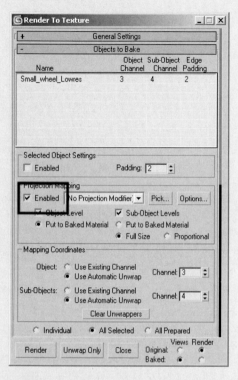

5. In the same group, click the Pick button to add targets to the projection mapping.

6. Highlight the Small Wheel High Res object on the Add Target dialog, and then click the Add button to accept the selection.

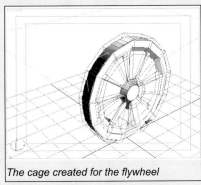

The cage created for the flywheel

7. On the Modify panel, open the Cage rollout of the Projection modifier.

8. Click the Reset button at the bottom of the rollout.

9. In the Cage rollout > Push group, set Amount to 1.7. Be sure to press **TAB** or **ENTER** to apply the change; the field value returns to 0.0.

In order for the Projection to work properly, the cage must encompass all of the geometry you want to project to the Render To Texture image. In this case pushing the cage outward accomplishes this.

10. In the Render To Texture dialog > Objects to Bake rollout > Mapping Coordinates group, set the Object option to Use Existing Channel and keep the default Channel value of 1.

11. If necessary, pan the dialog to display the Output rollout. Click the Add button.

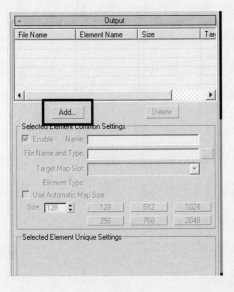

12. On the Add Texture Elements dialog, highlight DiffuseMap and NormalsMap and then click the Add Elements button to accept the selection. This will generate these two map types as output.

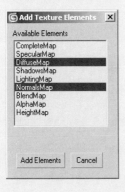

13. In the Output elements list highlight the DiffuseMap element.

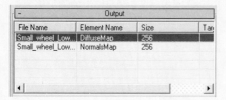

14. In the Output rollout > Selected Element Common Settings group, set Target Map Slot to Diffuse Color. This indicates you wish to replace the current Diffuse channel with the newly generated map.

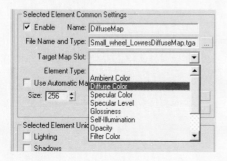

15. Set the Map Size to 512.

16. In the Output elements list highlight the NormalsMap Element.

17. In the Output rollout > Selected Element Common Settings group, set Target Map Slot to Bump. This ensures the Bump channel will use the resulting normal map file.

18. Set the Map Size to 512.

19. In the Selected Element Unique Settings group, turn on Output Into Normal Bump.

20. On the Render To Texture dialog, click the Render button.

21. Select the Small Wheel High Res object.

22. Right-click the object and choose Hide Selection from the quad menu.

23. Open the Material Editor.

24. Click the Pick Material from Object button ✎ .

25. In the Camera01 viewport, click the Small_wheel_Lowres object.

26. In the Material Editor, on the Shell Material Parameters rollout, set the Render option to Baked Material.

27. Click the Quick Render button to render the result.

Summary

After going through this lesson, you have an understanding of mapping and mapping coordinates. You have also learned about real-world mapping size and the UVW Map modifier. As well, you've learned how the Unwrap UVW modifier can aid in mapping and how to use the Render To Texture toolset to create diffuse and normal maps from a high-resolution object.

Materials and Mapping

In this lab, you will create and apply materials and textures to the underwater scene you built in a previous lesson. You will create materials appropriate for the scene and use the VertexPaint modifier to blend them together. Using special tools, you can align materials with scene objects. You will render the scene from time to time to check on your progress.

Objectives

After completing this lesson, you will be able to:

- Apply UVW Map modifiers to objects
- Adjust the UVW Map gizmo
- Create Standard materials
- Create Blend materials
- Apply map types to material definitions
- Use various map channels such as Diffuse, Specular, Bump, Reflection and Opacity
- Set a spotlight to project an image

Exercise 1: Create a Material for the Ocean Floor

In a previous lesson, you created an underwater environment but applied no materials. You created the ocean floor with a flat plane that you edited into an irregular terrain. In this exercise, you will create a material based on a bitmap to apply a sand texture to the ocean floor. You will also apply and adjust mapping coordinates so that the material displays properly on the mesh.

1. Open the file *UNDERWATER_SCENE_MATS_01.max*.

2. In the Perspective viewport, select the OCEAN_FLOOR_01 object.

 The ocean floor is a modified plane with a fair amount of detail. A sand texture map has already been created and provided for use in this exercise.

3. On the main toolbar, click the Material Editor button 🞂.

4. In the Material Editor window, click the first available material sample and name it *SAND_01*.

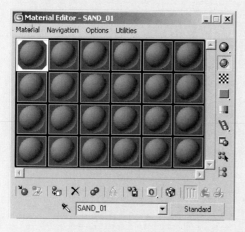

5. On the Blinn Basic Parameters rollout, click the Diffuse map button.

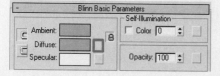

6. On the Material/Map Browser, double-click Bitmap.

7. Use the Select Bitmap Image File dialog to find and open the *Sand_01.jpg file*.

Note: To see the bitmap, click Bitmap Parameters rollout > View Image.

8. Click the Go To Parent button ⬆ on the Material Editor lower toolbar to return to the material top level.

9. Click the Assign Material to Selection button 🔲 on the Material Editor lower toolbar.

10. Click the Show Map In Viewport button 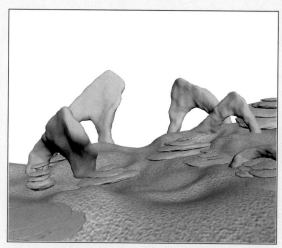 to see the material in the shaded viewport.

With Show Map In Viewport on, you can see the texture in the viewport.

11. From the Modify panel > Modifier List drop-down, choose UVW Map.

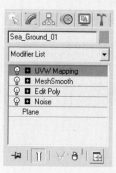

This applies and fits an orange mapping gizmo to the ocean floor plane. The default mapping type is Planar. Planar mapping should work well for this object, but you still need to adjust the tiling of the texture.

12. In the Modify panel > Mapping group, set both U Tile and V Tile to 8.0.

The sand image is now repeated eight times in each direction, making the sand grain finer.

Note that the Sand_01 texture you are using works well as a seamless texture. This means that no visible edges occur between tiles when the scene is rendered. You can use a 2D image-editing program to fine tune the tiling of the texture. The following images show both a poorly made and a well-made tiling image map.

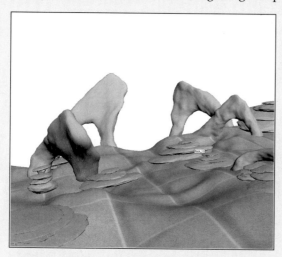

The tiling is clearly visible.

This texture map was made to tile without noticeable edges.

13. Render the scene to view the results.

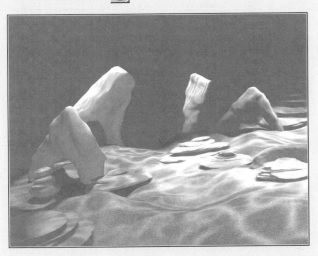

Exercise 2: Fine Tune the Sand Material

1. Continue from the previous section or open the file *UNDERWATER_SCENE_MATS_02.max*.

2. On the main toolbar, click the Material Editor button 🎱.

3. In the Material editor, choose the first sample slot in the upper left corner.

 This is the sand material applied to the ocean floor object.

4. Click the material type button to the right of the material name; it's currently labeled Standard.

This opens the Material/Map Browser.

5. On the Material/Map Browser, double-click Blend to choose this material type.

6. In the Replace Material dialog, choose Keep old material as sub-material? if necessary and then click OK.

This ensures that your work on the material so far is retained and is incorporated into the new material definition.

You now have access to two different materials: Material 1 and Material 2. Material 1 is the sand material that you retained.

7. Click the Material 2 button.

8. On the Blinn Basic Parameters rollout, click the Diffuse map button.

9. In the Material/Map Browser, double-click Bitmap.

10. Use the Select Bitmap Image File dialog to find and open the *Rock_01.jpg file.*

11. In the Bitmap Parameters rollout > Cropping/Placement group, click the View Image button.

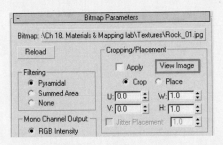

This dialog allows you to crop a smaller area of a larger image to use as a map. Since this image is already edited to tile seamlessly, be sure the Cropping/Placement group > Apply option is turned off.

12. Click the Go To Parent button ⬆ to move up one level in the material definition.

13. Rename the material *Rock_01.*

14. Click the Go To Parent button again to return to the Blend Basic Parameters rollout.

15. On the Blend Basic Parameters rollout, click the Mask map button.

16. In the Material/Map Browser, double-click Vertex Color.

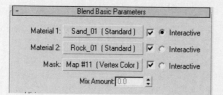

As its name implies, the Blend material blends two individual materials either by specifying a Mix Amount value, or by using a mask. The latter option provides better control over blending between the two materials.

Exercise 3: Create a Blend Mask

In this exercise, you will use the Vertex Color map to create a blend mask.

1. Continue working from the previous section.

2. In the Perspective viewport, select the OCEAN_FLOOR_01 object and right-click it to open the quad menu.

3. From the quad menu choose Properties.

4. In the Object Properties > Display Properties group, turn on Vertex Channel Display, if necessary. Also, choose Vertex Color from the drop-down list, if necessary.

5. Click OK to exit the dialog.

6. Go to the Modify panel ![] and choose VertexPaint from the Modifier List drop-down.

The VertexPaint modifier lets you paint vertex colors on an object. You're not restricted to vertex-level painting. Using sub-object selection, you can also control which vertices get painted face-by-face. All faces sharing a vertex have the adjacent corner shaded as well. As a result, the painted object receives a coarse gradient across each face.

Note: To render vertex colors, you must assign a Vertex Color Map, as described earlier in the Fine Tune the Sand Material section.

The VertexPaint modifier also lets you paint values for the alpha and illumination channels. These channels affect the transparency and shading channels of each vertex, respectively.

7. Click the Paint button (paintbrush icon).

8. Place the cursor over the OCEAN_FLOOR_01 object.

 The cursor takes the form of a crossed circle with a perpendicular line showing the surface normal at that point.

9. Drag to start painting on the model. Perform a few brush strokes by painting on the sea floor in the viewport.

 The brush strokes should appear in black.

10. Render the scene to view the results.

The end results do not appear in the viewport, but they do when you render the scene.

11. In the Material Editor > Blend Material, drag the Sand_01 button onto the Rock_01 button.

12. On the Instance (Copy) Material dialog choose Swap and click OK.

14. Render the scene again.

The areas that previously rendered as rock now render as sand and vice-versa.

13. Save the scene and name it *MY_UNDERWATER_SCENE_MATS_03.max*.

Exercise 4: Apply a Material to the Rocks

1. Continue from the previous section, or open *UNDERWATER_SCENE_ROCK_01.max* file.

2. Press the **H** key on your keyboard and select Rock_11 through Rock_14.

This selection is one of the rock piles in the scene.

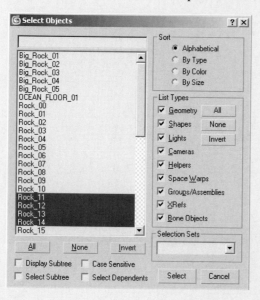

3. Press **ALT+Q** to activate Isolation Mode.

 This makes it easier to work on the selected objects only.

4. Press **M** to open the Material Editor.

5. Activate the second material, Rock_and_Moss, if necessary.

This is a Blend material with a Noise map in the Mask slot, similar to the one you created earlier for the ocean floor except that it uses a Noise map instead of a Vertex Color as a mask.

6. Click Assign Material To Selection ![icon] to apply the material to the selected rocks.

7. Click the ROCK_02 (Material 1) button.

8. Make sure the Show Map In Viewport button ![icon] is on.

Note: When using a Blend material, you can show only one material at a time in the viewport. To choose which material is shown in the viewport, use the Interactive setting on the Blend Basic Parameters rollout.

In the viewport, notice the stretching problem on the texture.

9. In the viewport, select Rock_14, the topmost rock.

10. From the Modify panel > Modifier List, choose UVW Map.

The default planar mapping applied to the rock fixes the stretching problem.

11. Drag the UVW Map modifier from the modifier stack to the viewport and drop it onto Rock_11, the second rock from the top.

12. Select Rock_11.

13. In the Modify panel > UVW Mapping> Alignment group, click the Acquire button.

14. In the viewport, click Rock_14.

15. On the Acquire UVW Mapping dialog, choose Acquire Absolute and click OK.

16. Repeat the procedure until all the rock objects in the scene are mapped with a UVW Map modifier.

17. Exit Isolation mode when done.

18. Render the scene to see the result.

19. Save your progress.

Exercise 5: Finalize and Adjust the Rock Material

1. Continue from the previous section, or chose File > Open from the menu bar, and open the *UNDERWATER_SCENE_ROCK_02.max* file.

2. Open the Material Editor ⚃.

3. Press the **H** key to open the Select Objects dialog and select Big_Rock_01 through Big_Rock_05.

4. From the Modify panel > Modifier List, choose UVW Map.

5. On the Modify panel > Parameters rollout, set the U Tile and V Tile values to 40.0.

6. In the Modifier panel > Alignment group, click the View Align button.

This aligns the UVW mapping projection to that of the camera.

7. In the Material Editor, click the Assign Material To Selection.

8. Render the scene.

Exercise 6: Create the Caustic Effect

Caustics are the visual pools of light that occur when light passes through a clear body such as water. In an ocean environment the waves and wind cause the surface of the water to become rough, affecting the light that passes through it. Simulating this effect is crucial to creating a convincing underwater scene. In the following exercise you will use a map to simulate caustics.

1. Continue from the previous section or open the file *UNDERWATER_SCENE_ROCK_03.max*.

2. Open the Material Editor ![icon] and click a new material sample slot.

3. Click the Get Material button ![icon].

4. In the Material/Map Browser, double-click the Noise Map.

5. Name the new map Caustic.

6. On the Coordinates rollout, set Source to Explicit Map Channel.

7. On the Noise Parameters rollout, set Noise type to Turbulence.

8. Set Size to 0.1, Noise Threshold > High to 0.3, and Levels to 2.0.

These values will affect the noise shape and the contrast between the two noise colors.

9. Click the Color #1 swatch and set the color to R=220, G=225, B=228.

10. Click the Color #2 swatch and set the color to R=85, G=99, B=115.

11. Open the Select By Name dialog and select Light_Direct01_Volume.

12. In the Modify panel 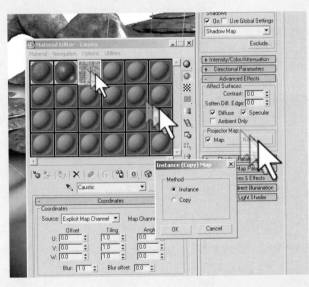 > Advanced Effects rollout, drag the Caustic material from the Material Editor onto the map button in the Projector Map group.

13. In the Instance (Copy) dialog, choose Instance, and then click OK.

14. Repeat the process with lights, Light_Direct02_Volume, Light_Direct03_Volume, and Light_FDirect_Volume_Back so that all these lights project a caustic effect into the scene.

Materials & Mapping

15. Click Rendering menu > Environment to open the Environment And Effects dialog.

16. On the Environment and Effects dialog > Atmosphere rollout, choose Volume Light Caustic and turn on Active to enable the effect.

17. Render the scene 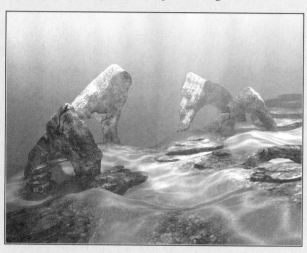. This time, it will take a bit longer to render, this is because atmospherics require more processing time to calculate.

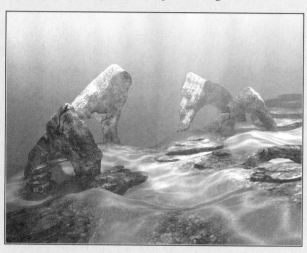

Summary

Materials and textures are important when creating a believable scene. Even if your models are highly detailed, poorly made and applied materials and maps can result in a rendered scene that does not look very good. Texturing and mapping can take a lot of time, but, it is well worth the effort to take the time to do it right.

Rendering

The Rendering chapter discusses the use of lights, cameras and rendering output techniques. This includes basic theory of camera shots and motion, basic lighting techniques, global illumination engines, and batch rendering. The final Scene Assembly Lab in this chapter is a "Full-Day Scenario" and is meant to be the last completed. You can follow the provided pointers or experiment with your own ideas.

When you have covered the chapters and the last lab, you are ready for the world of 3D animation. Congratulations and have fun animating!

- Lesson 18: Cameras
- Lesson 19: Basic Lighting
- Lesson 20: Global Illumination
- Lesson 21: Rendering the Scene
- Lesson 22: Scene Assembly Lab

Cameras

The camera acts as a roving eye, telling a story as it travels throughout the scene. It gives the viewer a privileged position from which to watch the story unfold.

As you plan your camera shots, try to focus on what holds your attention, what makes an image strong and when a timed action should take place. Consider these options, keeping in mind that the human eye is drawn to specific things such as movement, color differences, and weights of objects in a shot.

Objectives

After completing this lesson, you will be able to:

- Create and manipulate Target and Free cameras in 3ds Max
- Understand how to frame a camera shot
- Understand camera parameters such as lens size and aspect ratio
- Apply extreme camera angles to create dynamic shots
- Understand the line of action and abide by its rules
- Animate camera motion using Path Constraint

Camera types in 3ds Max

You can use two different camera types in 3ds Max to frame your shots: the Target camera and the Free camera.

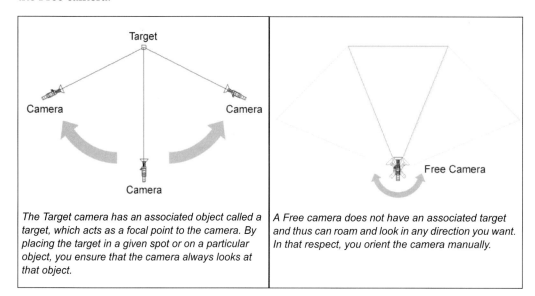

Target	
Camera	Camera
Camera	Free Camera
The Target camera has an associated object called a target, which acts as a focal point to the camera. By placing the target in a given spot or on a particular object, you ensure that the camera always looks at that object.	A Free camera does not have an associated target and thus can roam and look in any direction you want. In that respect, you orient the camera manually.

The camera type you use in a given situation depends largely on the action taking place and the camera shot you are trying to capture. You will learn how to create, position, and animate both camera types as you learn the theory associated with camera shots.

Framing a Camera Shot

A basic set of conventions assigns names and guidelines to common types of shots, framing, and picture composition. The most basic shot types are the long shot, the medium shot, and the close-up.

In some situations, you might use a more extreme camera shot to convey a particular feel for the story. For example, using an extreme close-up shot emphasizes emotions such as fear or anger in a subject's eyes.

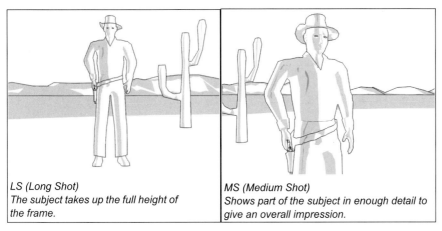

LS (Long Shot)
The subject takes up the full height of the frame.

MS (Medium Shot)
Shows part of the subject in enough detail to give an overall impression.

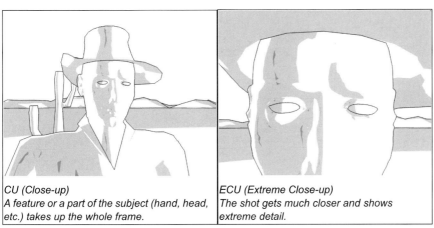

CU (Close-up)
A feature or a part of the subject (hand, head, etc.) takes up the whole frame.

ECU (Extreme Close-up)
The shot gets much closer and shows extreme detail.

Rendering

The following diagram shows the commonly used framing techniques:

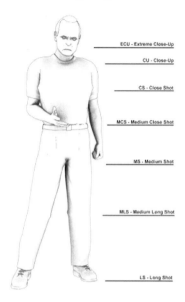

Exercise 1: Setting a Long Shot with a Target Camera

1. Open the file *Framing-shots.max*

2. On the Create Panel, click the Cameras button 📷 and then the Target button.

3. In the Top viewport, click in the middle of the church ruins and drag towards the gate to the right where the character is standing.

4. Right-click the Perspective viewport and press **C** to switch to the camera view.

5. In the bottom-right corner of the screen, click the Truck Camera button.

6. Drag inside the Camera viewport to center the character.

 Hint: If you are using a mouse with a wheel, you can press the wheel and drag as an alternative to the Truck Camera tool.

7. Click the Dolly Camera button. Drag in the Camera viewport until the character's full height fills the viewport.

8. Alternate between the Dolly Camera and Truck Camera tools to center the character in the viewport.

Exercise 2: Setting a Close-up Shot with a Free Camera

1. Continue working on the previous file or reopen the file *Framing-shots.max*.

2. In the Left viewport, zoom in on the character's head.

3. On the Create panel, click the Camera button 📷 and then click the Free button.

4. In the Left viewport, click a point in the center of the character's face.

 Note: When you create a Free camera, it is always oriented perpendicular to the viewport you create it in.

5. Right-click the 3D shaded viewport (Perspective or Camera) and press **C** to display the selected camera's viewpoint.

Rendering

6. Use the Truck Camera and Dolly tools as in the previous exercise to frame the character's head and shoulders.

Camera Lenses

In addition to positioning the camera in XYZ coordinates, you can also get closer or further away from a subject by modifying the camera lens.

The camera lens is your entry point into the world you create in your 3D scene. It is a tool you use to define the relationship between characters or objects to their environment. Different lenses have different personalities. The camera lens (or focal length) is expressed in millimeters (mm).

A wide-angle lens (30mm or less) distorts the perspective by exaggerating the distance between foreground and background. The camera is closer to the action, which translates into greater "depth" in the shot.

A long or telephoto lens (200mm or higher) compresses the depth of the image. Subjects or elements that are either close or far from the camera appear to lie at approximately the same distance. It allows very little or no perspective distortion. In a long-lens shot, the camera is at a considerable distance from the action.

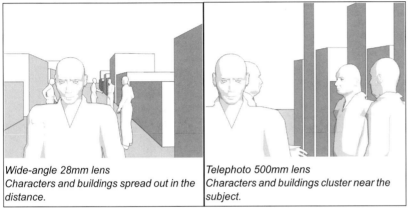

Wide-angle 28mm lens
Characters and buildings spread out in the distance.

Telephoto 500mm lens
Characters and buildings cluster near the subject.

The field of view (FOV) is the "cone" of vision that the camera captures of the world around it.

The field of view is inversely proportional to the camera's lens size.

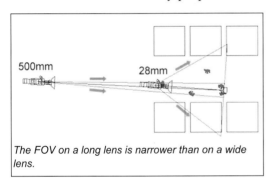

The FOV on a long lens is narrower than on a wide lens.

Exercise 3: Setting the Camera Lens and FOV

1. Open the file *Camera-Lens.max*.

 The scene already contains a 28mm wide-angle Target camera.

2. Select the camera in the Top viewport.

3. Using SHIFT+Move, drag the camera to the left on the X-axis to create a clone closer to the fireplace.

4. On the Clone Options dialog, make sure the clone type is set to Copy and name the clone Camera-long-lens.

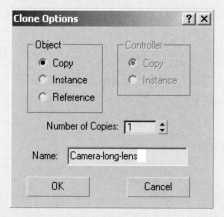

5. Right-click the bottom-left viewport to activate it and then press C to display the new camera shot. Notice the distortion in the perspective and how far the character appears to be from the camera.

6. With the camera still selected, go to the Modify panel .

7. On the Parameters rollout, click the 85mm button in the Stock Lenses group. The two camera views now show the main subject framed similarly, but other elements, such as the cactus and the mountains in the background, appear closer in the long lens shot.

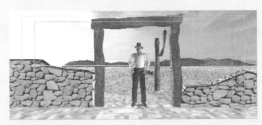

28mm wide lens

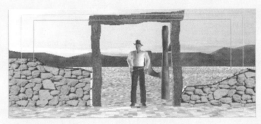

85mm long lens

8. On the Parameters rollout, change the lens value to 300mm. This reduces the field of view. The camera now shows a close-up shot of the character's midsection.

9. Make sure the camera is still selected. On the status bar, change the camera's X position to -160'. This moves the camera farther to the left and away from the character.

Unfortunately, it also moves the camera behind the wall. However, the advantage of virtual cameras over real-world cameras is that you can bypass this problem using camera clipping.

10. In the Modify panel , turn on Clip Manually, and set the Near Clip to 130' and the Far Clip to 200'.

Clipping Planes
☑ Clip Manually
Near Clip: 130'0.0"
Far Clip: 1000'0.0"

This sets the camera to display only elements within the clipping range.

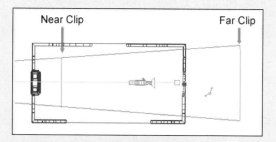

11. Bring the mountains within the clipping range by setting the Far Clip value to 1000'. Notice how the mountains appear much closer to the character in the shot.

300mm extreme long lens (telephoto)

Camera Aspect Ratio

The camera aspect ratio defines the relationship between the width and the height of the frame. This is typically dictated by the project you are working on.

If you are rendering an animation for standard TV or video, the camera aspect ratio will be set to 1.33:1 to accommodate the TV set. If you are rendering for HDTV, film, or sometimes for game cinematics, you may need to render in widescreen format (1.85:1) or anamorphic (2.35:1).

You gain more information in the shot by using a wider frame. Not only do you capture more of the environment around the subject, but it also helps to establish a mood. For example, a long shot of a man standing in the desert yields a greater sense of solitude when using an anamorphic lens than when using a video camera.

Video 1.33:1

Widescreen 1.85:1

Anamorphic 2.35:1

Exercise 4: Setting the Camera's Aspect Ratio

In real life, you set the camera aspect ratio by choosing the proper lens and hardware. In 3ds Max, you set the aspect ratio on the Rendering dialog. You will learn more about the Rendering dialog in the next lesson, but you will use it in this exercise to study the differences between various aspect ratios.

1. Open the file *Cam-Aspect.max*. A long lens camera (85mm) is already created in the scene, framing the character in a long lens shot.

2. On the main toolbar, click the Render Scene button ⬛. The Render Scene dialog opens.

3. On the Common Parameters rollout, click the Output Size drop-down list and choose NTSC D-1 (video).

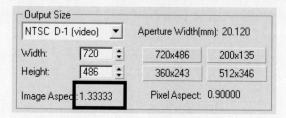

This automatically sets the aspect ratio to 1.33.

4. In the shaded Camera viewport, right-click the Camera label in the top-left corner of the viewport and choose Show Safe Frame.

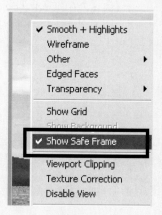

This ensures the view displayed in the viewport is always of the proper aspect ratio, even if you resize the viewport.

5. On the Render Scene dialog, choose the 35mm Anamorphic (2.35:1) option. Notice how the aspect ratio changes in the Camera viewport: The shot is now much wider than it is high.

6. Select the camera in the scene.

7. On the Modify panel ⬜, click the 50mm button in the Stock Lenses group. This ensures you have a long shot of the character in the scene. Compare this long shot to the previous one (1.33:1) and notice how much more of the surroundings you have brought into the shot.

Camera Angles

In addition to the camera-framing techniques discussed earlier, you can adjust camera angles to create more-dynamic camera shots.

So far, you've mostly been using an eye-level camera angle. This provides a familiar feel, because it's how you normally observe the world around you.

You can also frame characters and subjects based on their personalities. For example, big and powerful people look more threatening from a low-angle shot, while weak and frail subjects yield a sense of apprehension when viewed from a high angle.

Eye-level angle Low angle High angle

Exercise 5: Setting a Dynamic Camera Angle

1. Open the file *Camera-Angle.max*.

2. On the Create Panel, click the Camera button 🎥 and then click the Target button.

3. In the Top viewport, drag from left to right to create a camera looking at the character.

4. On the main toolbar, click the Select Object button ▸ to turn it on, and then click an empty area of the Top viewport to deselect all objects.

5. Still in the Top viewport, click the light blue line that connects the camera to its target. This selects both the camera and its target.

6. In the Front viewport, move the selection upward so that the camera and its target are level with the character's head

7. Right-click the Perspective viewport and press **C** to display the eye-level camera shot.

8. In the Top viewport, position the camera target on the character and the camera at a 45-degree angle.

9. In the Front viewport, move the camera downward, closer to ground level.

10. On the Modify panel, set the camera lens to 35mm for an more dramatic effect.

The Line of Action

The line of action is an imaginary line used to preserve consistency in camera shots, screen direction, and space. It serves to eliminate confusion when multiple camera angles are used, related to reversal of left/right screen space and lighting.

In the simple example where two people face each other, the line of action is typically the line of sight between the two subjects. With that in mind, you can then determine a working space of 180 degrees in which you can design camera positioning.

Do not cross the line of action.	Camera A showing a policeman (left) interrogating a suspect (right)

In any given scene, make sure the cameras are positioned within the established semicircle so that the resulting shots are consistent with one another.

Cameras B and C show close-ups of the subjects that are consistent with Camera A.	Alternating shots between cameras D and C shows the problem where one man is talking to the back of the other's head.

Exercise 6: Setting up a Triangle System

The triangle system is the simplest method of positioning cameras on one side of the line of action. All basic shots can be taken from three points within the 180-degree working space.

1. Open the file *Interrogation-room-triangle.max*. This scene contains two characters facing each other.

2. On the Create Panel, click the Camera button 📷 and then click the Free button.

3. Click a point in the Front viewport, midway between the torsos of the two characters to position the camera in the scene.

4. In the Top viewport, move the camera on the Y axis until the FOV (camera cone) encompasses the two characters.

5. Right-click the Front viewport and press **C** to display the camera shot. Press **F3** to display the viewport in shaded mode.

6. Right-click the Camera01 label in the viewport, and choose Show Safe Frame. This ensures that you see the correct aspect ratio for the camera shot even if you resize the viewport.

7. On the Modify panel , rename the camera and call it Camera-Master.

8. Make sure Camera-Master is selected. Using **SHIFT**+Move in the Top viewport, drag the selected camera to a point closer to the character sitting on the left.

9. On the Clone Options dialog that appears, choose the Copy method and name the clone Camera-Left. Click OK to exit the dialog.

10. Still in the Top viewport, rotate the camera about the Z axis so that the character on the right is inside the camera's FOV cone.

11. Right-click the Perspective viewport to activate it, then press **C** to display the new camera shot.

12. Repeat steps 8 through 11 to create a right camera shot aimed at the policeman.

13. Set the Camera-Right shot to display in the Left viewport in shaded mode. Turn on Show Safe Frame to view the correct aspect ratio.

Exercise 7: Shot Variation: Using an Over-the-Shoulder (OTS) Shot

1. Continue working on your file or open the file *Interrogation-room-OTS.max*.

2. In the Top viewport, select Camera-Left.

3. On the Modify panel ![icon], change the camera type from Free to Target.

4. Using the Move tool ✛ in the Top viewport, position the camera target on the suspect character to the right.

5. Select the camera and move to the left of the cop character, aligned with his right shoulder.

6. Adjust the vertical positioning of both the camera and its target to get a decent shot of the suspect character in the shaded viewport.

7. Repeat the procedure on Camera-Right to create an OTS shot of the cop character. Experiment with different camera lenses to compare the various shots.

The Moving Camera

Moving (animating) a camera on a 3D set is a lot easier than it is in the real world. On a movie set, moving a camera to create a panning or a tracking shot involves using a number of technicians and some heavy equipment. When the shot requires the use of a crane, it's even harder.

In 3D, these limitations simply do not exist. You can make the camera travel any way you want; even in ways that would be impossible in real life.

In 3ds Max, you can simulate a panning camera effect by rotating a Free camera or moving the target of a Target camera.

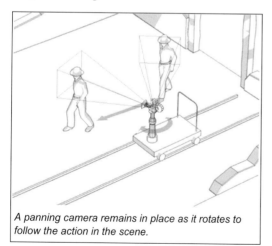

A panning camera remains in place as it rotates to follow the action in the scene.

You can simulate a tracking camera effect by animating both the Target camera and its target.

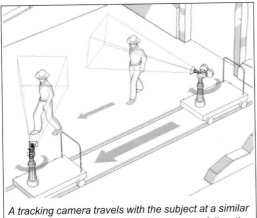

A tracking camera travels with the subject at a similar or different speed. It can also tilt and pan to follow the main action.

You can create a push-pull effect with either a Free or a Target camera, by animating the camera's position.

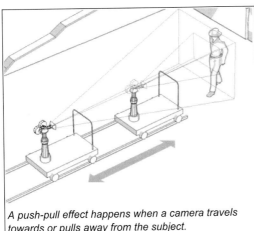

A push-pull effect happens when a camera travels towards or pulls away from the subject.

In 3ds Max, you can achieve a crane effect by placing the camera on a path that simulates the crane motion.

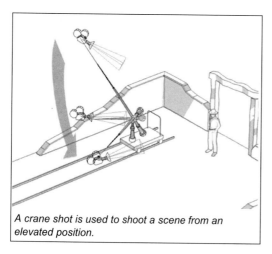

A crane shot is used to shoot a scene from an elevated position.

Exercise 8: Setting up a Crane Shot

1. Open the file *Interrogation-room-Crane.max*.

2. On the Display panel 🖥️ , on the Hide By Category rollout, turn off Shapes. A shape called Camera Path appears in the viewports.

3. On the Create Panel, choose the Camera button 📷 and then click the Target button.

4. Click anywhere in the Top viewport and drag to position the target on the suspect character on the right.

5. Right-click the camera in the Top viewport. From the quad menu that appears, choose Select Camera Target.

6. In the Front viewport, move the target up to shoulder level.

7. Select the camera.

8. From the Animation menu, choose Constraints > Path Constraint. A rubber-band line appears connected to the mouse cursor.

9. In the Top viewport, click the curved spline called Camera Path. The camera moves to the starting point of the path.

10. Right-click the Perspective viewport and press **C** to display the camera shot. Play back the animation to view the results.

Summary

In this lesson, you learned some basic principles of camera positioning, framing, and animation. You learned how to apply these principles to both Target cameras and Free cameras, in order to make a shot more interesting and more effective in a 3D scene.

Basic Lighting

Lighting is an essential part of the visual process. 3ds Max offers a variety of ways to achieve proper lighting. In this lesson, you will learn about the basics of creating primary light sources, and how you can improve the lighting of your scenes by also adding secondary light sources to achieve a better range of tones in your final rendered palette.

Objectives

After completing this lesson, you will be able to:

- Understand ambient light and how to fake it
- Use the standard light types in 3ds Max
- Adjust shadow parameters and set different shadow types
- Use a three-point lighting approach to light a scene
- Use the Light Lister to manage multiple lights

The Ambient Light Riddle

One of the common problems in 3D renderings is how to simulate ambient lighting.

In the real world, ambient lighting is the indirect light that bounces off the surfaces of objects. It can therefore vary in intensity and in color as it picks up the colors of the surfaces it bounces off.

The easiest way to represent ambient lighting in a 3D scene is to fake it with secondary lights, or else use one of the global engines provided in 3ds Max and that you will learn about in a later lesson.

To get better control of ambient lighting in your 3D scene, it is best to start in darkness. Most 3D applications provide an "ambient lighting" tool that usually translates into a uniform brightness, illuminating shadow areas in a flat and unrealistic way. Fortunately, this feature is turned off in 3ds Max, or more precisely set to a black color, forcing you, the user, to control ambient lighting on your own.

The Environment panel showing the default black Ambient color

Exercise 1: Setting the Ambient Color

1. Open the file *Ambient.max*.

 The scene shows a cup set on a tabletop.

2. With the Perspective viewport active, press **F9** to quick render the scene.

 The main light illuminating this scene casts rays from right to left, making the left side of the cup extremely dark.

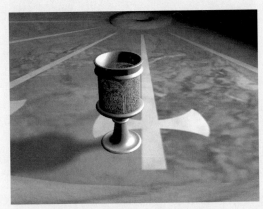

*Render performed with a single light and a
black Ambient light*

3. From the Rendering menu, choose Environment.

4. Click the Ambient color swatch and set its Value to 100.

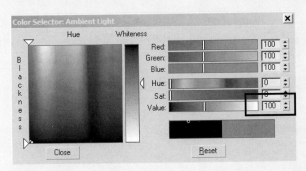

5. Render the Perspective viewport one more time, notice how the whole scene is brighter, but in a flat, low-contrast way.

You still cannot make out the details of the left side of the cup.

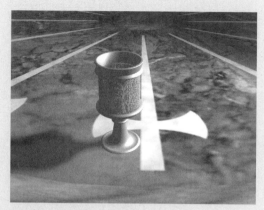

*Render performed with a single light
and a medium-gray Ambient light*

6. Set the Ambient color swatch back to full black again (Value=0).

7. In the Front viewport, select the black light on the left side of the viewport (Spot02).

8. On the Modify panel 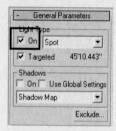 > General Parameters rollout, turn the selected light on.

9. Activate the Perspective viewport by right-clicking in it and render the scene again.

Now that global illumination has been simulated by adding a secondary light, notice how the final render appears much more realistic than the previous tests.

Render performed with a main light and a secondary light simulating ambient lighting

Light Types in 3ds Max

There are three categories of lights in 3ds Max: Standard, Photometric, and Systems.

Standard lights are simple to use and will be our main focus for this lesson.

Photometric lights are more complex than standard lights, but they provide a more accurate model of real-world lighting. Photometric lights are usually used in conjunction with the radiosity (global illumination) engine. You will learn more about radiosity in the next lesson.

Lighting systems simulate sunlight based on location and time of day, month and year. This makes them easier to set up than if you had to simulate sunlight using standard or photometric lights.

Using Standard Lights

The standard lights you use most often in 3ds Max are the Omni, Spot, and Direct lights.

Omni Light

The Omni light simulates rays shining out from a single point in space. Rays are emitted uniformly in all directions. This is somewhat similar to a bare light bulb.

Spotlight

The Spot light also simulates rays shining out from a single point but limits the illumination to a specific cone-shaped volume. This kind of control, which allows you to aim a light at a specific target, makes the Spot a popular choice for many lighting artists.

You have total control over the beam of light that defines the illumination cone. In fact, there are two cones that you can control: the hotspot (inner cone) and the falloff (outer cone).

When the two values are close, the cone of light becomes very sharp and translates into a crisp pool of light in the scene. However, if you set a Falloff value significantly higher than the Hotspot value, then you get a much softer-edged cone of light as the light intensity spreads from the inner to the outer cone.

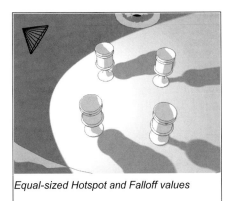

Equal-sized Hotspot and Falloff values

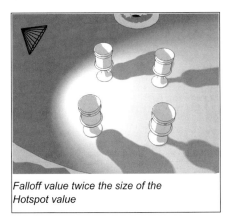

Falloff value twice the size of the Hotspot value

A spotlight can be targeted or free.

Target Spot

When you create a Target Spot, you use the target object (in the form of a small square) to orient the spotlight. The spotlight itself will always point to (look at) that target. This makes the Target Spot very easy to position in the scene. In addition, by linking the target to an animated object in the scene, you can ensure the spotlight will always follow the animated object.

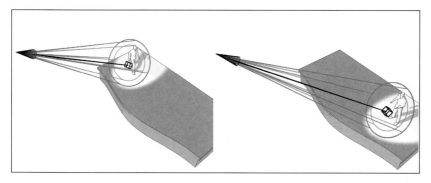

Free Spot

When you create a Free Spot, you orient that spot using the Rotate tool. A good example of when to use a free spot is when simulating the headlights on a car. As you animate the car in the scene, the spotlights' orientation follows that of the car.

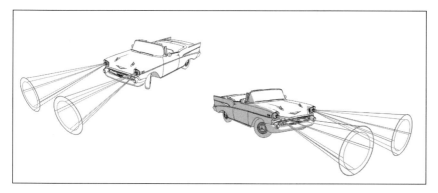

Direct Light

A Direct light has roughly the same workflow as a Spot light but casts rays through a cylinder instead of a cone. The rays are therefore parallel, making the Direct light suitable for simulating distant light sources such as the sun. Because the Direct light casts parallel rays, it does not matter how far you place it from the objects in the scene; the only thing that matters is the direction in which it is pointed.

Much like a Spot light, you can control the softness of the Direct light's cylindrical beam with Hotspot and Falloff values. A Direct light can also be targeted or free.

The Importance of Shadows

We see shadows every day but we seldom stop to consider how vital they are in helping to establish the spatial relationships that surround us.

CG shadows differ greatly from those in the real world, however, and creating believable shadows in a 3D environment requires skill and the ability to analyze shadow form, color, density and general quality.

Arguably, the most important visual cues that shadows provide is perception of depth and positioning between objects in an environment.

The car on the left appears to be floating in space. The car on the right is more grounded because of its shadow.

Various shadow types are available in 3ds Max but all are based on either of two algorithms: shadow maps and ray-traced shadows. There are considerable differences between the two types as the choice will ultimately dictate rendering quality and speed.

Shadow Maps

The shadow map method uses a bitmap that the renderer generates before final rendering. The process is completely transparent and does not store any information on the hard drive. The bitmap is then projected from the direction of the light. Shadow maps can be fast to calculate and can produce soft-edged shadows. On the downside, they are not very accurate and do not take objects' transparency or translucency into account.

Shadow map with soft edges. The shadowing is uniform and does not recognize the transparency of the glass.

Ray-Traced Shadows

Ray-traced shadows are generated by tracing the path of rays from a light source. They are more accurate than shadow maps but always produce hard-edged shadows. Because ray-traced shadows are calculated without a map, you do not have to adjust resolution as you do for shadow-mapped shadows, making them easier to set up. Ray-traced shadows take transparency and translucency into account, and can even be used to generate shadows for wireframe objects.

Ray-traced shadow with hard edges. The transparency of the glass is taken into account.

More Shadow Types

There are other shadow types that you can use in 3ds Max. Advanced ray-traced shadows are similar to ray-traced shadows but provide better antialiasing control and can generate soft-edged shadows. Area shadows simulate shadows cast by a light that has a surface or a volume as opposed to a point. Shadows of this type tend to become more blurred with distance. mental ray shadow maps are to be used with the mental ray renderer and are not covered in the 3ds Max Essentials courseware.

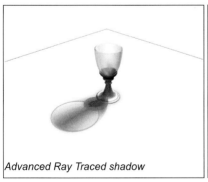

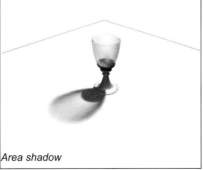

Advanced Ray Traced shadow

Area shadow

Rendering

Exercise 2: Creating a Target Spot

1. Reset 3ds Max.

2. Open the file *shadows.max*.

 The scene shows a wine glass on a flat wooden surface.

3. Make sure the Perspective viewport is active and then press **F9** to render the scene.

 The rendered scene looks flat for lack of contrast. The lighting is uninteresting and the absence of shadows makes for a weak connection between the glass and the tabletop.

4. Right-click the Front viewport to activate it.

5. On the Create panel, click the Lights button.

6. Click Target Spot on the Object Type rollout.

7. In the Front viewport, click and drag from the top-right corner onto the wine glass.

8. Activate the Perspective viewport and test-render the scene again.

By default, the Spot light does not cast shadows. The Hotspot and Falloff values are very close, making a "theatre spotlight" effect as the edge of the pool of light is very crisp.

9. With the light selected, go to the Modify panel and expand the Spotlight Parameters rollout.

10. Set the Hotspot/Beam value to 15.0 to decrease the light cone, where the intensity is at its maximum.

Set the Falloff/Field value to 100.0 to increase the overall diameter of the light so that the Spot light encompasses more of the 3D environment.

11. Render the Perspective viewport again.

Notice the softer edges of the pool of light in the rendered scene.

12. On the General Parameters rollout, turn on Shadows.

Leave the type set to Shadow Map.

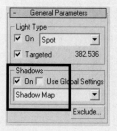

13. Render the scene again.

This time, you can see the shadow of the glass cast on the table. However, the shadow is solid and a bit too dark.

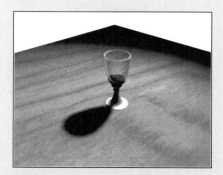

14. Expand the Shadow Parameters rollout, near the bottom of the Modify panel.

Decrease the Density value to about 0.6 (60%).

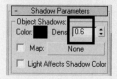

15. Render the scene again.

The shadow is lighter, but it still doesn't accurately represent light going through a glass.

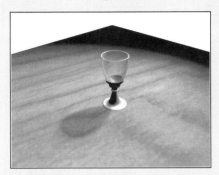

16. In the General Parameters rollout, in the Shadows group, set the shadow type to Ray Traced Shadows.

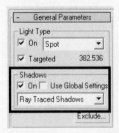

17. Render the Perspective viewport.

This time, the rendering will take longer, but the ray-traced shadow accurately takes into account the transparency of the glass.

Rendering

Lighting Techniques

When lighting in CG, your ultimate goal is to create a mood that projects an emotional connection with your audience. Many different lighting techniques are available in CG, but it doesn't matter which one you adopt as long as you achieve your goal.

Before you start creating lights in your 3D environment, take a moment to consider what you are trying to achieve and how to place light sources to achieve it. Think of color, shadow, contrast; look at the world around you and think of how you can achieve similar results.

If you have no experience with lighting, you can follow some basic guidelines established in cinematography, such as three-point lighting.

Three-Point Lighting

As its name implies, the technique of three-point lighting uses three lights with very specific functions:

The Key Light

The key light is the main or dominant light in the scene. It is often the only one that casts shadows and is used as the primary light source in the scene.

The Fill Light

The fill light functions primarily to control shadow density. It is often not enough to control the density of the main light's shadows. The fill light helps to remedy that problem by softening the effect of shadows in the scene. At the same time, it acts as a bounce light, simulating global illumination. Typically, the Fill light is less intense than the key light.

The Backlight (or Rim Light)

The backlight's sole purpose is to separate the subject from the background, giving the scene greater depth. It works by illuminating the back of an object or character so that the silhouette is easier to see.

Exercise 3: Working with Three-Point Lighting

1. Reset 3ds Max.

2. Open the file *3-point_start.max*.

3. With the Camera viewport active, press **F9** to render the scene.

The scene shows the rendering of a statue based on 3ds Max's default lighting. The general mood is far from interesting. You will use the three-point lighting technique to make the scene more appealing.

4. On the Create panel, click the Lights button .

5. Choose Target Spot from the Object Type panel.

6. In the Front viewport, click and drag from the top-left corner to the statue.

7. On the main toolbar, choose the Move tool .

In the Top viewport, move the spotlight and position it in the bottom-left corner of the viewport.

8. On the Modify panel, rename the spotlight: Main_Light.

 Before you make adjustments to the main light, you will create the fill light and backlight.

9. On the Create panel, under Lights, choose the Target Spot again.

10. In the Front viewport, create a second light by dragging it from the center-right of the viewport to the statue.

11. Using the Move tool, adjust the position of the new spotlight in the Top viewport so that it is directed at the statue from roughly the opposite direction of the main light, using the camera vector as a mirror plane.

12. Rename the second light: Fill_Light.

13. Create one more spotlight in the Front viewport, dragging from the top-center of the viewport to the statue.

14. In the Top viewport, move the new spotlight so that it is directed at the statue from the "northeast" direction.

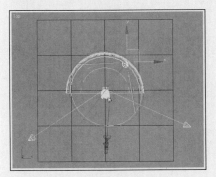

15. Rename the light Backlight.

16. Select the Main_Light and go to the Modify panel.

17. On the General Parameters rollout, turn on Shadows and leave the type set to Shadow Map.

18. On the Spotlight Parameters rollout, set Hotspot to 30.0 and Falloff to 100.0.

19. On the Shadow Parameters rollout, set Density to 0.8.

This prevents the shadows from being too dark.

20. On the Shadow Map Parameters rollout, set Size to 2000 and Sample Range to 6.0.

Increasing these two values ensures the shadow edges are soft and of better quality that the default settings allow.

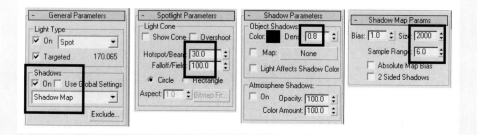

21. Select the Fill_Light.

22. On the Intensity/Color/Attenuation rollout, set the Multiplier value to 0.4.

This makes the fill light less intense than the main light.

23. In the Far Attenuation group, turn on Use.

This causes the light intensity to fall off with distance, based on Start/End distances you specify.

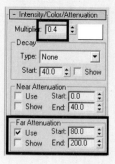

24. Adjust the Start/End Attenuation values so that the light attenuates from the front of the statue to the vault wall. Keep an eye on the Top viewport for reference.

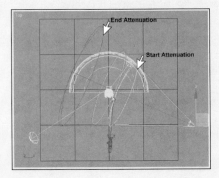

25. Select the Backlight.

26. On the Intensity/Color/Attenuation rollout, set the Multiplier value to 0.6.

27. In the Far Attenuation group, turn on Use.

Adjust the Start/End Attenuation values so that the light attenuates from the statue's head to its knees. Keep an eye on the Front viewport for reference.

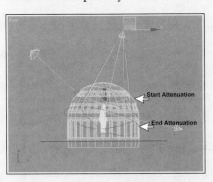

28. Render the Camera viewport.

Compare the rendering to the first test render you created early in this exercise.

Light Lister

Light Lister is a modeless dialog that lets you control a number of features for each light. It is a very useful tool for managing multiple lights in your scene. You can easily change light parameters such as Multiplier values and shadow types, turn lights off and on, turn shadows off and on, and so on.

In the next short exercise, you will use Light Lister to analyze how the three-point lighting affected your scene earlier and how using different lighting combinations affects the final rendering.

Exercise 4: Using the Light Lister

1. Open the file *3-point_final.max*.

2. From the Tools menu, choose Light Lister.

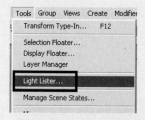

3. On the Light Lister dialog, turn off Fill_Light and Backlight.

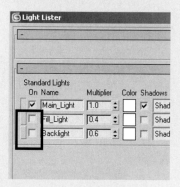

4. Render the Camera viewport.

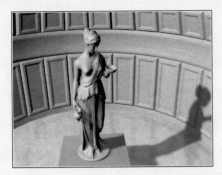

With only the key light lighting the scene, the right side of the statue is drowned in black.

5. On the Light Lister, turn off Main_Light and turn on Fill_Light.

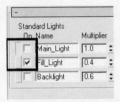

6. Render the Camera viewport again.

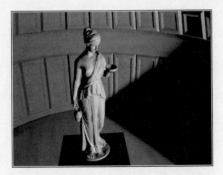

The fill light provides most of the ambient lighting for the scene.

7. On the Light Lister, turn off Fill_Light and turn on Backlight.

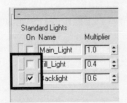

8. Render the Camera viewport.

The back light provides a subtle glow around the head and shoulders that helps separate the character from the background.

9. Experiment some more.

Try turning on both the main and fill lights but turn off the backlight. See how the subtle illumination of the backlight makes a big difference in the final render.

Backlight turned on (right picture) provides a subtle illumination of the head and shoulders area.

Summary

In this lesson, you learned how to use standard lights in 3ds Max to good effect. You have learned about light types, shadows, and the importance of ambient lighting and how to fake it.

You learned basic lighting techniques such as three-point lighting, and how to use the Light Lister to analyze your scene and make subtle changes to your lighting parameters.

Proper CG lighting is not learned overnight, but takes time and practice. You have experimented with some basic principles and will take this knowledge to the next level in the following lesson, where you will learn about global illumination and how to use it in 3ds Max.

Global Illumination

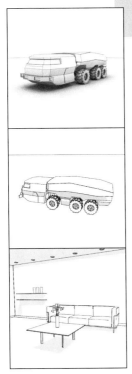

In this lesson you explore how lighting works in the real world and how it affects lighting in CG. Good CG lighting has always been a source of concern for 3D artists, and significant progress has been made in 3D software architecture for the purpose of improving lighting quality in the scene at render time. One method for achieving convincing CG lighting is global illumination.

Objectives

After completing this lesson, you will:

- Have a good understanding of what global illumination is and how it works
- Be able to use the two different GI calculation systems within 3ds Max
- Understand how lighting works in general
- Achieve realistic lighting with simple setups

Global Illumination

If you've ever wondered how you can see under your desk even though there are no light sources there, the answer is simple: Light bounces off the surfaces it strikes. Some light bounces are more important than others, depending on the nature of the surface.

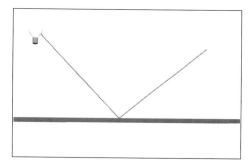

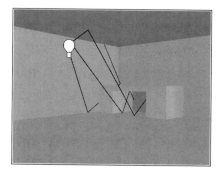

Light travels in a straight line; when it hits a surface, it bounces off in the opposite direction.

A light ray that strikes an uneven surface can break up into multiple rays.

When a light bounces off a surface, it also collects some of the color information from the surface. This is called color bleeding. For instance, if light bounces off a bright red fabric that's close to a white wall, the light rays bouncing off the fabric have a red tint that can affect the perceived color of the wall.

Global Illumination Engines

3ds Max has two types of global illumination built in: *Light Tracer* and *radiosity*.

Light Tracer

The Light Tracer provides soft-edged shadows and color bleeding for brightly lit scenes such as outdoor scenes. The Light Tracer does not attempt to create a physically accurate model, and is easier to set up.

Radiosity uses a more accurate physical-lighting model. It is useful for both indoor and outdoor scenes and is often used for architectural renderings. We'll cover radiosity later in this lesson.

Exercise 1: Light Tracer

1. Open the file *Light Tracing.max*. The scene contains a truck that is lit by only one Skylight object.

A simple environment with a truck model

2. Press **SHIFT+Q** to create a quick rendering of the scene.

At this time, no shadows are cast and the rendering is very flat.

Rendering

3. From the Rendering menu, choose Advanced Lighting > Light Tracer.

This opens the Render Scene dialog to the Advanced Lighting panel, with the Light Tracer active. The Light Tracer automatically activates the shadows on the skylight, giving a more three dimensional look to the render. It also significantly increases rendering time.

4. Decrease the Ray/Samples value to 60. This decreases rendering quality, but it also shortens the rendering time. Use a lower value for test renderings; you can always increase it later for the final render. Also set Global Multiplier to 2.0.

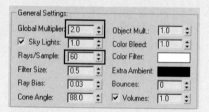

5. Render the scene again. The scene is much more convincing, although there is some noticeable noise due to the decreased samples value. The shadows are much nicer and there

is even a faint blue halo around the ground shadow resulting from the color bleeding off the truck.

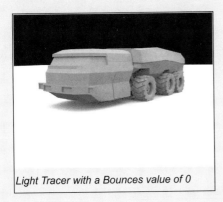

Light Tracer with a Bounces value of 0

Some areas are still very dark.

6. On the General Settings rollout, set the Bounces value to 2. This will increase rendering time, but the end result is often worth the wait.

7. Render the scene one more time. As you can see, the rendering is brighter than before because light bounces off surfaces more, thus eliminating the pitch-black shadows that often plague 3D renderings. However, noise patterns are visible in the shaded areas.

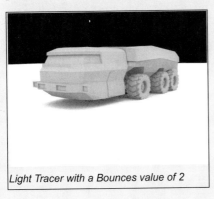

Light Tracer with a Bounces value of 2

All areas receive some amount of illumination.

8. Increase the Filter Size value to 3.0. This smoothes out the noise patterns in the shadow areas.

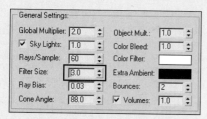

9. Render the scene again. There are now fewer artifacts in the rendering.

Using Light Tracing

Although light tracing is most often used with outdoor scenes, it can be used for indoor scenes as well. It works best when combined with the Skylight object. Light tracing usually requires long rendering times, so it is always a good idea to decrease the Rays/Samples value for test renders. Once you have achieved the desired look, you can increase the Rays/Samples value for the best quality in the final render.

Radiosity

Radiosity is the other global illumination method native to 3ds Max. Radiosity calculates the interreflections of diffuse light among all the surfaces in your scene. Radiosity uses material properties to receive and cast rays; it also needs a certain amount of additional subdivision of models in the scene for the best accuracy. Radiosity is often used in architectural rendering for its accuracy and real-world physical scale approach.

Radiosity works by painting light shadows on top of the geometry using a vertex-paint method. The greater the subdivision (vertices) in your models, the better-looking and more accurate the solution is, but it also takes a longer time to process the solution.

Photometric Light

You'll find the Photometric category on the drop-down list on the Create panel > Lights category.

Photometric lights differ from standard lights in that they use photometric (light energy) values (lumens, candelas, lux) that enable you to define lighting values more accurately, as they would exist in the real world. You can create lights with various distributions and color characteristics, or import specific photometric files available from lighting manufacturers.

Radiosity works well with photometric lights because they represent real-world values. There are two important things to remember when using photometric lights, whether you use them on their own or in conjunction with radiosity:

1. The sizes of the scene objects and the units that you choose must represent real-world values. For example, consider that you cannot light an entire stadium with a single 50-watt light bulb.

2. Use Exposure Control to obtain the full range of brightness in your renderings.

Exposure Control

If you are in a very bright place and the lights are suddenly switched off, turning everything dark, your eyes adapt to the new lighting. Exposure Control is somewhat similar in that it lets you adjust the output levels and color range of a rendering, as you might adjust film exposure. Exposure Control is especially useful when rendering with radiosity.

Exposure Control is set on the Environment panel; four different types are available here. Arguably, Logarithmic Exposure Control provides the best solution because it attempts to improve the dynamic range, thus providing higher contrast between lit and dark areas.

Exercise 2: Radiosity

1. Open the file *Radiosity.max*. It is a simple living area with six photometric area lights that have been set up with an intensity of 520 candelas each.

2. Render the scene. There is potential for a good rendering, but the image is currently too dark overall. In the real world, light would bounce off the various surfaces and illuminate the darker areas such as the ceiling. You will use radiosity to achieve that effect.

3. From the Rendering menu, choose Advanced Lighting > Radiosity.

The Render Scene dialog opens to the Advanced Lighting panel with Radiosity active. Radiosity works differently from the Light Tracer: While Radiosity needs to calculate a solution before it can show a result, Light Tracing calculates the solution at render time.

4. Start by decreasing the Initial quality value to 70% to accelerate the radiosity calculation. As with lowering the Light Tracer Rays/Sample value, this option decreases quality but speeds up the evaluation process. You can always increase this value later for the final render.

5. Expand the Radiosity Meshing Parameters rollout. The following steps are crucial for achieving good-looking results.

6. In the Global Adaptive Subdivision group, turn on Enabled, and then turn off Use Adaptive Subdivision. This ensures constant subdivision of the scene objects.

7. Change Maximum Mesh Size to 12. This determines the size of the subdivision on all objects in the scene.

8. In the Light Settings group, turn off all options except Shoot Direct Lights. When on, these options can increase the quality of the rendering while significantly increasing processing time. You do not need them for this exercise.

9. Go back up to the Process group, where you previously changed the Initial Quality value, and set Refine Iterations (All Objects) to 2. This helps avoid artifacts in the rendering.

10. Click Start to calculate the radiosity solution. A progress bar displays and gives you feedback on calculation time.

When the radiosity calculation is done, the results are shown in the viewport.

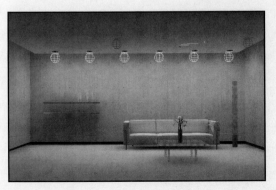

Some noise patterns and artifacts are still visible on the surfaces.

11. In the Interactive Tools group, set Indirect Light filtering to 2 and the Direct Filtering to 1. This reduces the artifacts under direct lighting and in the shadow areas.

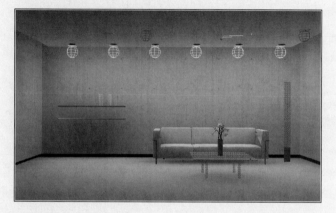

With the proper filtering, the noise patterns are artifacts are less noticeable.

12. Render the scene to view the results.

Exercise 3: Radiosity Material

1. Open the file *Radiosity Material.max*. It shows the same room with but with only the default lighting setup. However, the two floor lamps have self-illuminated materials applied to them. In this exercise, you will calculate a radiosity solution based on material properties.

2. Render the scene. As you can see, the rendering is based on the default lighting in 3ds Max and the lamps are self-illuminated. The rendering is flat and quite dull.

3. 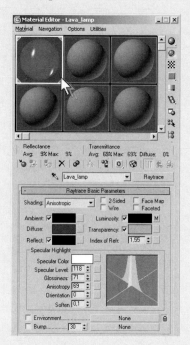 Open the Material Editor and click the first material (Lava_lamp).

4. Click Raytrace to change the material type.

5. From the Material/Map Browser, choose Advanced Lighting Override.

6. The Replace Material warning opens. Choose Keep Old Material As Sub-Material and click OK. This ensures that the existing Raytrace material remains part of the material definition you are building up.

7. On the Advanced Lighting Override Material rollout, change the Luminance Scale value to 2200.0. This gives the material a Luminance value that the radiosity solution converts into light.

8. From the Rendering menu, choose Advanced Lighting > Radiosity.

9. Lower the Initial Quality value to 70.0 and set the Refine Iterations (All Objects) to 2.

10. On the Radiosity Meshing Parameters rollout, turn on Global Subdivision Settings > Enabled and make sure Use Adaptive Subdivision is off.

11. Set Mesh Settings > Maximum Mesh Size to 12.0.

12. Turn off Shoot Direct Lights. This is yet another option that can improve the quality of the rendering but takes a long time to process. You don't need it for this exercise.

13. Click Start to calculate the radiosity solution.

14. Once the Solution is processed, go to the Interactive Tools group and increase the Filtering for indirect and direct light as you did earlier.

The results display in the viewport.

15. Right-click in the viewport and choose Unhide All from the quad menu.

A new lamp appears on the coffee table.

16. Examine the Radiosity setup panel and note the warning message. Whenever you make a change that affects the lighting in the scene, you need to recalculate the solution. Adding

another light source on the coffee table (the new lamp has the same Lava_lamp material applied) forces you to recalculate the radiosity solution.

17. Click Reset All to start afresh.

18. A warning appears; click Yes to proceed.

19. Click Start to calculate the new solution.

20. Render the scene to view the results.

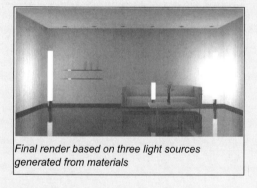

Final render based on three light sources generated from materials

21. Save your scene for future use.

Important things to know when using Radiosity

As mentioned, it is important to have light sources in the scene, or an object or material that act as light sources.

You must use a subdivision method to achieve accurate radiosity results on the various objects.

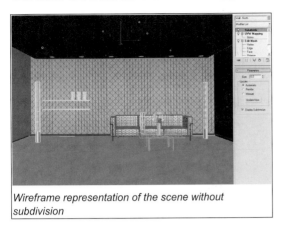

Wireframe representation of the scene without subdivision

If you prefer to subdivide geometry on a per-object basis, use the Subdivide modifier, which was designed for that purpose.

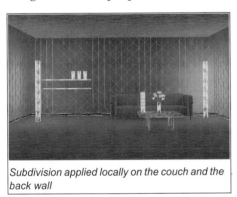

Subdivision applied locally on the couch and the back wall

As seen in the previous exercises, you can set global subdivision on the Advanced Lighting panel.

Global subdivision applied to all the objects using radiosity

Rendering

You can also use adaptive subdivision to increase detail wherever necessary. Adaptive subdivision works by defining an upper and lower limit. The radiosity solution subdivides the mesh based on contrast between the lit and shaded areas. Smaller sub-divisions are created wherever additional detail is required.

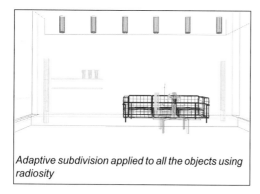

Adaptive subdivision applied to all the objects using radiosity

Summary

3ds Max gives you various ways to achieve global illumination. In addition to the methods described in this lesson, you can fake it with standard lights, or use another renderer such as mental ray, which can create highly accurate global illumination solutions.

Whichever method you use, global illumination is one of the best the lighting techniques for bringing your renderings to life.

Rendering the Scene

Rendering is typically the final stage of the 3D process. It is certainly the last thing you do when you want to show the final product to a client. The final product can be an architectural rendering, the latest design for a game box, a simple Web-based animation, or even a feature film. The final rendering takes into account all other aspects of the production pipeline including modeling, texturing, rigging, lighting, and animating.

Objectives

After completing this lesson, you will be able to:

- Set up your scene and save your renderings
- Use various 3D effects
- Use rendering tools efficiently
- Record different scene states
- Use Batch Render to automate the rendering process

Rendering in 3DS Max

By default, 3ds Max uses a scanline renderer to render the scene. The Material Editor also uses the scanline renderer to display materials and maps. As its name implies, the scanline renderer renders the scene as a series of horizontal lines. Other options are available to you; mental ray is an advanced renderer that comes with 3ds Max, or you can also use other plug-in or third-party renderers that you have installed.

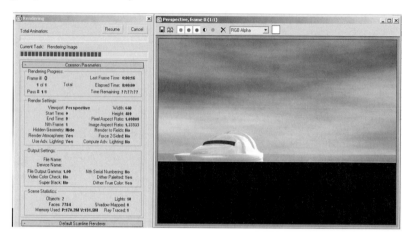

Rendering creates a 2D image or animation based on your 3D scene. It shades the scene's geometry using the lighting you have set up, the materials you have applied, and environment settings such as background and atmosphere.

Render Scene Dialog

You set the parameters for rendering on the Render Scene dialog. The keyboard shortcut to open this dialog is **F10**. You can also click the Render Scene button on the main toolbar.

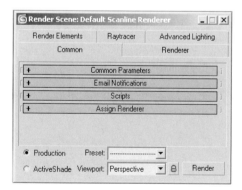

The Render Scene dialog has multiple panels, accessed from tabs at the top of the dialog. The number of panels and their names can change, depending on the active renderer.

Common Panel

The Render Scene dialog's Common panel contains controls that apply to all renderers. The Common panel contains four rollouts; this lesson focuses on the Common Parameters rollout.

The Common Parameters rollout sets parameters common to all renderers.

Time Output

The Time Output group lets you specify which frames to render and whether to generate an animation (e.g., AVI file), sequential single-frame output, or a combination of different frames that are not sequential.

Output Size

The Output Size drop-down list lets you choose from a number of standard film and video resolutions and aspect ratios. Choose one of these formats, or use the Custom choice to specify your own settings.

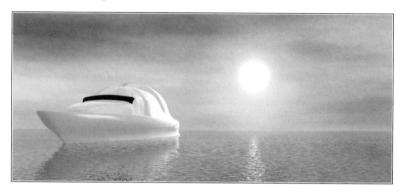

35mm Anamorphic (2.35:1)

Custom (640x800)

Exercise 1: Output Size

1. Open the file *Boat_model_Size.max*.

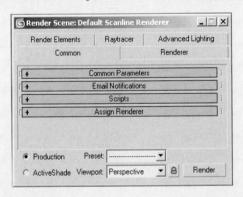

A summer day at sea

2. Press **F10** to open the Render Scene dialog.

3. Make sure the Common panel is active and that the Common Parameters rollout is expanded.

 Examine the Output Size group.

4. From the Output Size drop-down list, choose 35mm Anamorphic (2.35:1).

5. Minimize the Render Scene dialog.

6. Right-click the Camera01 label in the viewport and choose Show Safe Frame.

This allows you to view the camera's aspect ratio in the viewport.

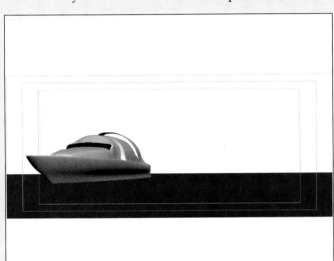

Using Safe Frame is important when framing a shot; it can help you optimize image composition.

Render Output

Another important part of the common parameters rollout is the Render Output group. This is where you will be able to save your output files to disk when you are done.

The Render Output group and its parameters

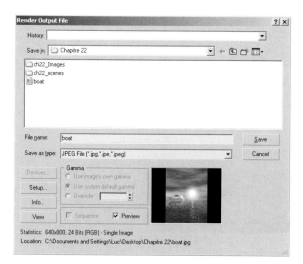

Click the Files button to specify the output filename and image type.

If you render a single frame, you can also save your images by clicking the Save Bitmap button on the toolbar of the rendered frame window.

You're prompted for a file name and a file type for output.

If you attempt to render a sequence of frames, you first need to specify the base file name and image format or you will be prompted by a warning.

File Type

When you render a scene, you can output a still image or an animation. You can output to most of the known formats such as JPG, TGA, TIF, and many others. Movie file types include AVI and Quicktime. Some of the formats support various options. If output options are available, these appear in a separate dialog. In the 3ds Max reference, file options are explained along with the description of the image file's format.

RAM Player

The RAM Player is a useful tool that lets you load a sequence of frames into memory and play it back at a specific frame rate.

You can also save an image sequence in AVI or MOV format from the RAM Player using the Save command.

Note: It can take some time for the RAM player to save the animation. It might look like your computer is frozen and not responding, but this is usually not the case; it is actually saving the animation to disk.

The RAM player also serves as a useful comparison tool. You can load images or sequence of images into the two different channels and compare scene setups, lighting, materials, and other aspects of your work.

Exercise 2: Using the RAM Player

1. Start or reset 3ds Max.

2. From the Rendering menu choose RAM Player.

3. On the RAM Player toolbar click the Open Channel A button.

4. Locate and open the image file *Couch_No_GI.png*.

5. Click OK to accept the default RAM Player Configuration setup. Now that the first image is loaded, you will load the second image into channel B.

6. On the RAM Player toolbar click the Open Channel B button.

7. Locate and load the Image file *Couch_GI.png*.

8. Click OK to accept the default configuration. As you can see, half of each image appears in the player window.

9. Click in the window and drag horizontally in both directions to compare the two images. You can click the A and B buttons on the toolbar to toggle display of the images and use the Horizontal/Vertical Split Screen button to compare images from top to bottom.

Object Properties Rendering Control

Object properties are important when rendering. You can use them to achieve results that are practically impossible in real life, such as to toggle the visibility of an object to make it appear only as a reflection.

Exercise 3: Rendering Control

1. Open the file *Rest_area.max*. This is the same scene that was used in the Global Illumination lesson.

2. Press **H** to open the Select Objects dialog and then select the Couch, Mies Table, and Flowers+Vase groups.

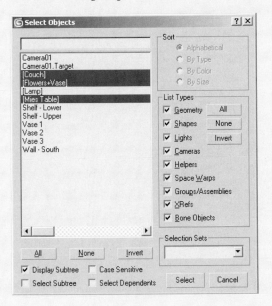

3. Right-click and choose Properties from the quad menu.

4. In the Rendering Control group, turn off Visible To Camera.

5. Click OK to accept the change.

6. Render the scene.

As you can see, the objects still cast shadows and are still visible in the reflection, but they are invisible to the camera.

You can use this option to create interesting special effects in the rendering.

Rendering Environment and Effects

Rendering effects let you add post-production effects without having to render the scene every time to view the results. With the Effects panel of the Environment And Effects dialog, you can add various effects and view them prior to final rendering of an image or animation.

Render effects let you work interactively. As you adjust an effect's parameters, the rendered frame window is automatically updated with the final output image of the scene geometry and the applied effects. You can also choose to update the effect preview manually.

Exercise 4: Creating a Sun using Lens effect

1. Open the file *Boat.max*.

2. From the Rendering menu, choose Effects.

3. The Environment And Effects dialog is displayed.

4. Click the Add button.

5. Choose Lens Effects and click OK.

6. Scroll down to the Lens Effects Globals rollout and click the Pick Light button.

7. Select the Omni light that is visible near the top of the viewport.

The name Sun appears in the drop-down list of the Lights group.

8. On the same rollout, click the Load button.

9. Open the *Sun.lzv* file.

LZV files store the settings for one or more lens effects prepared in advance.

10. Press **SHIFT+Q** to quick render the scene.

Do not close the rendering window. As you can see, the sun is too dim. You will make it brighter.

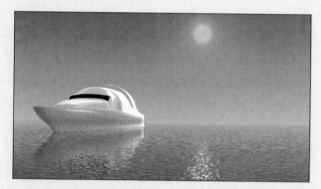

11. On the Lens Effects Globals rollout, increase the Intensity value to 300.

12. Click the Update Effect button to update the rendering.

The button updates the effect only. You don't have to re-render the complete scene, so Update Effect gives quick results.

13. Save your scene for later use.

Scene States

The Scene States function offers a fast way to save different scene conditions with various lighting, cameras, material settings, environment, and object properties. A particular scene state can be restored at any time and rendered to produce numerous interpretations of a model.

Exercise 5: Scene States

1. Open the file *Boat_states.max*.

2. Right-click in the viewport and choose Manage Scene States from the quad menu.

3. Click the Save button.

4. Highlight all options in the Select Parts list, and then name the scene state Daytime and click the Save button.

5. Close the Manage Scene States dialog.

Next you will create a different scene state.

6. Press **M** to open the Material Editor.

7. Press **8** to open the Environment And Effects dialog.

8. Drag the Night Sky (lower-right) map from the Material Editor to the Environment Map button in the Background group of the Environment panel.

9. Make sure Instance is chosen and then click OK.

10. Close the Material Editor and the Environment And Effects dialog.

11. From the Tools menu, choose Light Lister.

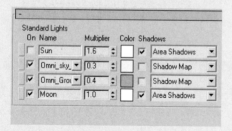

12. On the Light Lister dialog, turn off the Sun light and turn on Moon.

13. Change the color of Omni_sky to a bluish grey.

You can set its RGB values to RGB [140,148,155].

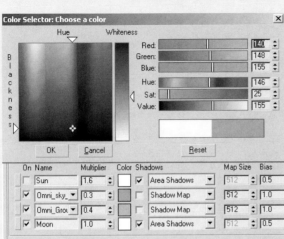

14. Close the Color Selector dialog.

15. Set the Multiplier value of Omni_ground to 0.2.

 This halves the light's intensity.

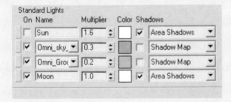

16. Close the Light Lister dialog and try a Quick Render.

17. Right-click in the viewport and choose Manage Scene States from the quad menu.

18. Save the new Scene State; call it Nighttime.

19. Close the Manage Scene States dialog.

20. Save your scene.

Now that you have multiple scene states defined, you can easily switch back and forth using the Restore Scene State function.

21. Right-click in the viewport

22. From the quad menu, choose Restore Scene State > Daytime to go back to a daytime rendering.

23. Render the scene to test the results.

Batch Render

The Batch Render tool offers you a more efficient and visual approach to setting up tasks when you want to render without having to be in front of the computer. With Batch Render you can render all your scene states at once, and you can also render from different points of view based on different cameras in the scene.

Exercise 6: Batch Render

1. Continue working on your file or open the file *Boat_Batch_Render.max*.

2. From the Rendering menu, choose Batch Render.

3. Click the Add button.

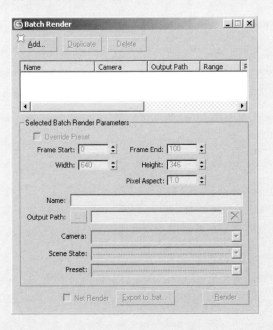

4. In the Name field, change the existing name to Daytime. Be sure to press **ENTER** after typing the name.

5. From the Camera and Scene State drop-down lists, choose Camera01 and Daytime, respectively.

6. Set an output path and name the output file *Boat_Daytime.jpg*.

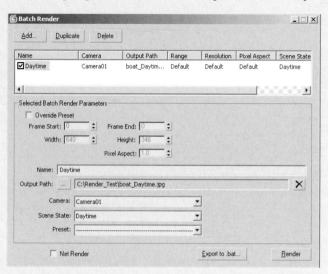

7. Add a second batch render job and name it Nighttime.

8. Set Camera to Camera01 and Scene State to Nighttime.

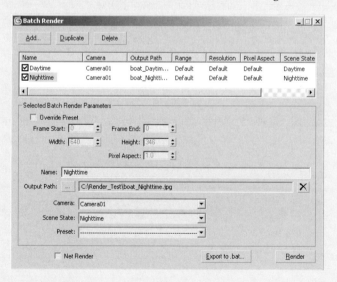

9. Set an output path and name the output file *Boat_Nighttime.jpg*.

10. Click Render.

Batch Render takes over rendering the scene based on the two states that you set up. The rendering is accomplished without any need for intervention on your part.

Summary

In this lesson, you learned to set up rendering output, how to use the RAM Player to preview your work and compare different images, and how to use environment effects to make the scene more interesting. You also learned how to save and recall scene states in order to create renderings of the same scene with different properties applied. Lastly, you learned to use the Batch Render tool to automate the renderings of your project.

Rendering

Scene Assembly Lab

This last lesson is a project or scenario lesson. Minimum instruction is provided. You can choose to do some or all of the tasks.

You will be working on the Last Gas(p) gas station scene from the modeling sections of this book. Some files will be provided, others you will create on your own.

If you are in a class, you can choose to work in a team to simulate a studio environment on a larger project.

Objectives

After completing this lesson, you will be able to:

- Approach the problems of developing scenes and animations with a minimum amount of instruction.
- Model different objects using appropriate techniques
- Create interesting materials on your own.
- Create a lighting environment suitable to the mood you wish to create.
- Animate your scene to convey the intended thoughts to the audience.

The Last Gas(p) Gas Station

The overall idea of the Last Gas(p) gas station is to demonstrate the classic struggle of opposites in an amusing manner. In this case the opposites are represented by the two main characters and their surroundings. The first character, Armani Man, is your typical upwardly mobile city slicker. He has all the trappings: exquisite clothes, an expensive sports car, and an attitude to match.

Car model courtesy of Alan Wilson — www.paperpilot.com

The second character, Pops, is the gas station attendant. He appears as dusty as the gas station and desert that surround the station. As apposed to Armani Man, the impression of Pops should be slow-moving, practical, seen it all, and hardened by the elements.

The overall story should develop as follows: Armani Man is driving along a deserted road and sees a sign warning that this is the last gas station for the next 133 miles. Fearing that he might run out of gas in the desert, Armani Man turns in to the Last Gas(p) station, and pulls up to the pumps. The station appears to be open, as noises, movements, or changing lighting inside would indicate, but there's no sign of an attendant. Armani Man, being the kind of guy he is, honks his horn several times. Finally, out of nowhere, Pops appears next to the driver side window. A rapid conversation ensues, and somehow Armani man winds up on the ground, and

Pops has taken over the car. Pops peels out of the station in the direction from which Armani Man came. The Last Gas(p) sign breaks and reveals the "p" in the sign. As Armani Man lies in the dust, looking up at the various structures of the station, the structures shimmer in the heat and disappear. Was the gas station just an illusion?

In the sections that follow, you will find suggestions to help elaborate the scene and create the animation as described above. Feel free to change or enhance the suggestions made here to that of your own.

Modeling

Open the file *Modeling Start.max*. This file contains much of the objects created in the modeling lessons plus some additional geometry.

This is the starting file for some modeling that the director has asked you to perform.

The gas station pumps are blocked out but have not been detailed. The art director has given you a sketch to model a more detailed gas pump.

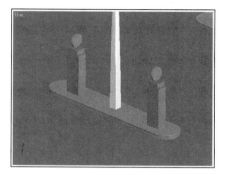

The blocked-out gas pumps in the startup file

Sketch of the detailed gas pump

In addition to the gas pump sketch, the art director has provided a sketch of an old soft-drink vending machine.

Sketch of the soft-drink vending machine

The suggested location for the vending machine is between the office door and the garage door.

Materials

The materials in the final version of the scene will vary from ones that look worn out and faded to those that are shiny and new. The latter materials are mostly related to the Armani Man character and his car. You are tasked with developing the older-looking materials in the gas station scene. The scene file Materials Start.max contains all the geometry in the previous section, If you would like to add elements you modeled, you will need to merge them. Open the file *Materials Start.max*.

First, start with the sky. The scene already contains a hemisphere object called Sky. When you open the Material Editor you will note a Sky material that is already designed. You will modify this material and the mapping coordinates on the hemisphere to obtain a mapped sky dome. Based on the time of day you choose for the scene, use one of the following bitmap options:

Daytime bitmap (Sky.Day.Low.jpg)

Nighttime bitmap (Sky.Night.Low.jpg)

A daytime Sky material should look as follows:

Daytime Sky material applied to the Sky dome

In general, the scene should become more worn looking. change the material of the Gas Pump Island object to take into account the fact that the top and sides of the base are different: It has a concrete top and worn, painted sides. Apply this material to all the curbs in the scene. Since the island is modeled as one object, you will need to select polygons at the sub-object level, and then apply the appropriate material to the selection.

Gas Pump Island object with simple material applied

Gas Pump Island object with Multi/Sub-object material applied

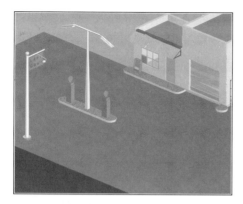

Curbs with different materials applied

Next you should create a material that shows wear in the parking area of the gas station, render a top view of only the parking area curbs and signs, and then create a matte in a paint program that you can use in a Blend material.

Rendered image of parking area

Mask created in a paint program

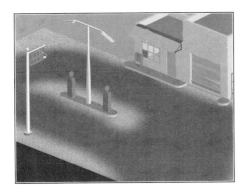

The mask allows you to mix materials to give a worn look to heavily traveled parts of the parking area.

You needn't always create materials of your own; a wealth of materials is readily available in the material libraries that come with 3ds Max. Look in the following material libraries for the listed material and apply it to the indicated object.

Material library:	*architectural.materials.woods & plastics.mat*
Material:	*Woods & Plastics.Finish Carpentry.Wood.Boards*
Object(s):	*Glass09 plywood*
Material library:	*architectural.materials.doors & windows.mat*
Material:	*Doors & Windows.Glazing.3*
Object(s):	*Glass01* to *Glass 08*

Results of applying materials to the glass, and broken window pane

Rendering

Continue to work around the building and surroundings until you are satisfied with the materials applied to the scene.

Textured building walls, window frame, and oil can dispenser

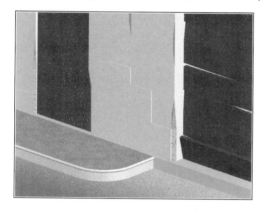

In places where the building walls are broken, use another material for exposed concrete.

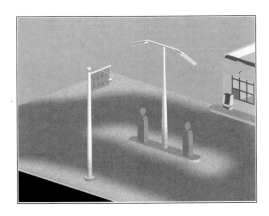

A gradient material at the pole bases shows where paint has worn off.

Using a mask to add a dirt edge next to the road

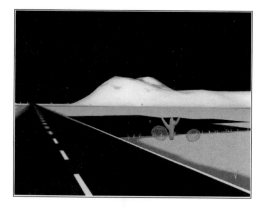

A Gradient Ramp map can be used with noise to simulate vegetation at the upper levels of the hills.

Materials applied to the Last Gas(p) scene

Lighting

Open the file *Lighting Start.max.*

Some lighting has already been provided in the scene for a daylight scenario. The scene contains four lights of which only three are used in simulating daylight. The fourth light was part of an exercise earlier in the book to light the Last Gas(p) sign. In this section you have the option of improving the daylight simulation or to switch to an illuminated night scene.

In the daylight scene you can do a number of things including using a Sunlight or Daylight system. You can also opt to use the Light Tracer advanced lighting method when you render the scene. In addition the use of exposure control can improve the appearance of the final output.

Some improvements to the duality scene using exposure control and the Light Tracer.

To create a good-looking night scene, you will need to insert more lights in appropriate locations. Don't forget, however, that the more lights your scene contains, the longer it will take to render. For elements like the interior of a car or lighted parts of the gas pump, self-illuminated materials should be sufficient.

For a night scene, turn off the three lights that were enabled in the duality scene. You should also turn on the light that was created for the Last Gas(p) sign, and add lights for the lights above the gas pumps as well as some lights for the interior of the building. Replace your sky bitmap with *Sky.Night.Low.jpg* and add self illumination to the material.

The night scene

Add interest by including a volume light.

Animation

In this last section of this lesson you will apply animation techniques to the Last Gas(p) scene. Our instructions are generic in nature and do not depend on how refined the scene is in terms of materials and lighting. The illustrations use the daylight scenario without the additional modeling elements outlined in the modeling section of this lesson. If you have had time to work on those elements, you can merge them into the scene before doing final renders. At some point in this scenario you will need the complete Armani Man and Pops characters; you can find these in the files *Armani Man.max* and *Pops.max*.

Open the file *Animation Start.max*. Save your work often, preferably to a different MAX file for each sequence described below, for example *Sequence1.max*, *Sequence 2.max*, etc.

To refresh your memory, we'll review the storyline:

Armani Man is driving along a deserted road and sees a sign warning that this is the last gas station for the next 133 miles. Fearing that he might run out of gas in the desert, Armani Man turns in to the Last Gas(p) station, and pulls up to the pumps. The station appears to be open, as noises, movements, or changing lighting inside would indicate, but there's no sign of an attendant. Armani Man, being the kind of guy he is, honks his horn several times. Finally, out of nowhere, Pops appears next to the driver side window. A rapid conversation ensues, and somehow Armani man winds up on the ground, and Pops has taken over the car. Pops peels out of the station in the direction from which Armani Man came. The Last Gas(p) sign breaks and reveals the "p" in the sign. As Armani Man lies in the dust, looking up at the various structures of the station, the structures shimmer in the heat and disappear. Was the gas station just an illusion?

Sequence 1: Armani Man driving along the deserted road.

Time: 1-2 seconds

Notes: Need to insert the car (*F_Type06.max*) into scene and prepare for animation. Use the Camera Driver View attached to the car.

Approach to the Last Gas(p) gas station

Sequence 2: Sees the Last Gas sign.

Time: 2-3 seconds

Notes: Need to create a small model for the last gas sign, and a bitmap for the lettering.

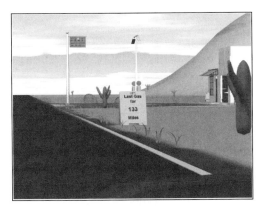

New camera focuses attention on sign

Rendering

New camera tracks sign

Sequence 3: Armani Man focuses on gas station and pulls into station (left-hand side of the pumps).

Time: 4-5 seconds

New camera focuses attention on sign

Sequence 4: Armani Man looks towards the building and waits for attendant to arrive, while changes in lights from the building indicate that there is someone inside. Armani Man honks his horn several times.

Time:5-6 seconds

Now attention is focused on the gas station.

Sequence 5: Out of nowhere, Pops appears next to the driver-side window. A rapid conversation ensues.

Time: 2-3 seconds

Out of nowhere, Pops appears on driver's side of car.

Rendering

Sequence 6: Somehow Armani Man winds up on the ground, and Pops has taken over the car. Pops peels out of the station and drives back in the direction from which the car originally came.

Time: 4-5 seconds

Armani Man, now on the ground, looks at his car pulling away with Pops at the wheel.

Sequence 7: The Last Gas(p) sign breaks and reveals the "p" in the sign.

Time: 3 seconds

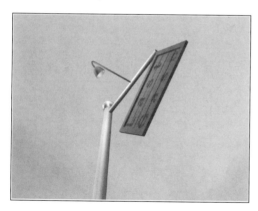

Sign breaks with transition to Last Gasp.

Sequence 8: As Armani Man lies in the dust, looking up at the various structures of the station, the structures shimmer in the heat and disappear.

Time:3-4 seconds

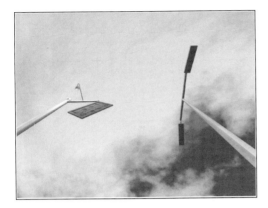

While Armani Man looks up at the sky, the gas station structures shimmer and disappear.

Total Time 24 seconds (minimum) 31 seconds (maximum)

Shown below is one interpretation of the final animation.

Summary

In this lesson you have been immersed into a small project which can be done individually or in a group. The project allows you to develop working techniques for modeling, materials, lighting, and animation. In addition you will need to develop some skills in managing your projects, especially if you decide to work in teams.

Rendering

Index